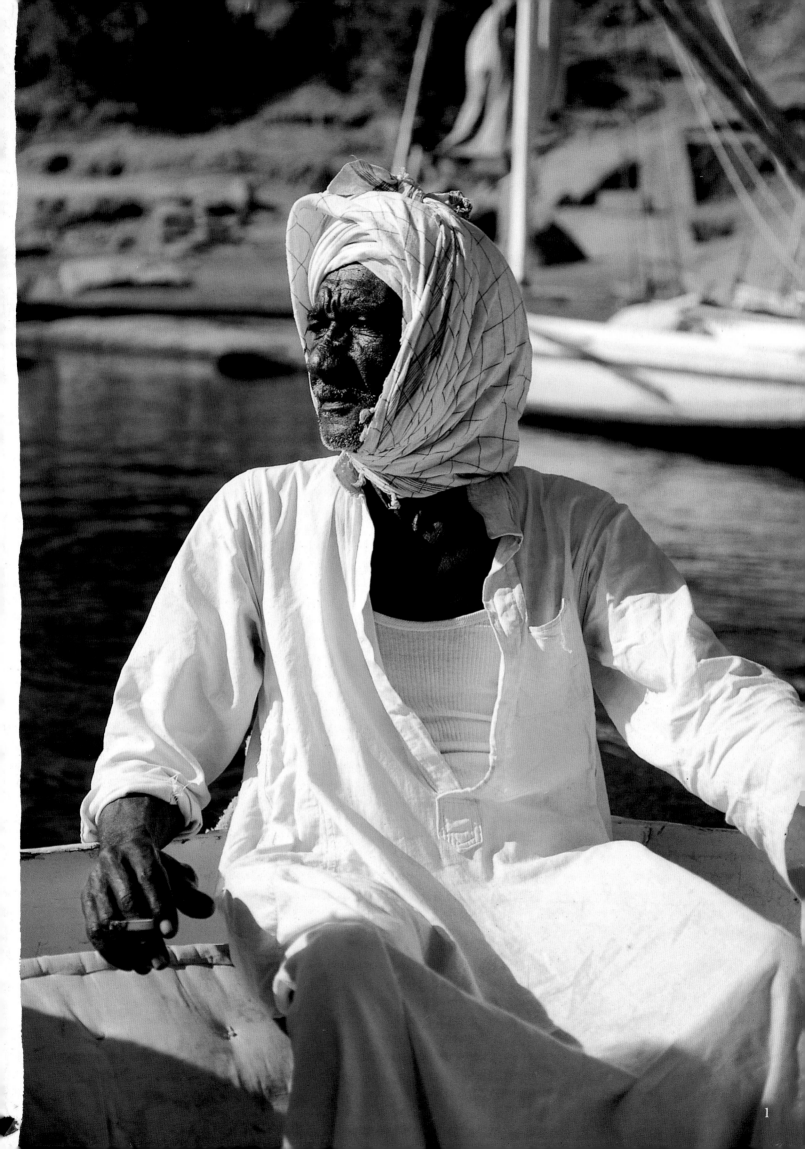

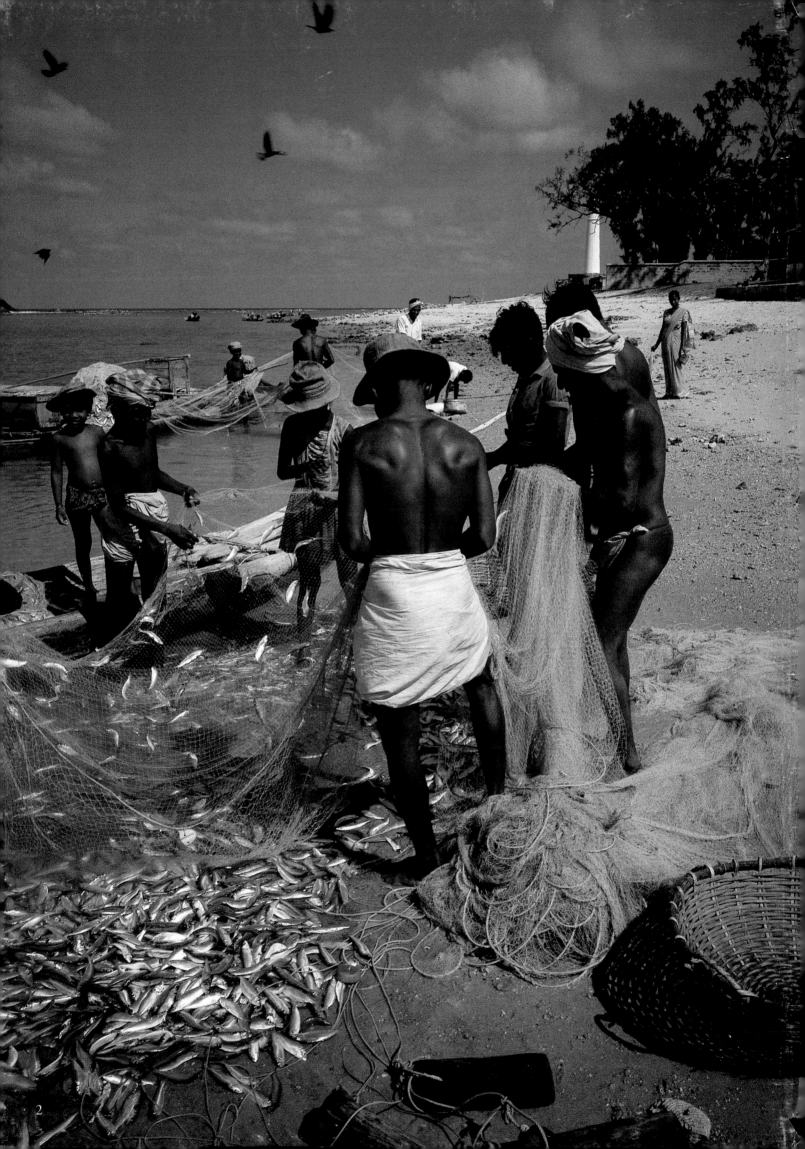

PEOPLE

LEGENDS IN LIFE AND ART

ROLOFF
BENY

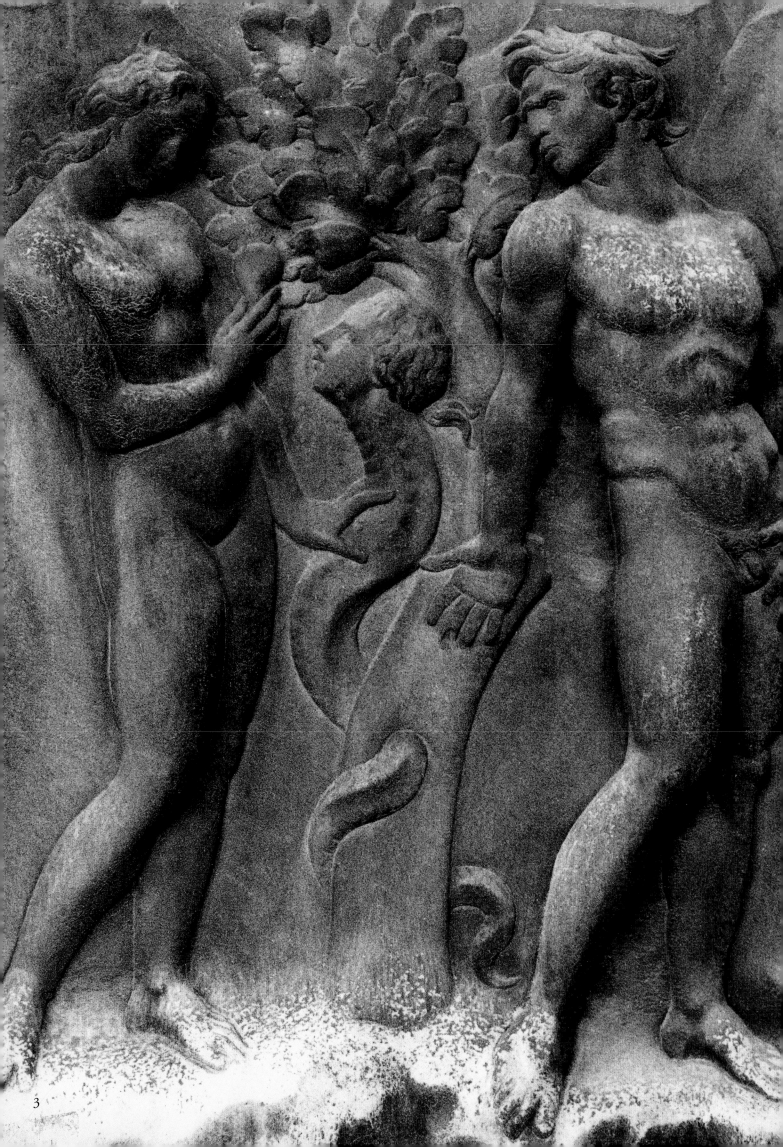

3

PEOPLE
LEGENDS IN LIFE AND ART

ROLOFF
BENY

PRESENTED BY MITCHELL CRITES
PREFACE BY JACK McCLELLAND
WITH 158 ILLUSTRATIONS
151 IN DUOTONE
7 IN COLOUR

Douglas & McIntyre
VANCOUVER / TORONTO

THIS BOOK IS DEDICATED TO
SIGNY EATON, PEGGY GUGGENHEIM, EVA NEURATH
AND FARAH PAHLAVI, THE SHAHBANOU OF IRAN,
WHO, AS ROLOFF'S PATRONS, PUBLISHER AND
FRIENDS, OPENED SO MANY DOORS

PUBLISHER'S NOTE
Roloff Beny's autobiographical writings are set in *italic*

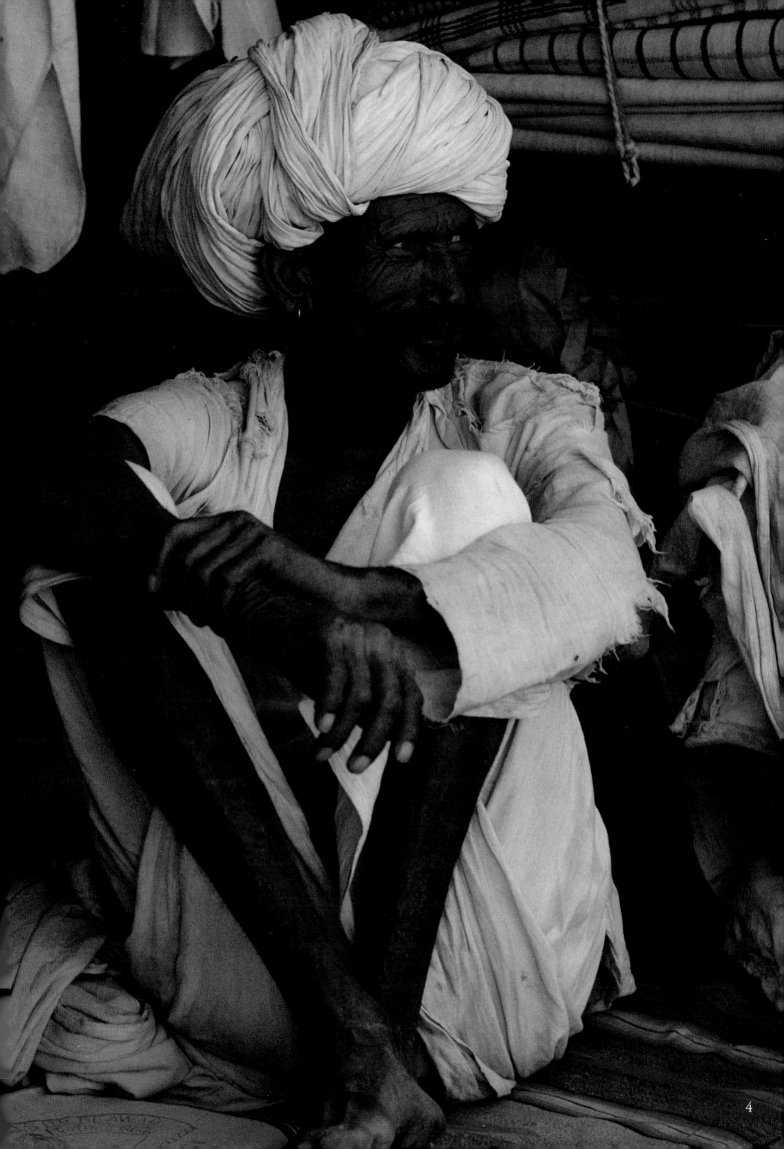
4

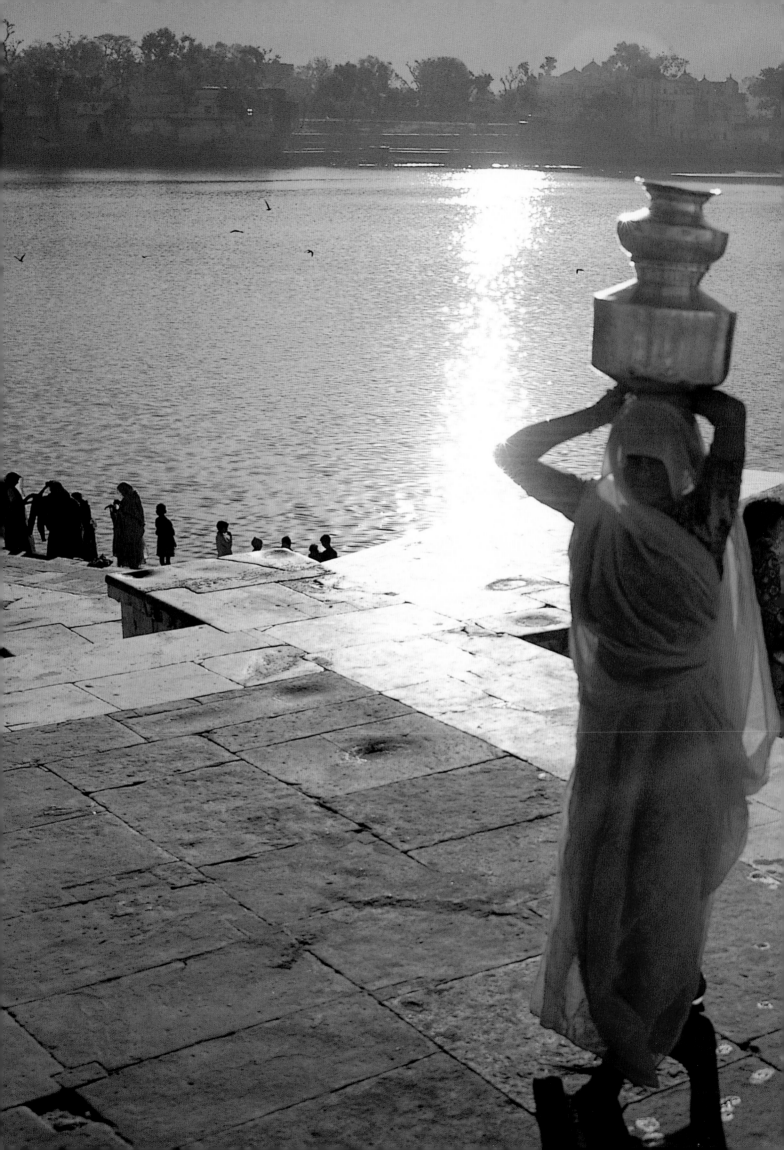

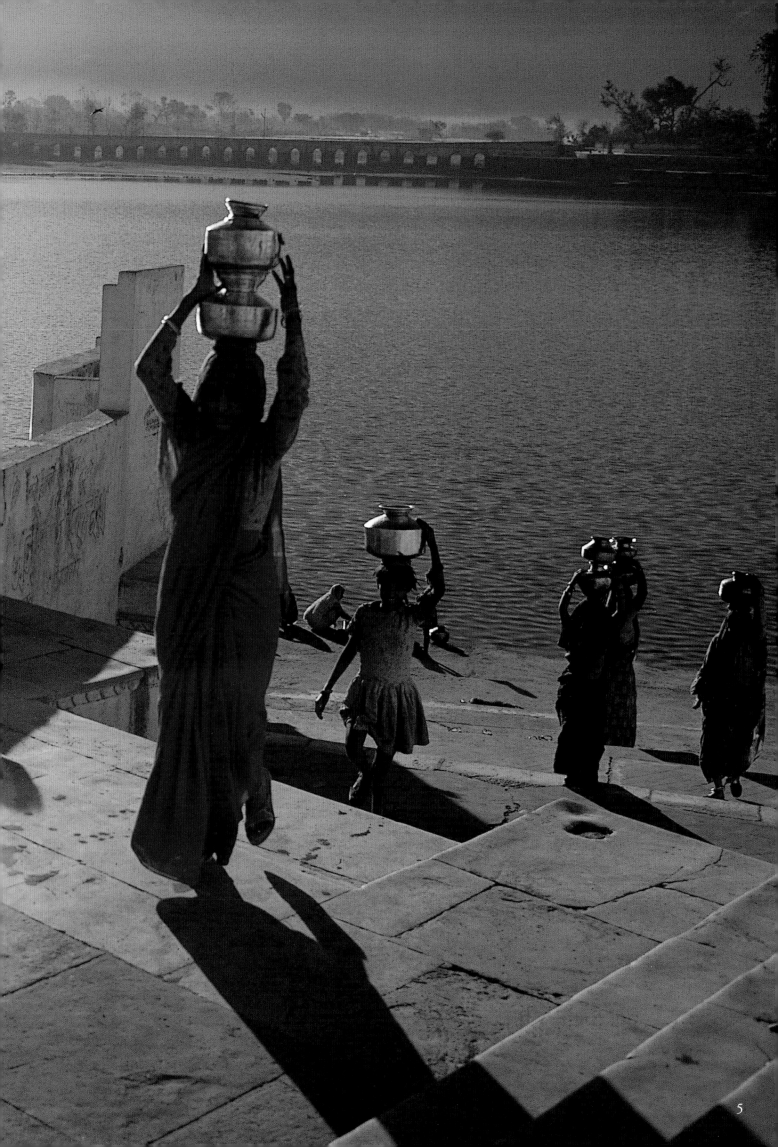

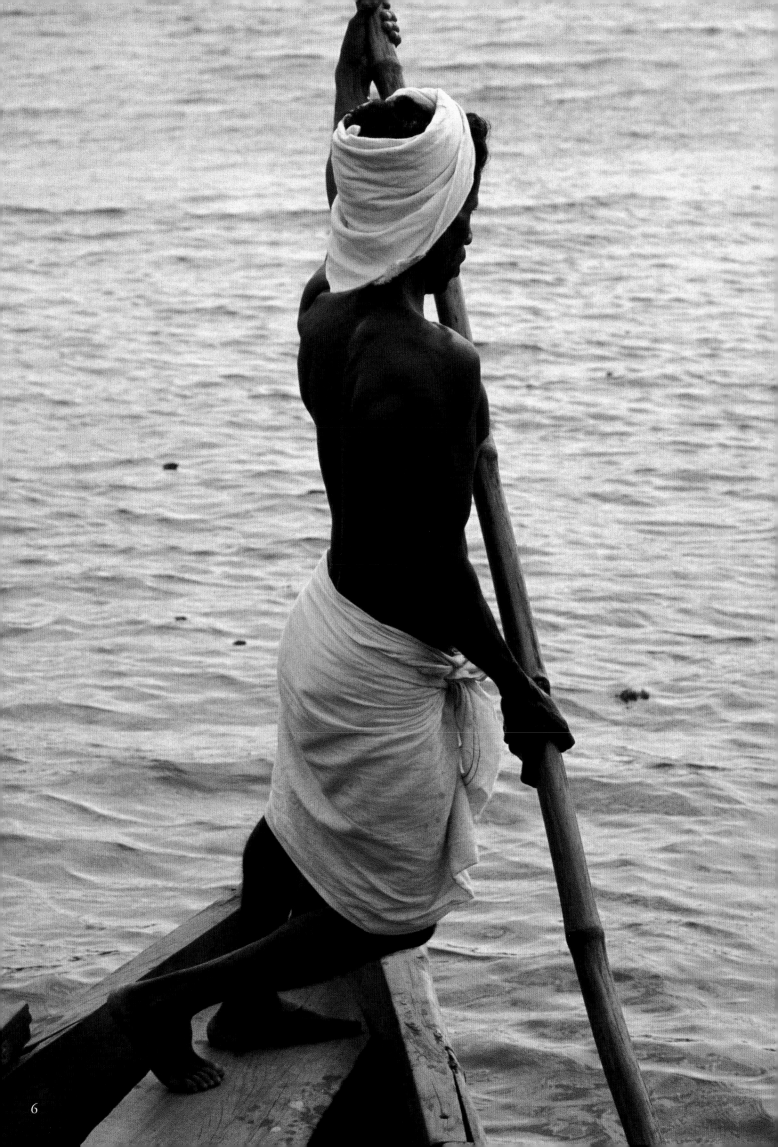

PREFACE

Many of those who knew Roloff Beny may well consider these photographs to be his most significant works. Despite his great achievements in the study of landscape, art and architecture, he was always deeply interested in people. Perhaps this partly explains, in terms of elementary philosophy, how an individual from a small town in western Canada became one of the world's greatest photographers.

Is it an exaggeration to refer to him as such? I think not. His work was collected and published in eighteen different volumes, most of them in five or more separate languages, almost all of them originated by Thames and Hudson, London, who are perhaps the world's finest art-book publishers. A gallery is named after Roloff Beny in honour of his work at the Royal Ontario Museum in Toronto.

Like many gifted individuals, Roloff could have achieved success in almost any field he chose. He was originally an extremely talented young painter who was already exhibiting at the age of fifteen – much of his work is now part of the permanent collection at the University of Lethbridge, Alberta. He might have been a writer, as affirmed by his recently published *Visual Journeys*. He should have had an award as the world's most flamboyant dresser. But photography became and remained his main interest and without doubt his greatest achievement was in that field.

It was as a photographer that Roloff set out to meet and study the world's most interesting people. His vision of some of them, among the rich and famous and among the most humble of peasants, is collected here for the first time in a single volume and needs no comment from me.

I was invited to write this preface as head of the Roloff Beny Foundation, as the Canadian publisher of most of his books and as one of his good friends. The Foundation has already provided the initial funding for the Roloff Beny Gallery at the Royal Ontario Museum. In the future it will be supplying scholarships for young aspiring artist-photographers throughout Canada.

Jack McClelland

CONTENTS

CONTENTS

1 Ferryman, sitting in his felucca on the Nile, Upper Egypt.

2 Fishermen pulling in the evening catch along the southern coast of Sri Lanka.

3 *Adam and Eve*, 1425–38, a carved panel by Jacopo della Quercia (1374–1438), round the middle portal of S. Petronio, Bologna, Italy.

4 Rajasthani farmer wearing his traditional turban at the weekly market in Jaipur, India.

5 Village women at sunset drawing water from the sacred lake at Pushkar in the Indian state of Rajasthan.

6 A solitary boatman along the Sri Lankan coast.

7 A craftsman splitting bamboo for making fishing-net needles, Japan.

8 A Hindu sadhu, or wandering ascetic, meditating at a temple dedicated to Shiva, the Lord of Creation, in Kathmandu, the capital of Nepal.

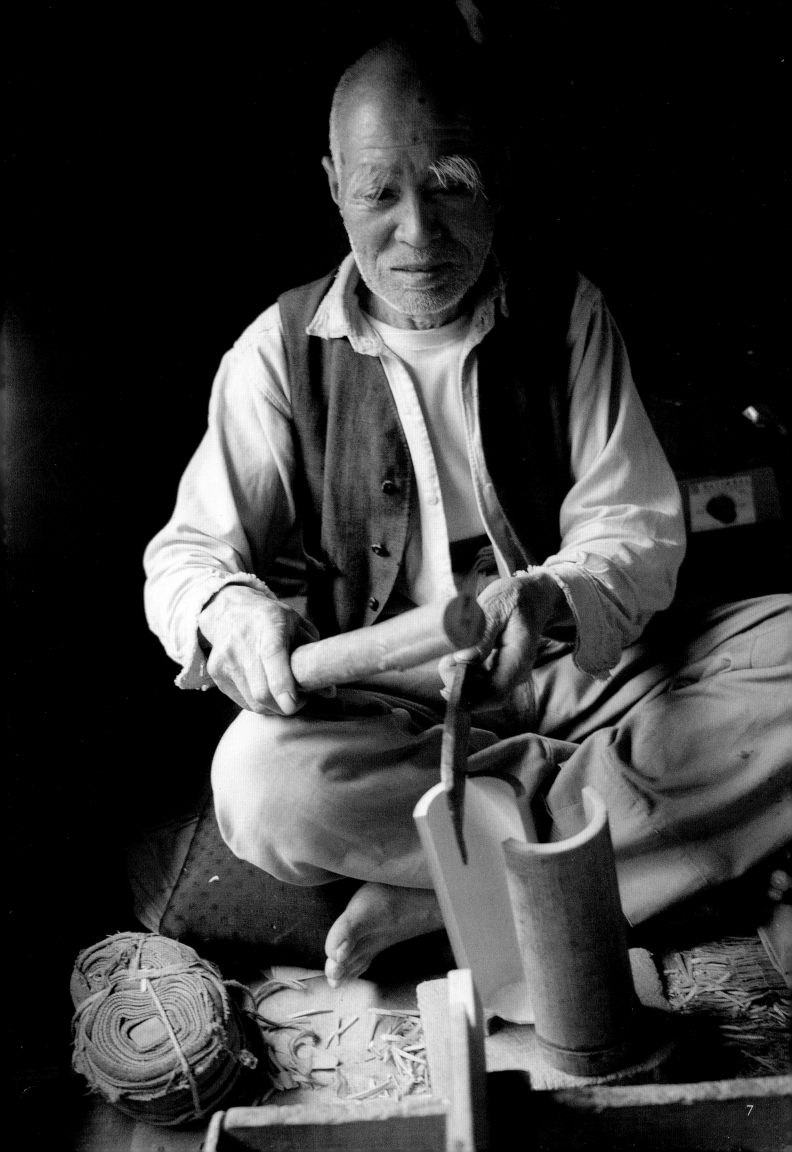

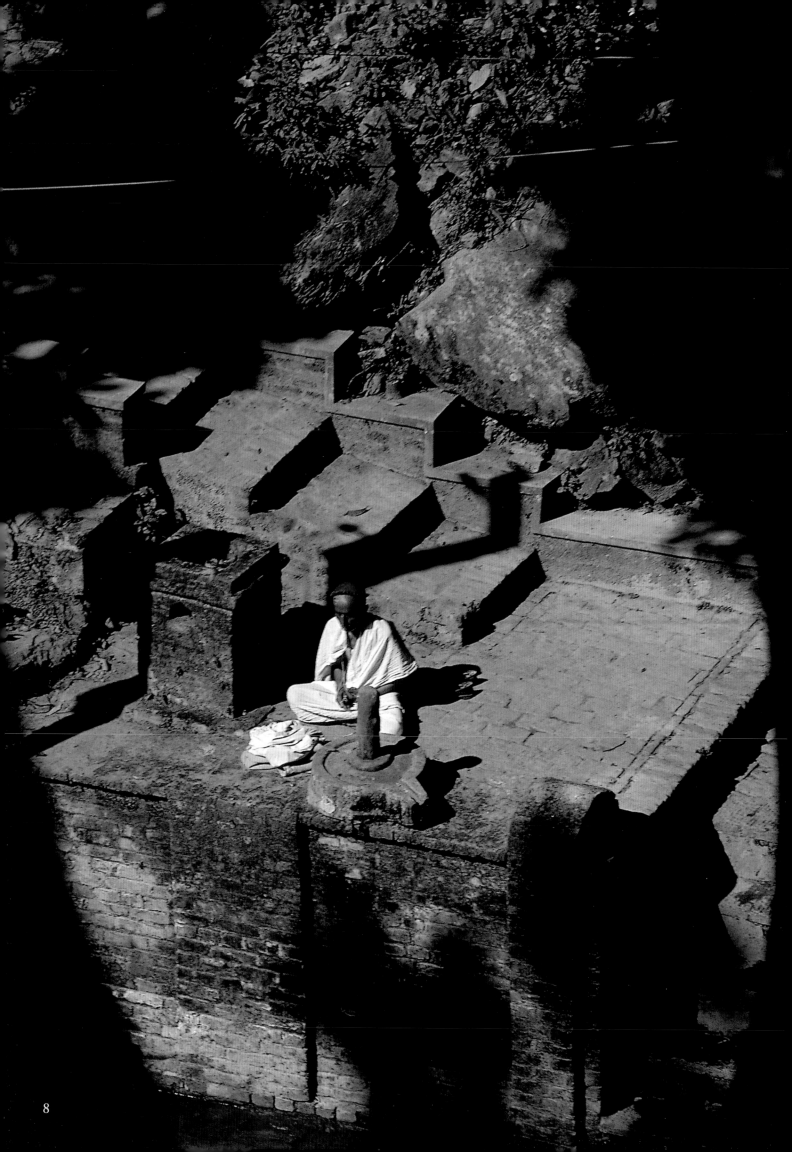

Introduction

ROLOFF BENY WAS AN ARTIST AMONG PHOTOGRAPHERS, A passionate and romantic traveller in every corner of the globe, and – before his untimely death in 1984 – the creator of some of the most beautiful books published this century. His international reputation as a photographer rests primarily on his sensitive interpretations of the architecture and sculpture of the ancient and classical world, as well as his dramatic portraits of Japan, Sri Lanka, India, Iran and the countries that border the Mediterranean. Critics praised the artistry and craftsmanship of Roloff's books, but would often ask, 'Where are the people?' They were there, but usually appearing only as timeless grace notes to complement – and provide scale for – the vast landscapes, crumbling ruins and images of ritual splendour.

However, an unexpected and virtually unexplored aspect of Roloff's photography lay buried in the archive at Tiber Terrace, his home and studio in the heart of old Rome, where he had settled permanently in the mid-fifties.

During the past forty years, hundreds of people have walked through my lens – friends, acquaintances and strangers. I have made portraits of them for my own pleasure and sometimes for their own enjoyment. But there were faces so close to me I never thought of recording them, and many others who evaded my camera. Still, this is my private gallery, my world of people. Some of them are my favourite personalities, captured on stages, film sets or yachts, in studios, palaces or gardens.

For far too long the people in my film library have assembled in the dark, vying for space, jostling each other and expanding into cupboards, shelves and dossiers, almost as if they were having a party or house-guesting at Tiber Terrace – but always confined here, invisible ghosts, never escaping into the light. Too frequently they themselves have departed this world, leaving only images, etched on film, and in many cases, memories of special luminosity, the warmth of the encounter which brought them before my camera.

Unlike the photography for his sixteen books, which were carefully researched and often commissioned projects, Roloff's 'People' archive – as he liked to call it – grew haphazardly over the years through friendships and contacts in a glittering world of society, royalty and the arts which both fascinated and entranced him. It was not until the last five years of his life, when he had perhaps been stung by the criticism of the absence of people in his work, that Roloff seriously set to work on the 'People' book. It was an exciting project and one that he cared about strongly, but this was also a period of

extreme tension compounded by professional, health and family problems. In particular, the Iran he knew and loved and had worked in for most of the seventies had been swept away by the tide of fundamentalism and with it the benevolent and personal patronage of the Shah and Shahbanou who had commissioned two magnificent books on their country. Roloff turned to Anwar Sadat, Prime Minister of Egypt, and to the monarchs of Spain and Greece for guidance and support, while at the same time working on three smaller projects: the churches of Rome; the gods of Greece; and a survey of his first love, the culture and life of the Mediterranean.

Roloff continued to work steadily on the 'People' book with his art director, Antonella Carini, in Rome and with editors and publishers in London, Toronto and New York. Franco Bugionovi, a gifted master printer, who had collaborated closely with Roloff since his third book, *Pleasure of Ruins* (1964), began preparing final prints, but progress was agonizingly slow and the book refused to take shape. Roloff changed its title almost weekly – *In Flesh and Stone, Pleasure of People, Dust Before the Wind, Entrances and Exits, Walking Through My Lens, The Constant Instant, A Privileged View* and *People of Earth and Heaven* were all suggested at one time or another. All the visitors to Tiber Terrace were asked their opinion about who should 'make' the book and who should be 'banished'. Roloff, always his own worst editor, seemed incapable of making the difficult choices necessary to finalize the portraits and texts for the book. He was naturally nervous about revealing a whole new side to his photography so late in his career, but there seemed to be something even deeper bothering him.

I remember once during our travels together in Iran that Roloff had confided to me his almost morbid fascination with the tomb of the Shah's mother, which was under construction in Tehran. We would often pass the building and it seemed odd that the tomb, although it appeared to be finished, was always being worked on – with another minaret being added, or the tilework being stripped clean and done again with new designs and colours. We learned that the local superstition stated that if the tomb were ever completed in her lifetime, the Queen Mother would die. The image of the Tehran tomb haunted Roloff and, although he kept working on the 'People' book until weeks before his death, the photographs and texts never seemed to take final shape.

My faithful Italian maid, Maria, housekeeper and guardian of twenty years, interprets her dreams and mine each morning as I have my breakfast in bed, my

19

favourite vice. For years her proverbs were disarming and frightening, directly warning of the unpredictable quality of life. She intuitively felt the horror I had of flying. Packing my bags was already traumatic, and then saying goodbye to each room, to each object, to the plants on the terrace, and most poignant of all, to my sleeping archives, as if I were bidding farewell to my life, to my children.

When I told Maria how many of the famous people I had photographed were no longer with us, tears came to her eyes, her short peasant body shuddered, then in a calm voice, she said, 'Signor Beny, I have always told you, "Remember, Death always sits on our shoulder".'

With that gloomy adage, she barked, 'Now, avanti, get up and finish your book before it kills you. You have lost too many faces already, and you're not getting any younger. Anyway, what is the title of your book? Soon, you'll have to call it the Book of the Dead!'

Roloff left clear instructions in his will that any of his book projects that were advanced, but unfinished, should be published in the same style and with the same standard of quality as all his earlier works. When Eva Neurath, the co-founder of Thames and Hudson, Roloff's mother publisher, and I were asked to piece together the 'People' book, we found ourselves faced with thousands of photographs, revisions of texts, layouts and dummies. Roloff had tried chronological and geographical formats for the book and had played with chapters such as 'Stars and Strangers', 'Dinner with the Rich and Famous' and 'Pets and their People'. After months of deliberation, we decided that the book should follow the various roles and professions that people assumed in life, thus removing the constraints of time and space and allowing us to wander freely through Roloff's extraordinary life and the grand stage on which he worked.

In his diaries, later reminiscences, 'People' texts and unfinished auto-biography, Roloff recorded many actual photographic events and their settings, as well as his own personal observations and relationships with his famous friends and colleagues. After sorting through literally thousands of pages of written material in London, Jill Eldredge Gabriele has selected and edited these vivid and perceptive impressions which accompany and amplify the portraits themselves.

Many of Roloff's famous subjects were old friends who would drop by Tiber Terrace and in a relaxed, casual mood agree to be photographed. Sometimes, they were given a timeless, eternal look, like his images of sculpture which brought the objects to life, and in another setting, they could appear vulnerable

and very much part of the moment. Although Roloff could at times be an impossible snob and a self-acknowledged name-dropper, I also recall from our many travels together that he was as happy drinking tea with a Rajasthani villager in his mud hut as attending a banquet at the imperial palace in Tehran.

Roloff's portraits were never staged studio shots. He worked at a slow pace and was uncomfortable with complicated flash photography and lighting, preferring to work with natural light. He always searched for the inner nature of his subjects.

The artistry of a photograph is determined by what's inside a person and what he is ready to receive. My photographs are not just beautiful pictures, but a happening. If it ever ceases to be a happening, it is time to put the camera on ice.

Roloff was a splendid portrait photographer and a perceptive observer of the human condition, perhaps far greater than he ever realized. His diary notes, written in the summer before his death, express most clearly his aspirations and feelings that surrounded the 'People' book.

When a writer publishes his notebooks, he is often indulging in a dangerous sort of self-exposure. Everything is immediate, raw, unfinished. I am a photographer, my pencil is my camera, my notebooks are my archives and my images are my life.

Standing on my terrace, I am still hypnotized by the setting I chose twenty-five years ago – two thousand years of history in a shattered mosaic heaped over the seven hills of Rome. Now the Tiber is black velvet and dusk has come. I let down my own invisible line into the darkness, baited with half memories, as I untangle images of distant figures that once walked through my lens. I am no longer alone, but a traveller returned with the joy of a thousand faces.

Roloff spent some of his happiest and most creative moments in Iran, and I am reminded of a Persian saying of which he was especially fond. It is repeated when people say goodbye – 'May your shadow not decrease.' I feel that with the publication of this long-delayed book, one so close to his heart, that, in Roloff's case, his shadow is both alive and well.

MITCHELL SHELBY CRITES
Delhi, late autumn, 1994

Life and Art

ROLOFF SPENT MOST OF HIS ADULT LIFE WANDERING THE world in search of images for his books. They were unquestionably his happiest times and he approached each journey with characteristic energy and determination.

Homer's Odysseus and Venice's Marco Polo have always been my two favourite alter egos. Like them, I disappear for months, for years, to the strangest, most outlandish places in my hunger for images – in that maniacal fanaticism which has cost me more than one friendship. 'You're going to kill us, Roloff!' was one of Peggy Guggenheim's leitmotifs in India. Of course, she was over seventy at the time.

The fate of the photographer – of a photographer like me – is to travel. My main task is to be there, to capture the moment, the place wherever it may be. When I'm on a mission, all fatigue vanishes. I lose all sense of vertigo. I feel no need to stop and eat – as all my ex-assistants will testify with disgust.

One of Roloff's most favoured titles for his 'People' book was *In Flesh and Stone* and it is with such images – of sculpture and traditional people – that we begin this book. Roloff had an incredible gift for bringing bronze, wood and stone to life through his sensitive and perceptive awareness of light. 'Light is atmosphere that can change and through light I photograph what the sculptures feel like.' For instance, Lorenzo II appears to rise from his marble tomb and the towering figure of Michelangelo's *David* reflects the contemporary form of Philippe Chaveaux, Salvador Dali's model for *Crucifixion*. Roloff possessed an excellent knowledge of ancient and classical literature and art and often connected a face of today with a sculpture from the past. I can still see him leaping from the jeep on the road to Shiraz and rushing up to a startled Iranian villager and telling him he had just stepped off the nearby friezes at Persepolis and must be 'immortalized'.

Roloff studied the 'architecture of faces', as he called it, and found beauty and strength among the young and old, in the bearing and costumes of men, women and children. He preferred a timeless, ethnic look, one that was undisturbed by the ugliness of modern urban life. When inside a temple, mosque, or sanctuary of any kind, Roloff moved with ease and grace, fascinated by the keepers of the faith and the arcane rituals and traditions they preserved and passed on to the next generation.

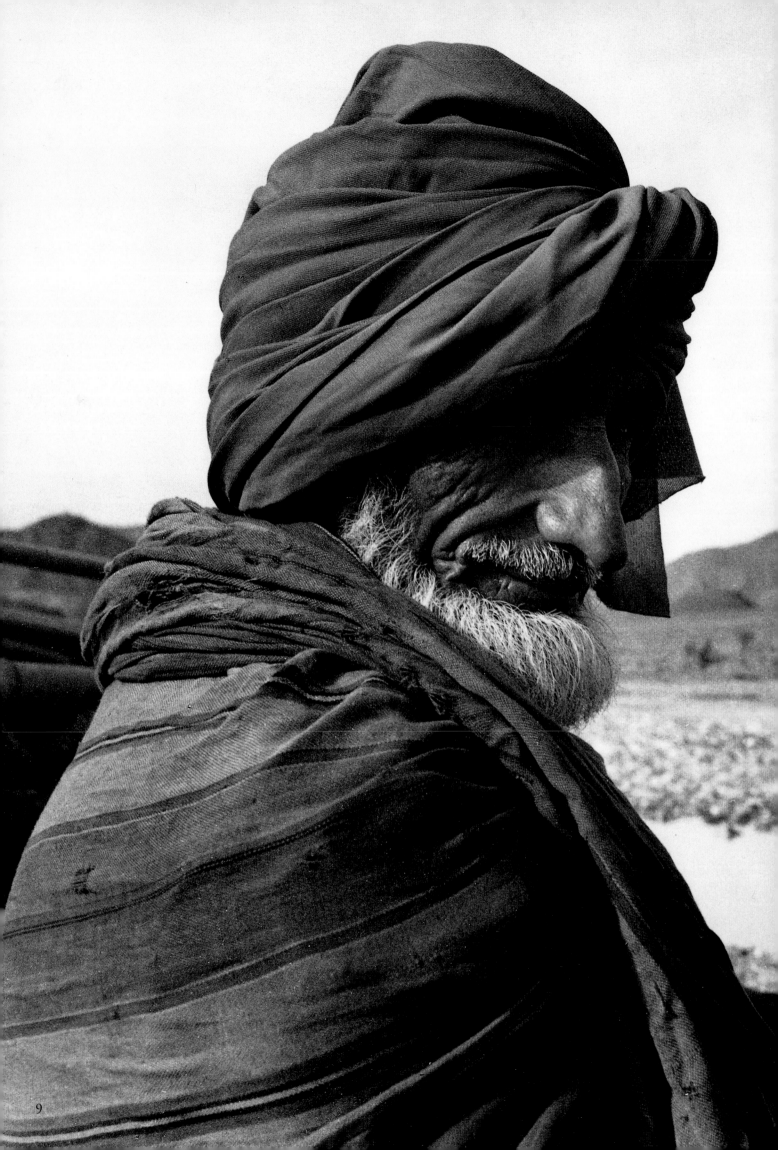

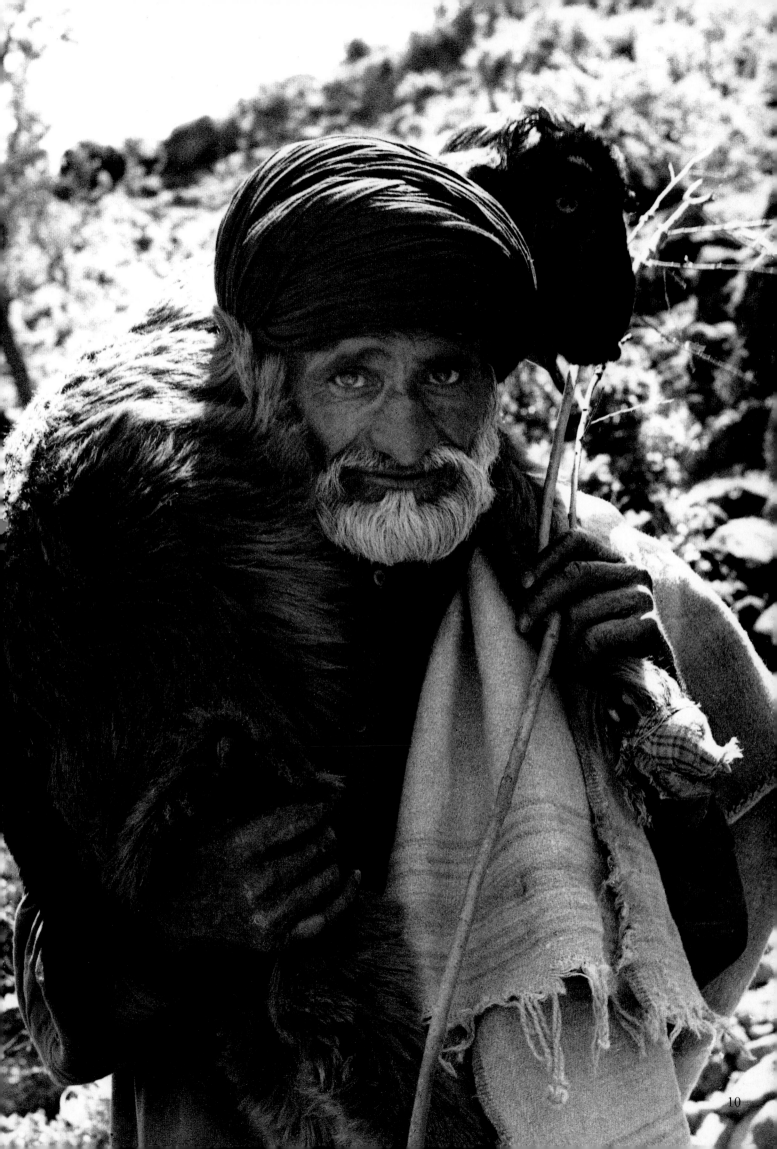

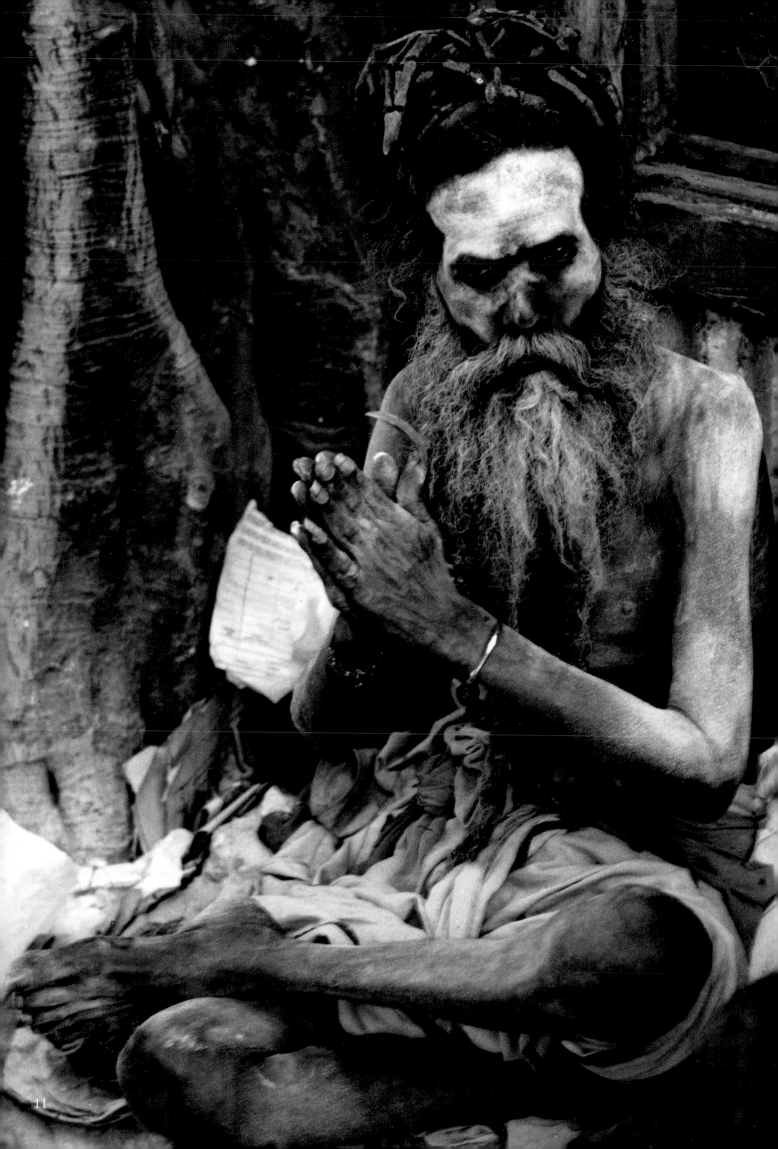

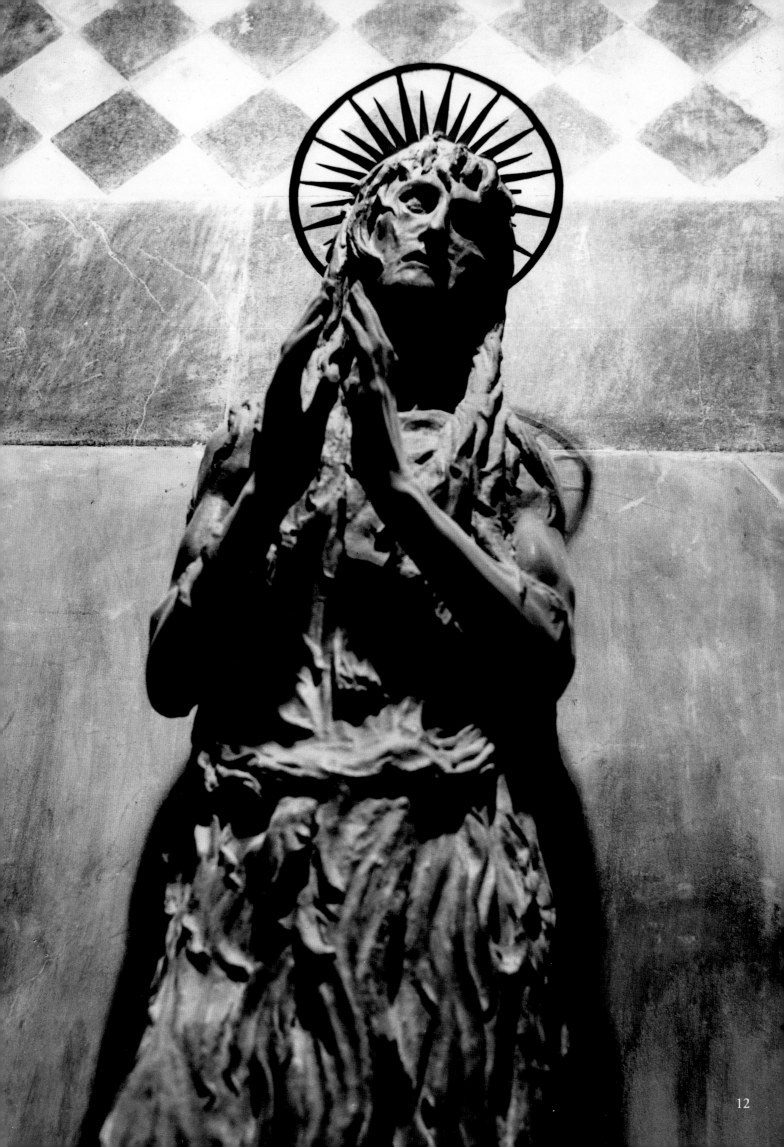

12

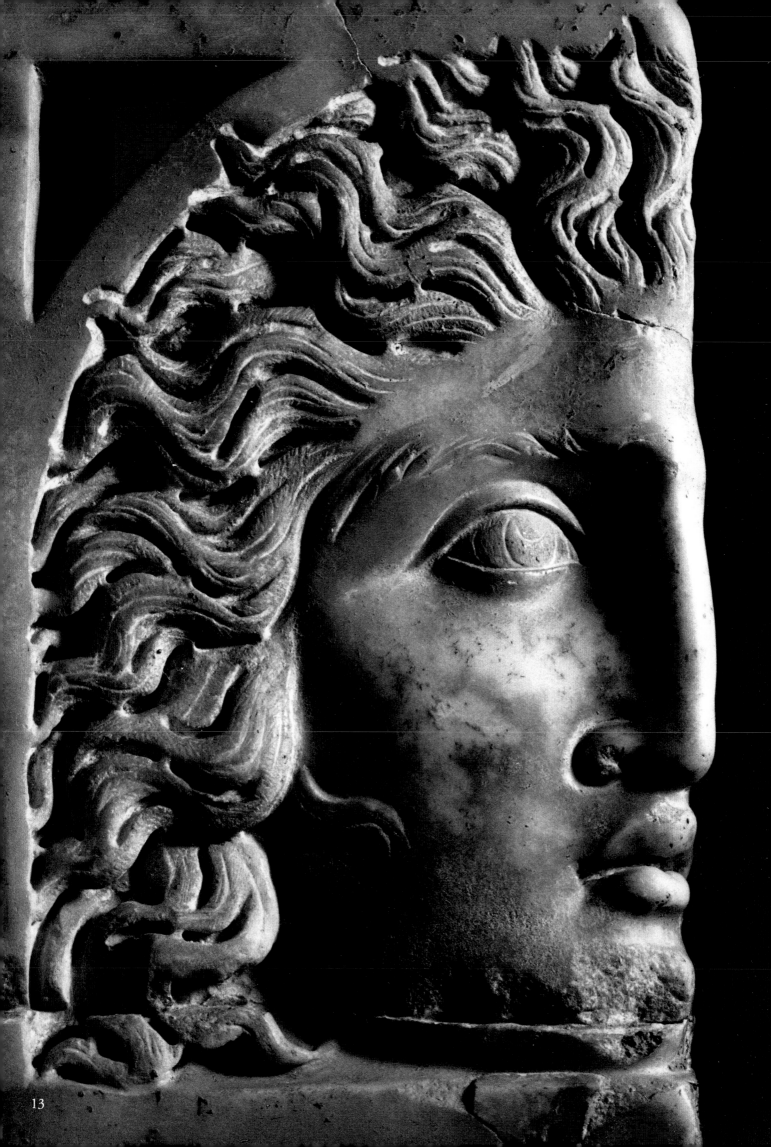

13

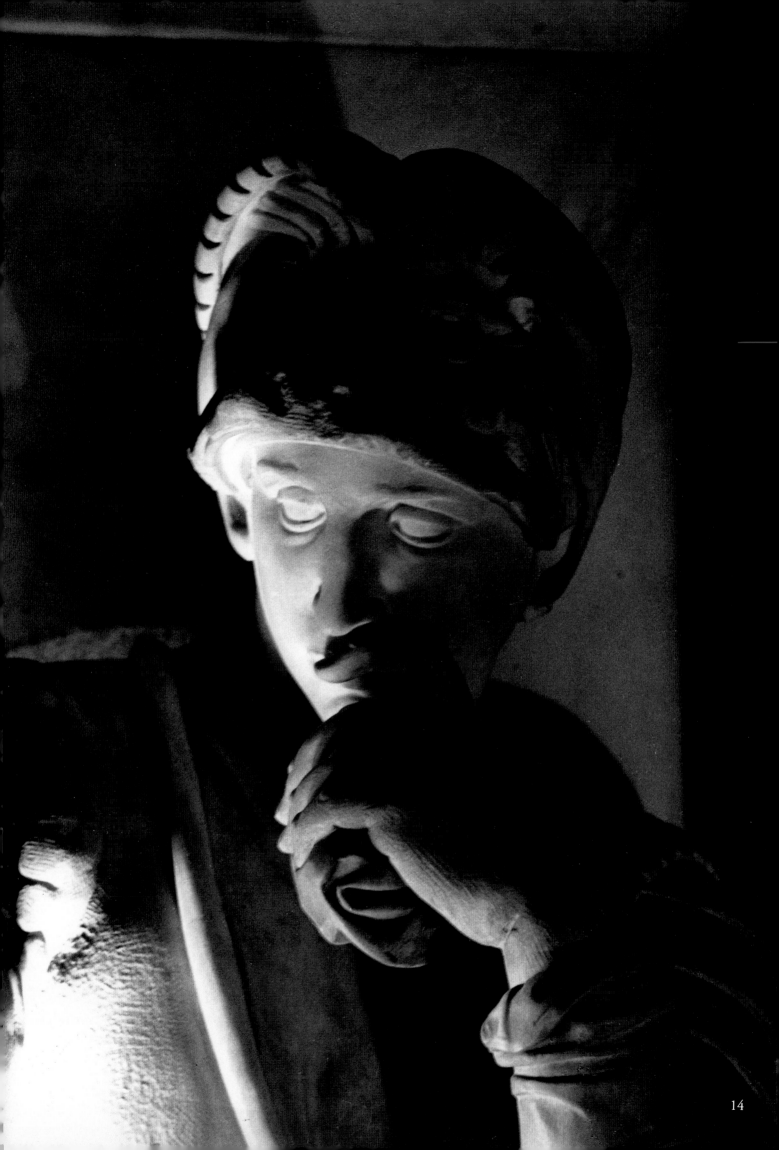

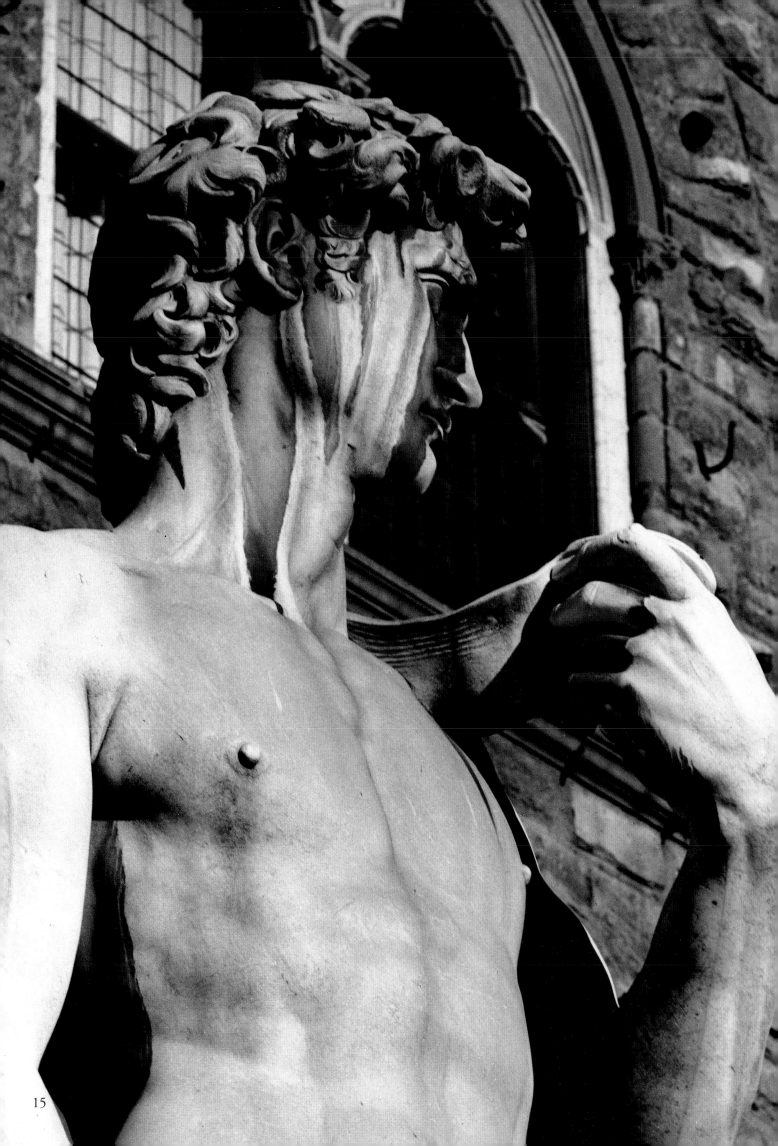

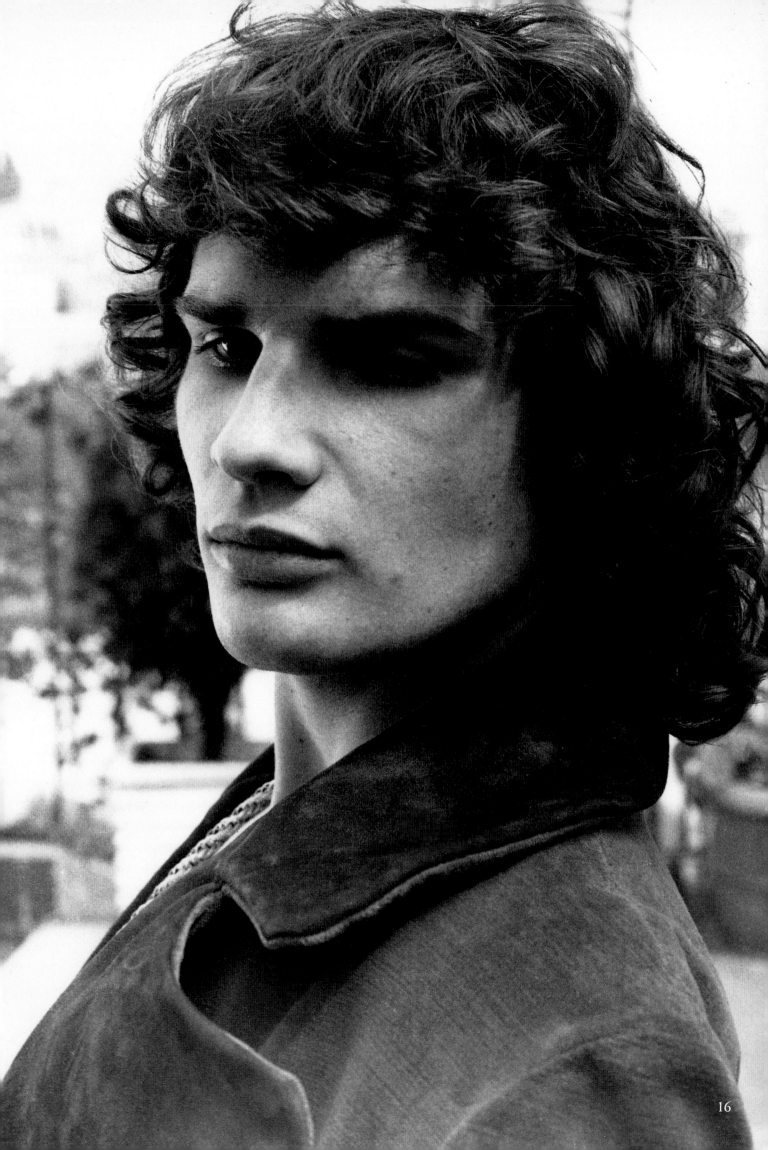

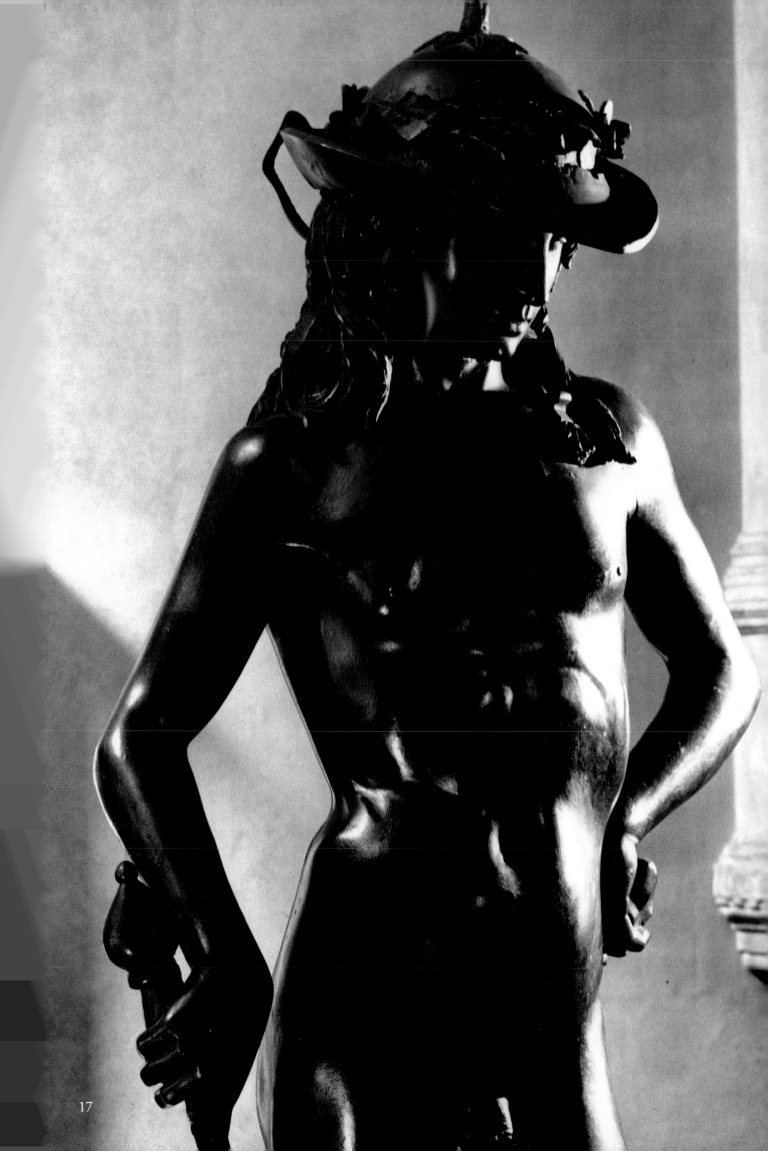

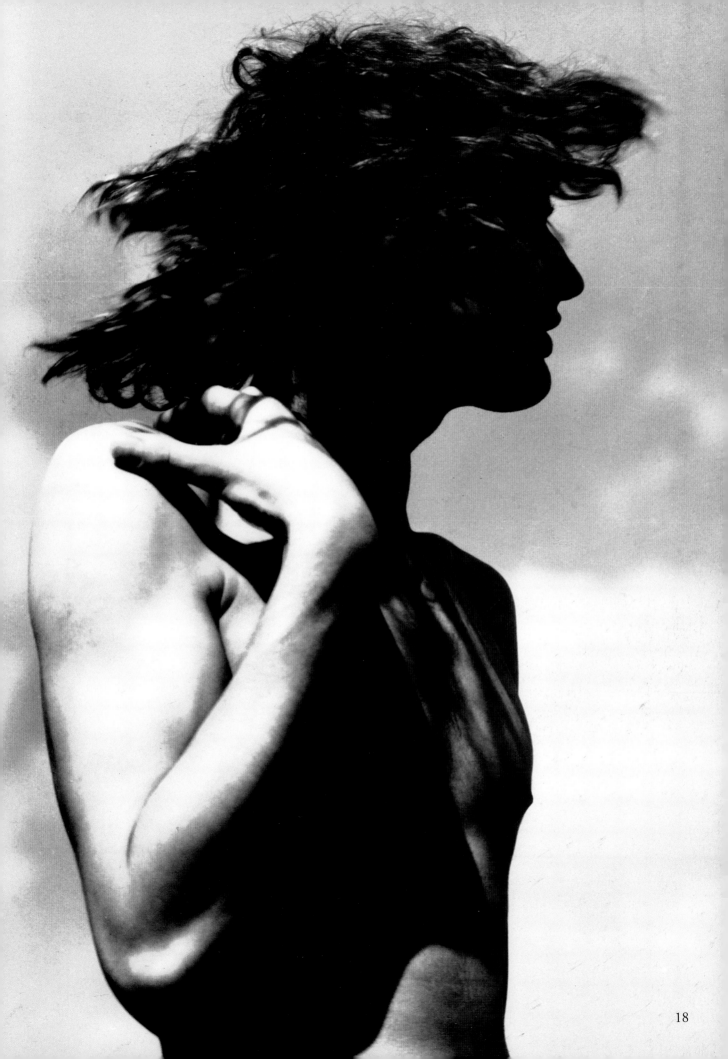

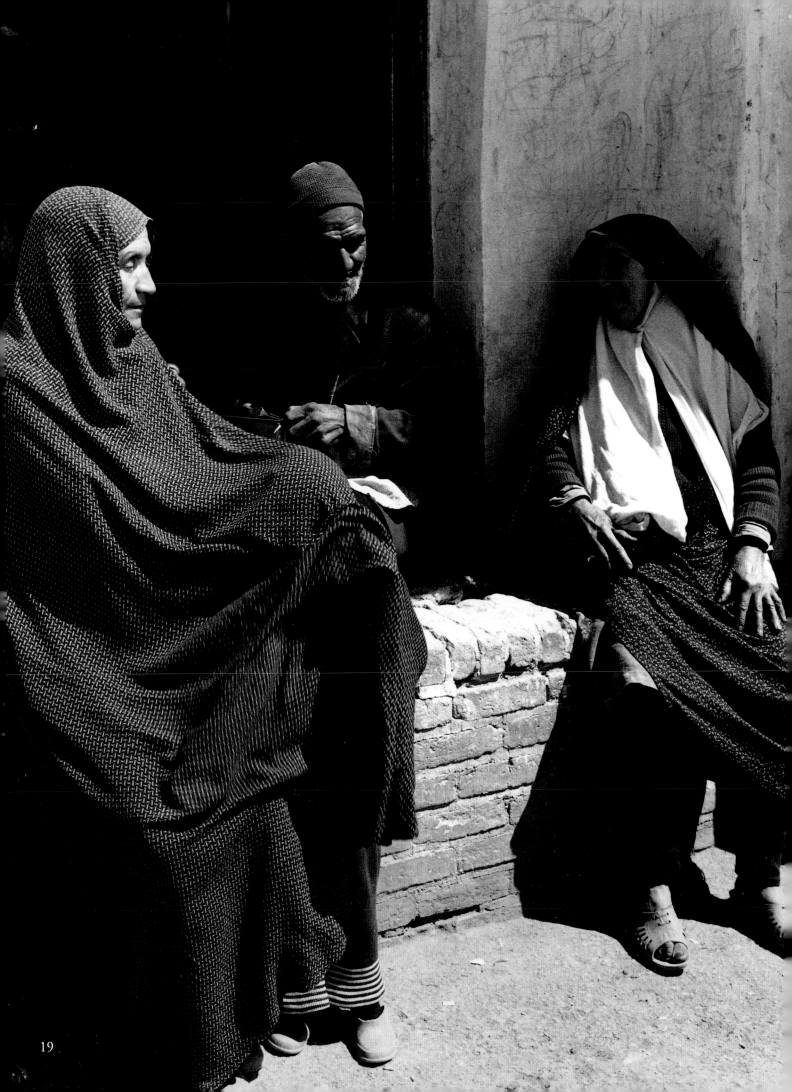

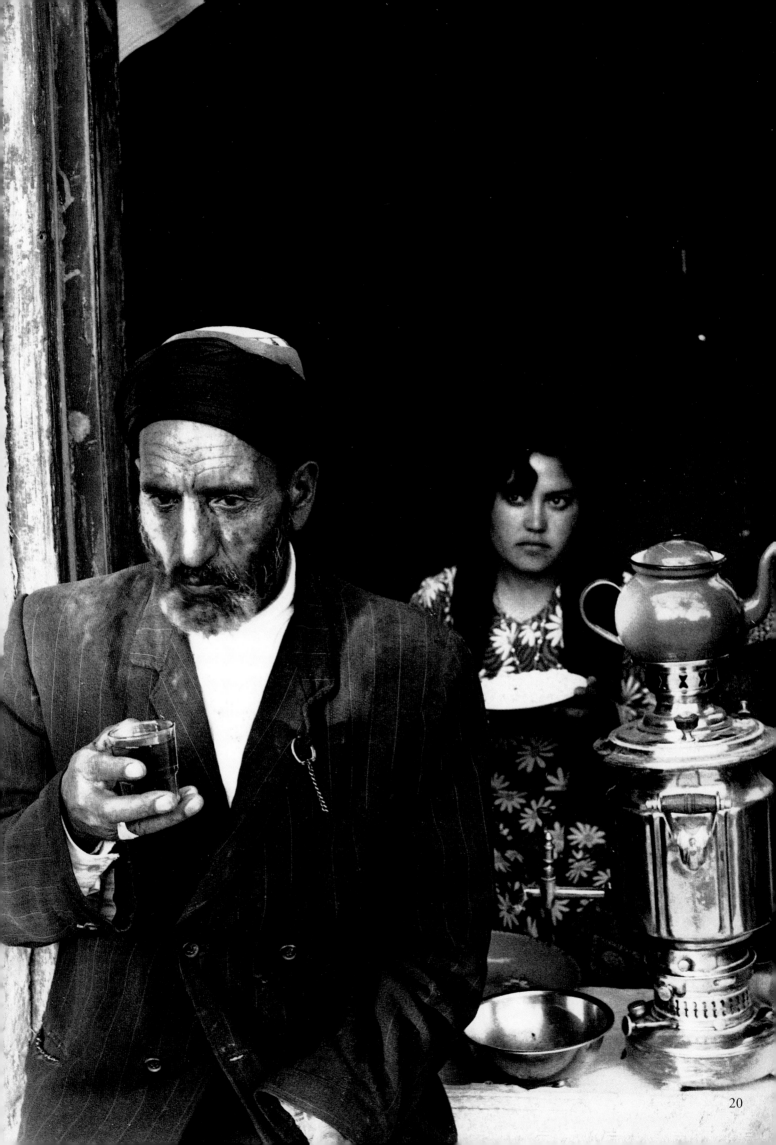

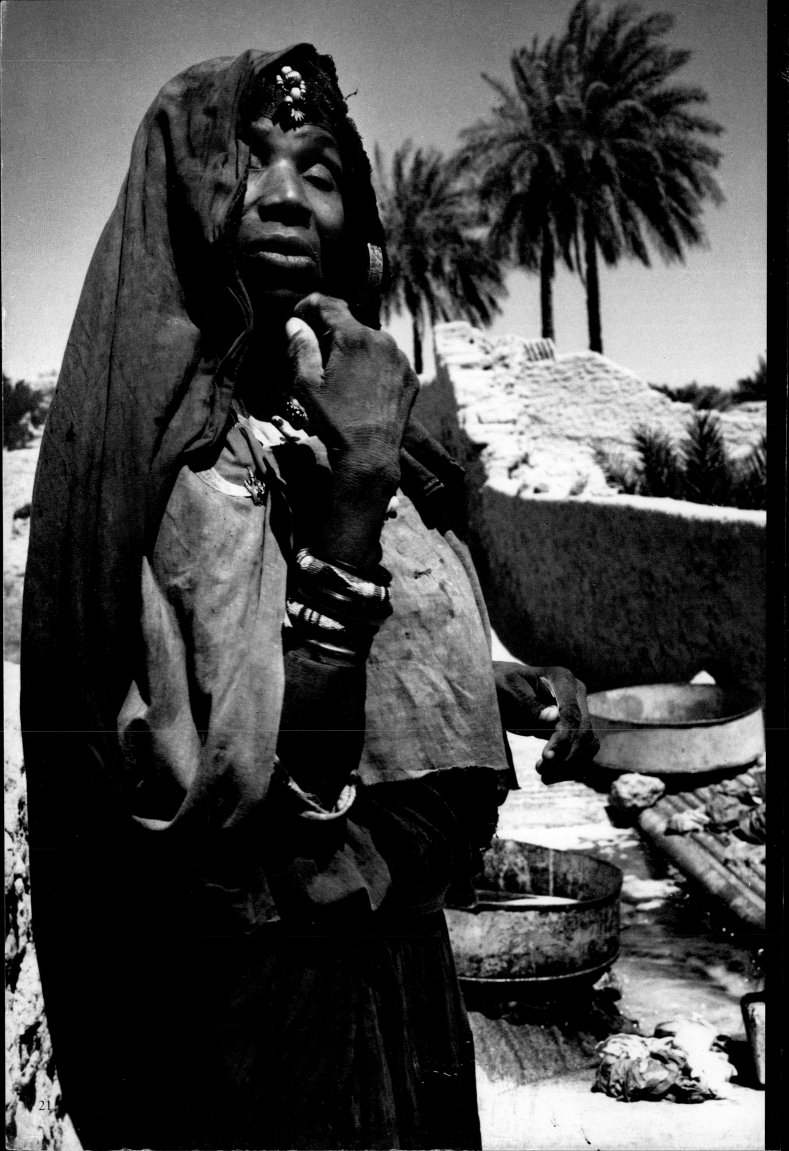

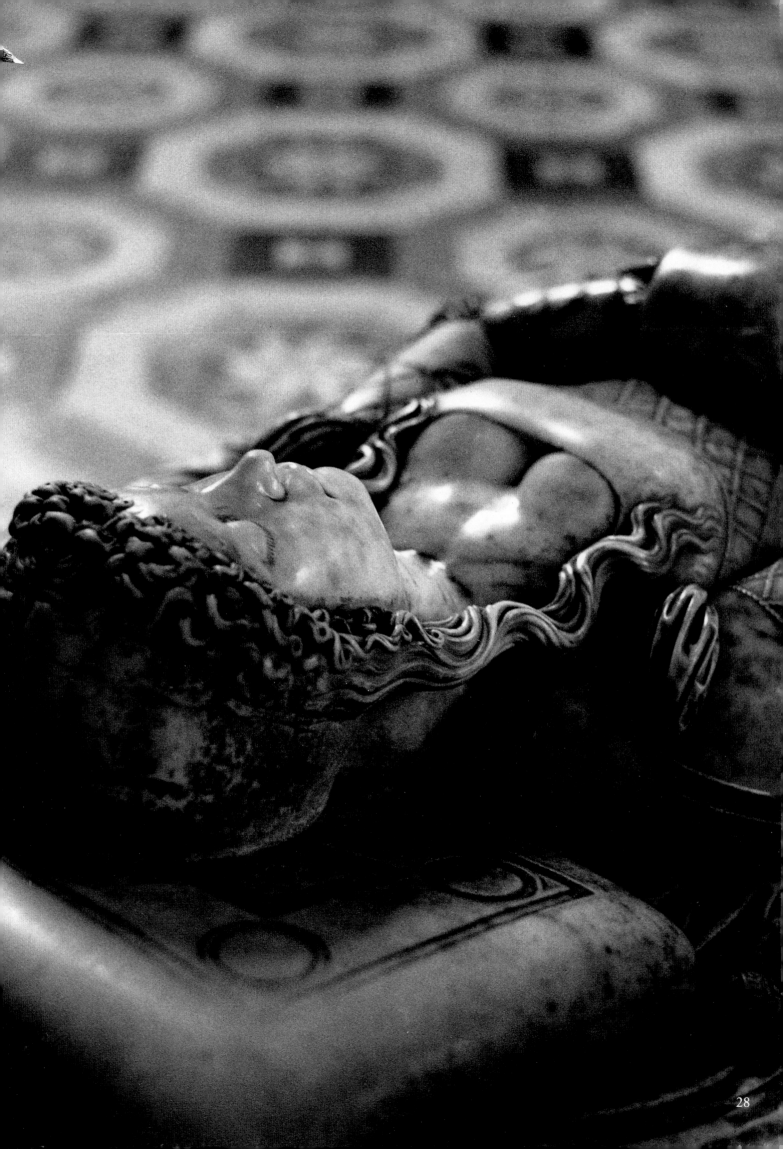

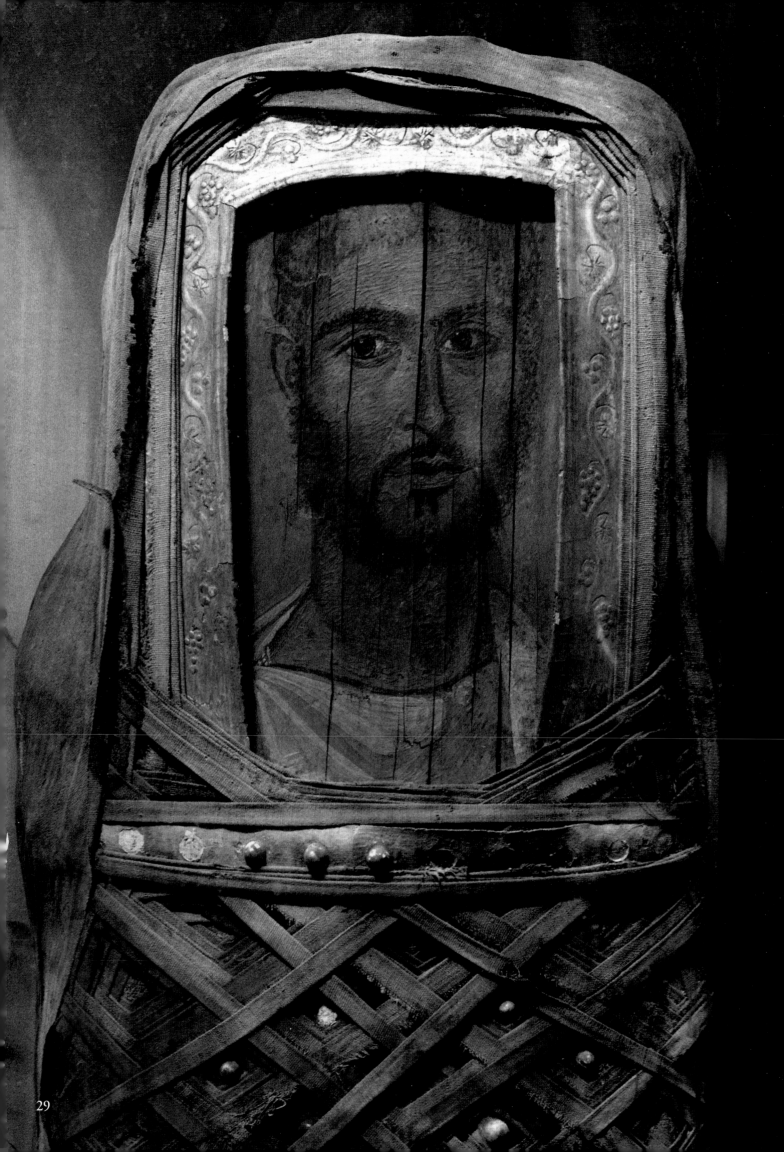

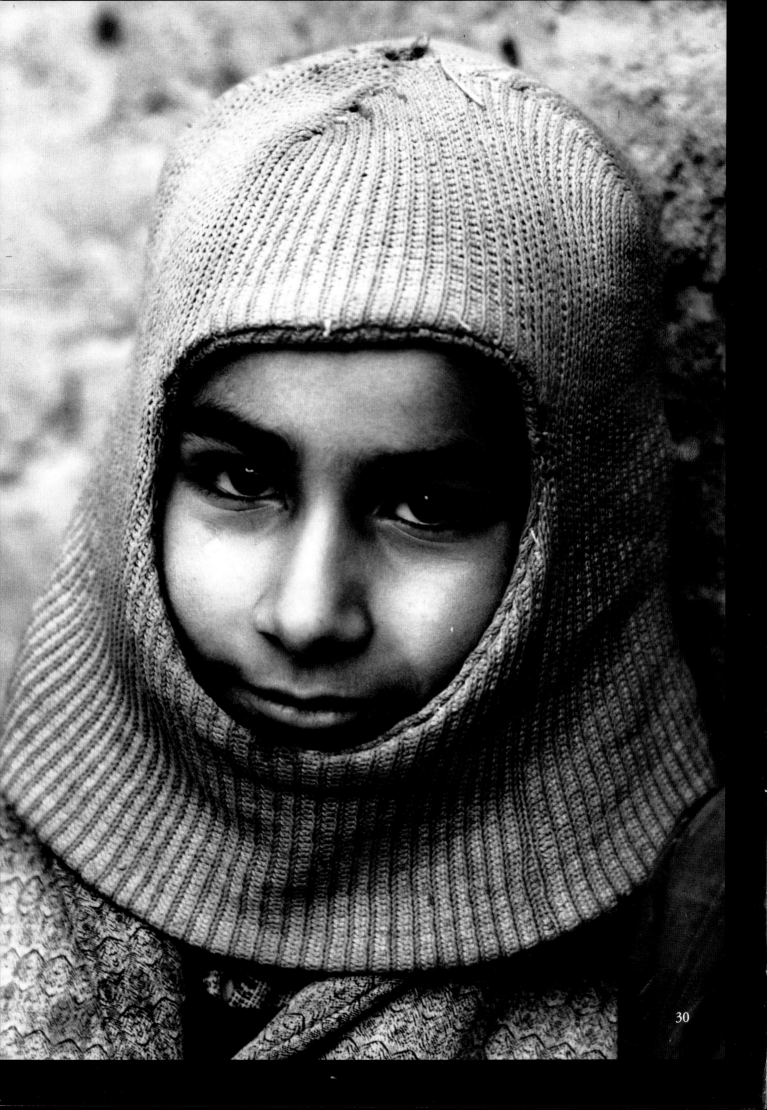

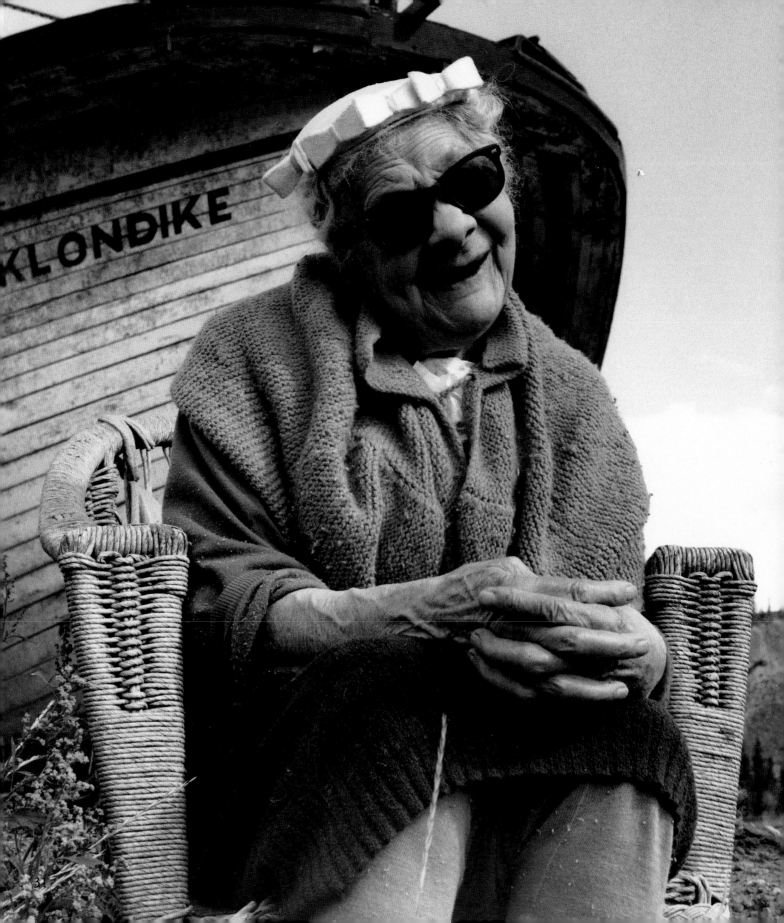

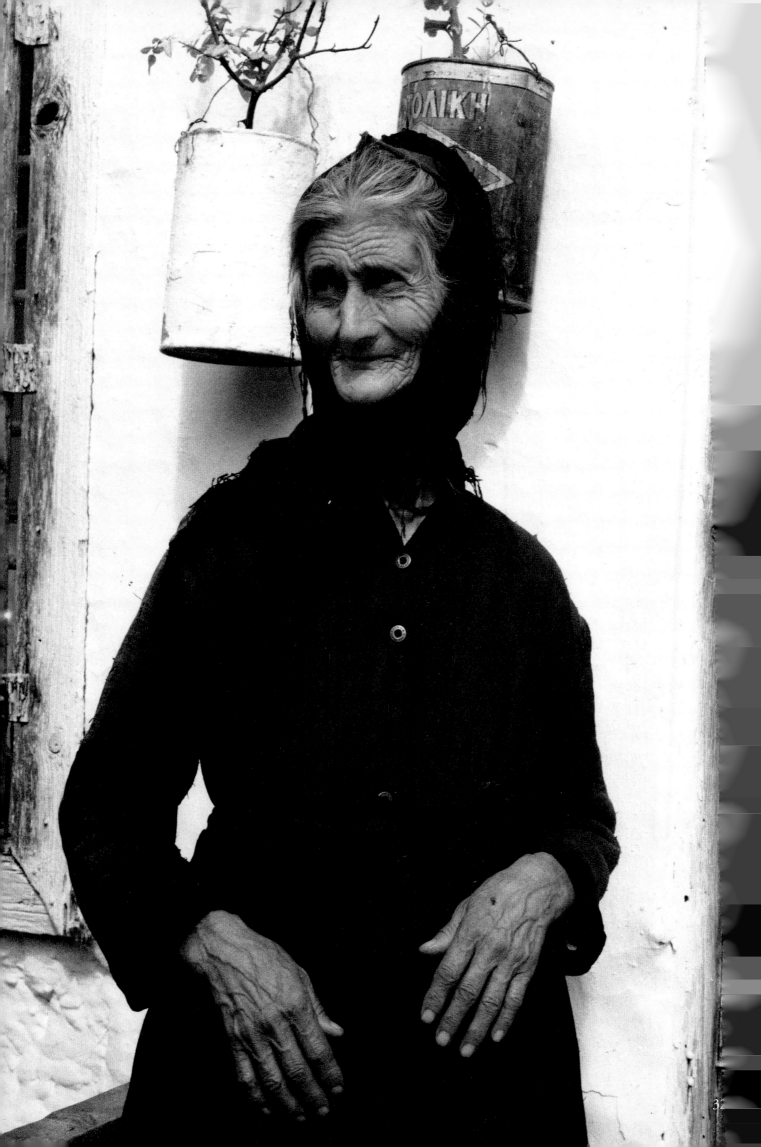

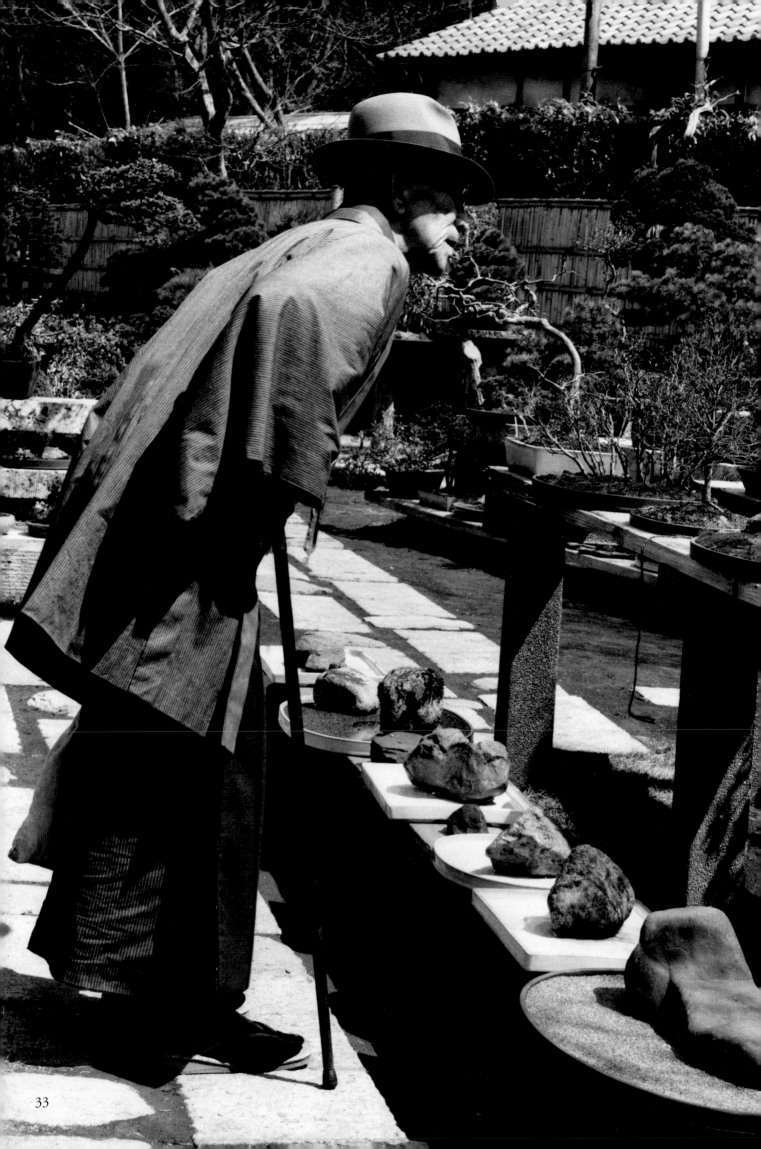

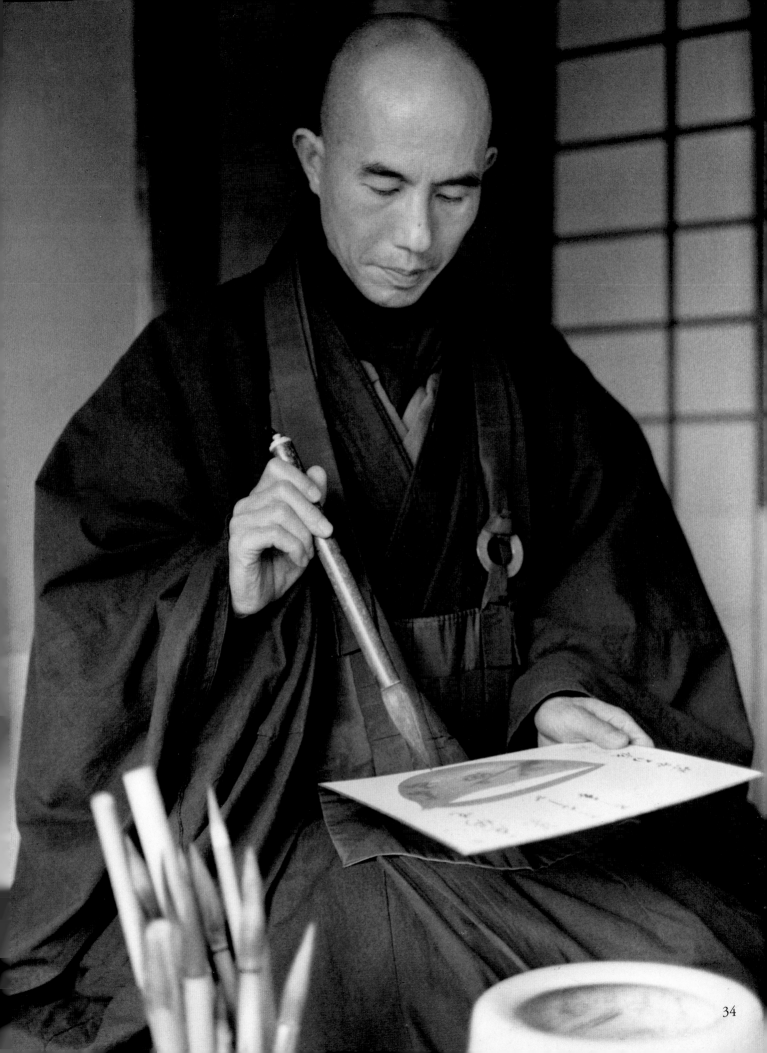

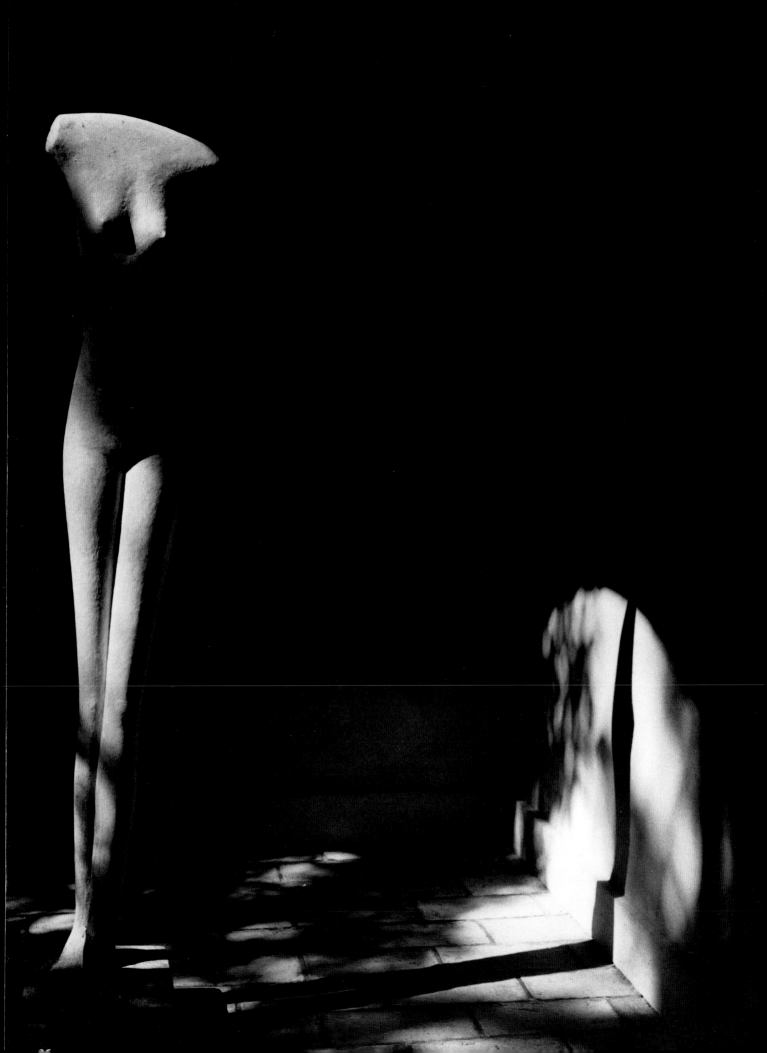

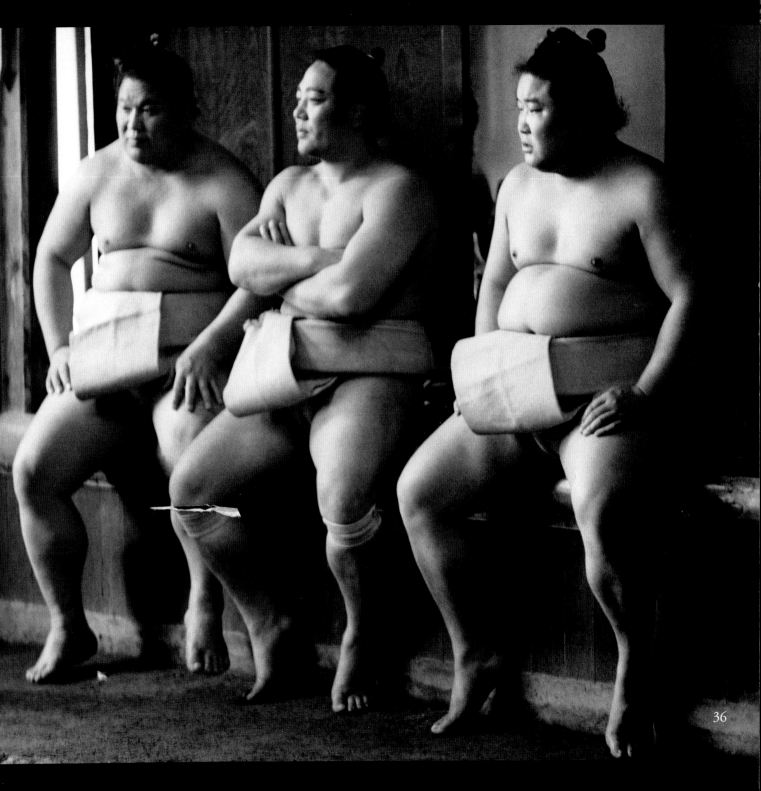

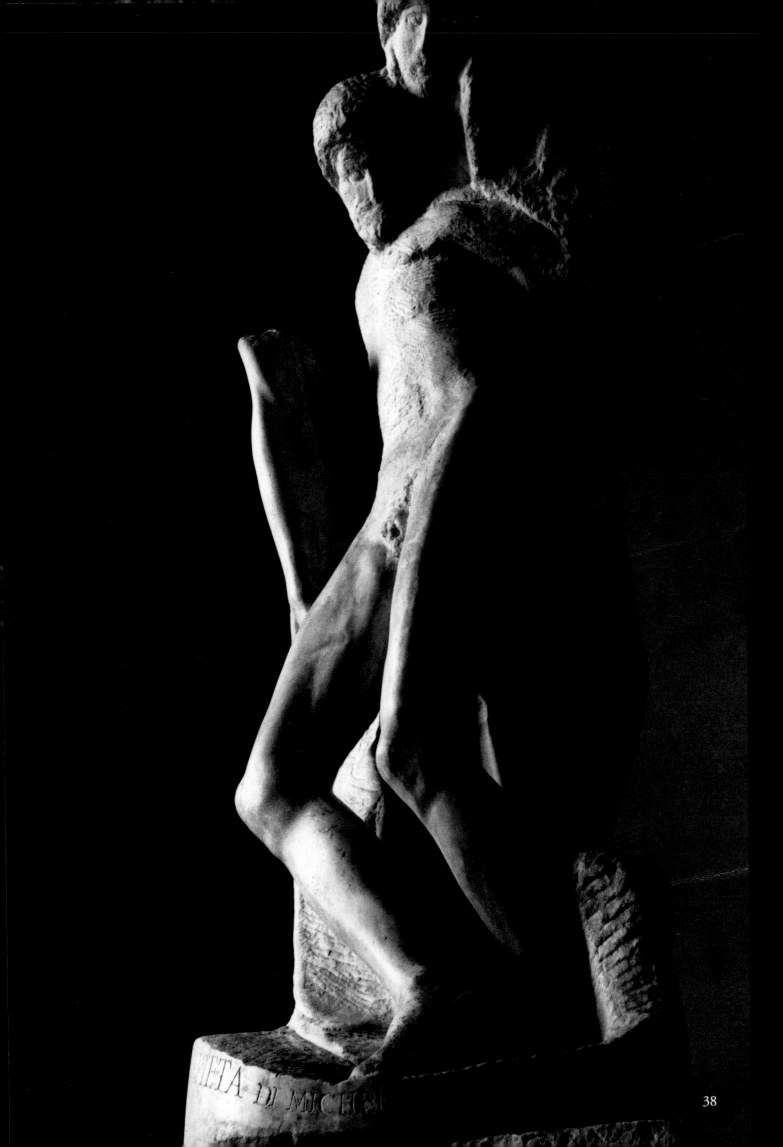

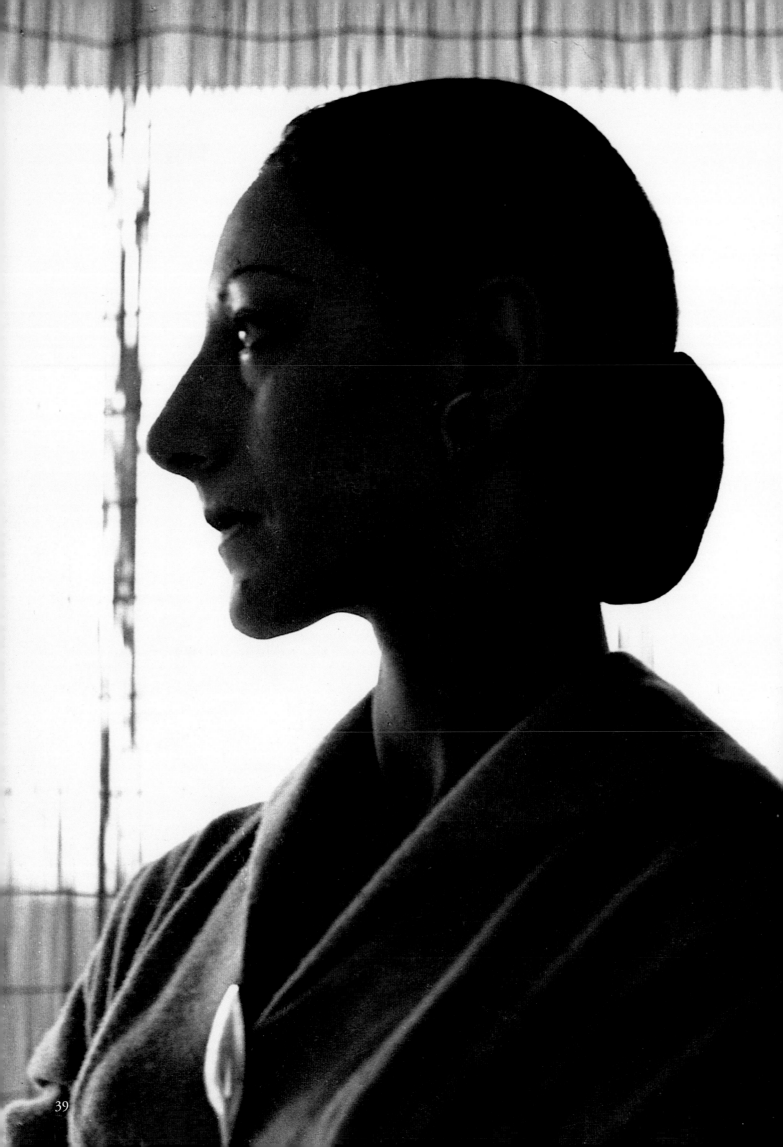

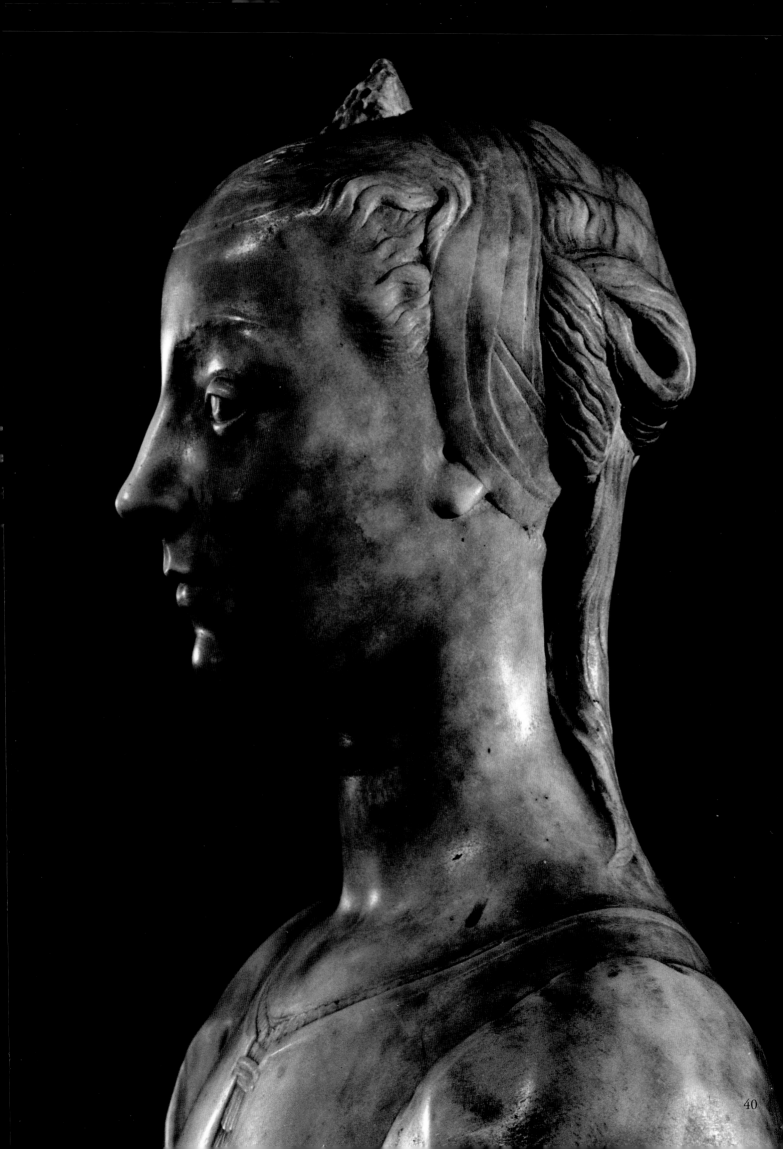

40

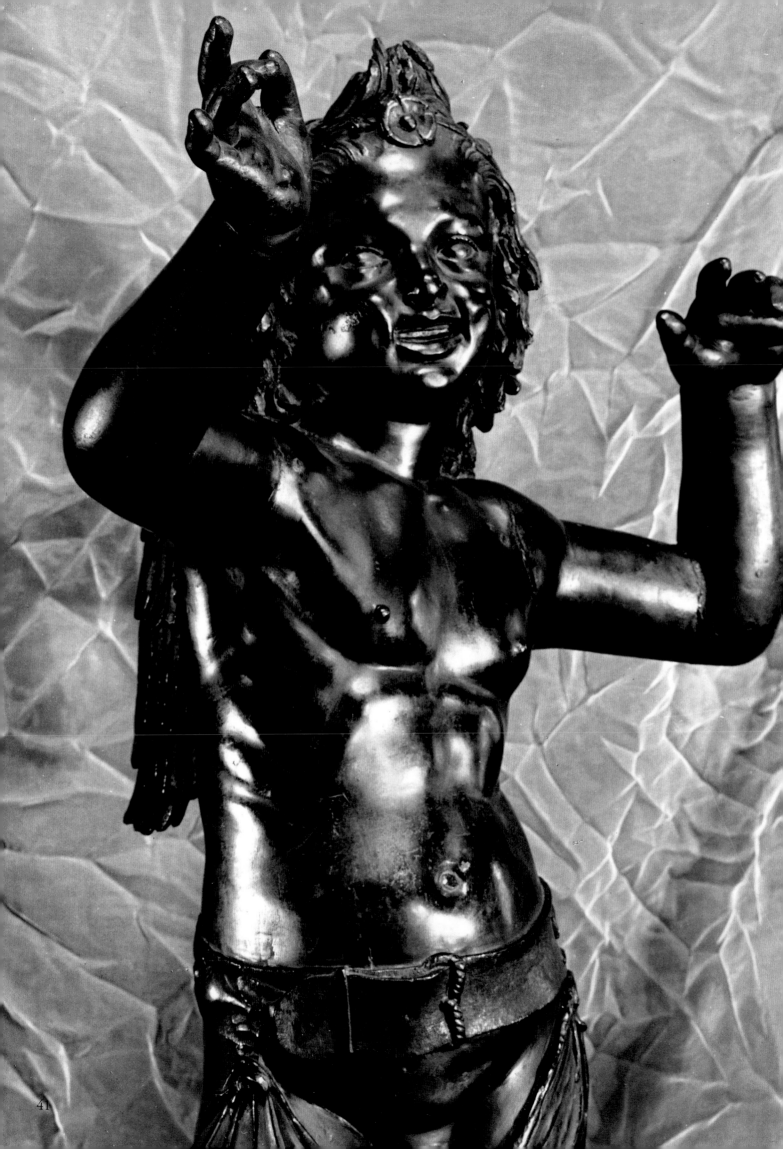

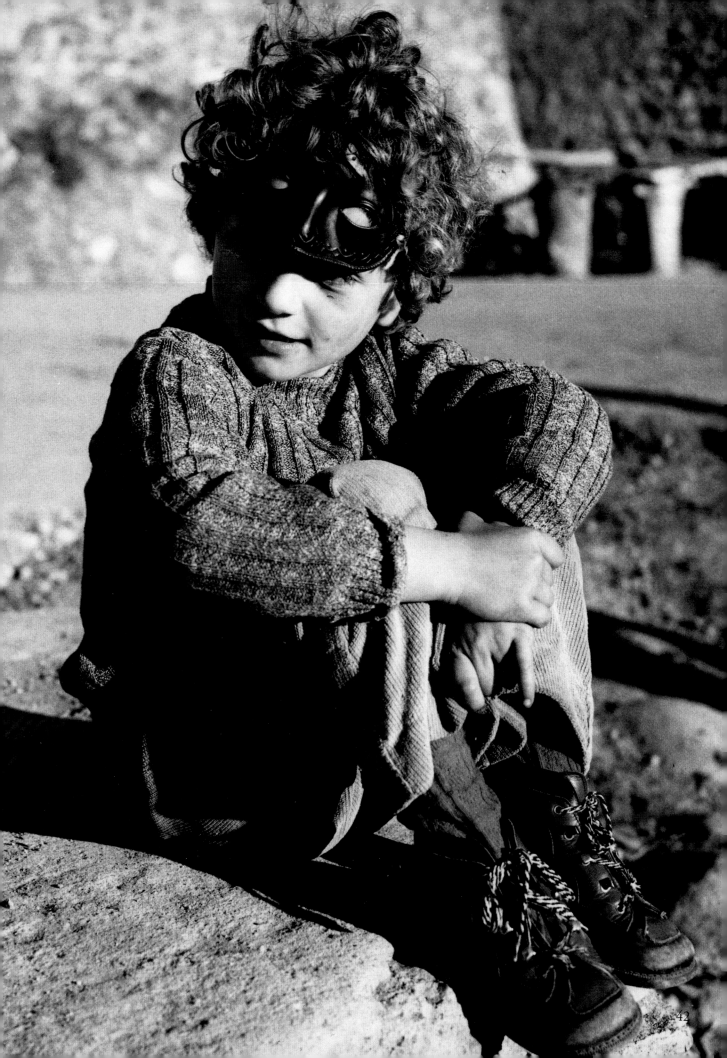

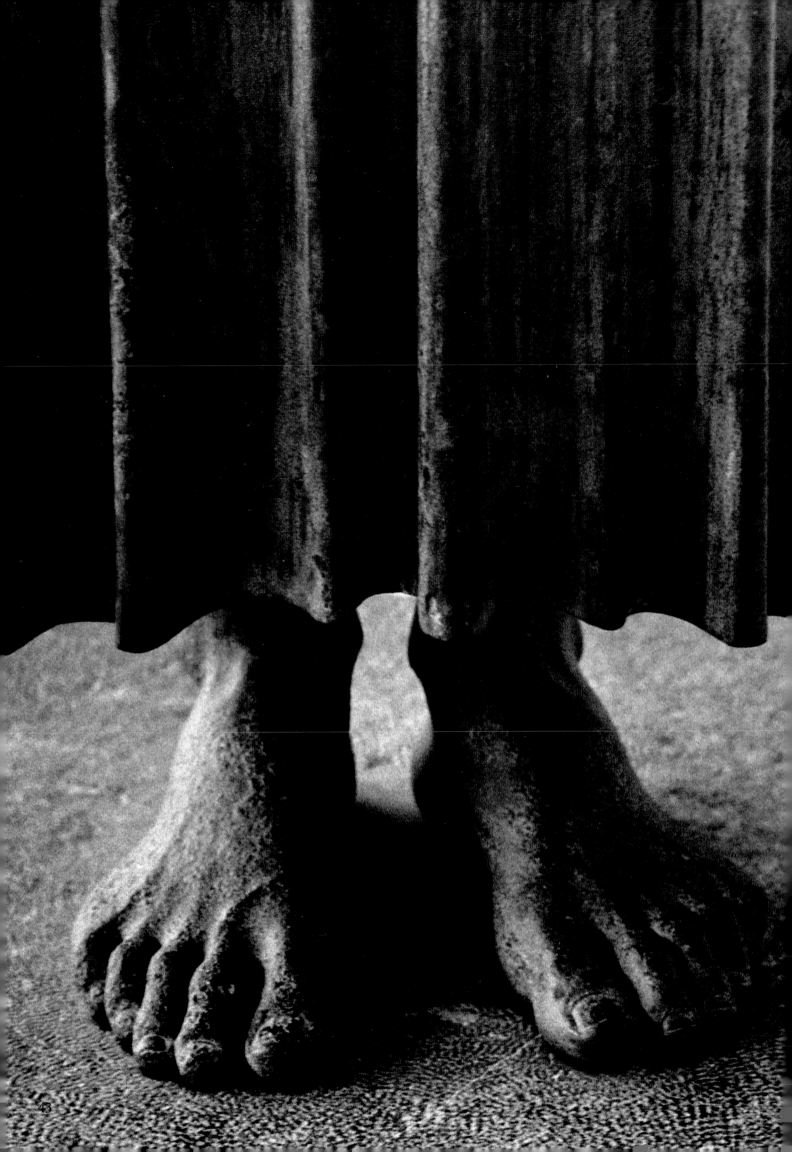

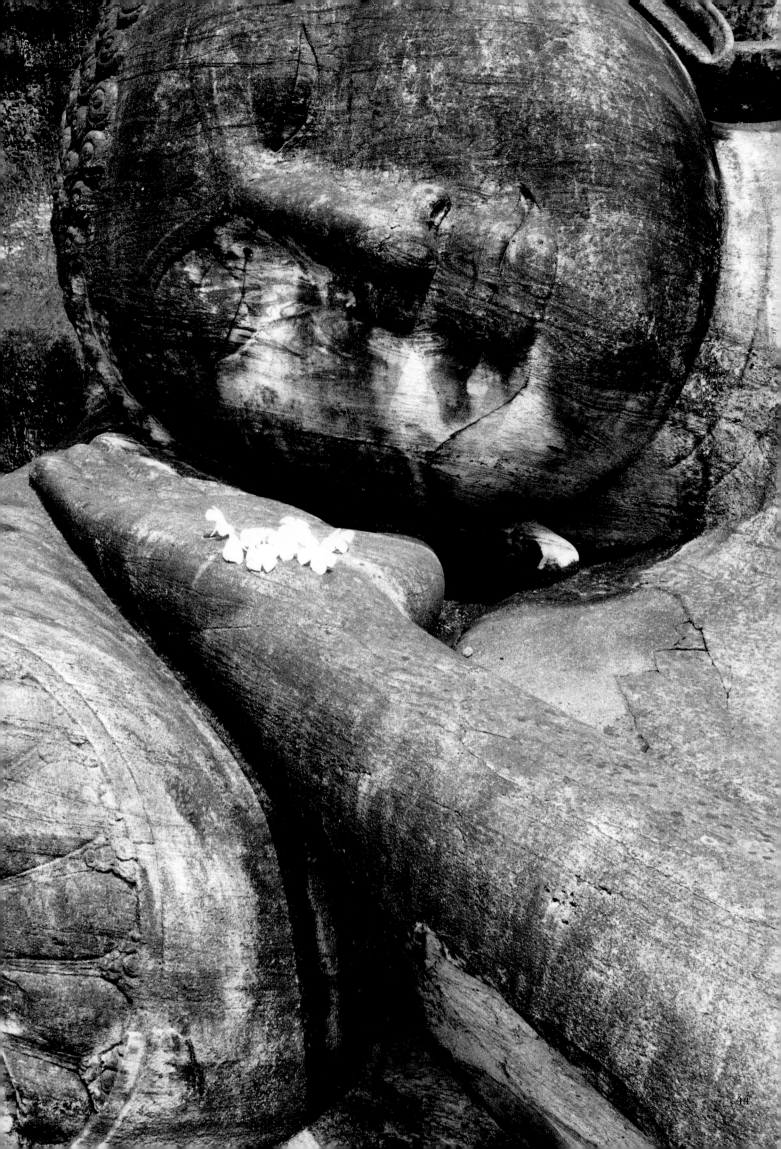

44

9 Near the fabled desert fortress of Bam in southeastern Iran, a Baluchi shepherd guarding his flock.

10 A Kashmiri shepherd carrying a black goat on his shoulders to sell at the local market, northern India.

11 A sadhu, his body smeared with ash, giving religious instruction to his disciples deep in the jungles of Sri Lanka.

12 The penitent *Magdalen*, 1465, a painted wooden statue by Donatello (*c.* 1386–1466), the Baptistery, Florence.

13 Corner of a carved marble sarcophagus lid dating from the second century AD in the National Museum of Antiquities, Algiers.

14 Marble tomb effigy, 1519–34, of Lorenzo II, Duke of Urbino (1492–1519), by Michelangelo (1475–1564), the Medici Chapel, S. Lorenzo, Florence.

15 The gigantic marble image of *David*, 1501–4, by Michelangelo, the Accademia Gallery, Florence.

16 Philippe Chaveaux, French actor, singer and model for Salvador Dali's painting of the *Crucifixion*, 1954, photographed during a weekend visit to Tiber Terrace, Rome, in the early sixties.

17 Donatello's bronze of *David*, 1430s–50s, the Bargello Museum, Florence.

18 Philippe Chaveaux (see caption 16).

19 A cobbler chatting with his customers in the village of Qahrmanlu in the Province of Azerbaijan, Iran.

20 The afternoon ritual of tea in the central Iranian town of Semnan.

21 Christened the 'Empress of Ghadames', this majestic village woman was photographed in the Libyan Desert during preparation for Roloff's first book, *The Thrones of Earth and Heaven*, published in 1958.

22 A traditional Kathakali dancer applying his make-up for a performance in the southern Indian state of Kerala.

23 Sun worshippers on the Sperlonga beach near Rome.

24 *Idol*, Greek or Roman bronze statue, the Archaeological Museum, Florence.

25 A small girl dwarfed by the ruins of the old cathedral in Antigua, Guatemala.

26 Young man relaxing in front of the abandoned early nineteenth-century Sans Souci Palace in Haiti.

27 Woman bathing near Stromboli on the eastern coast of Italy.

28 Recumbent marble figure of Beatrice d'Este, 1498, from the tomb of Lodovico Sforza and his wife by Cristoforo Solari (d. 1527), the Certosa of Pavia.

29 Portrait of a young man painted on a mummy case in the Greco-Roman Museum in Alexandria, Egypt.

30 Note from Roloff's Iran diaries:

A little Persian boy, one frosty morning in 1975 on the road to Yazd, metamorphosed into a childlike Alexander the Great.

31 Lucille Hunter, 'Klondike Annie', one of the oldest residents of the Canadian Yukon, photographed for Roloff's Canada book, *To Every Thing There is a Season*, published in 1967.

60

32 Elderly woman in the village of Dodoni in the Yannina region of northwestern Greece.

33 A master gardener inspecting his bonsai plants, Japan.

34 A traditional calligrapher at work, Japan.

35 *Woman Walking*, 1932–34, plaster sculpture by Alberto Giacometti (1901–66), Peggy Guggenheim Collection, Venice.

36 Christened *The Three Graces* by Roloff, a study of monumental Sumo wrestlers waiting for their match, Japan.

37 Funerary Kouros, a marble statue discovered at Volomandra in Attica and now in the National Archaeological Museum, Athens.

38 The *Rondanini Pietà*, Michelangelo's last sculptural work, left unfinished at his death in 1564, Castello Sforzesco, Milan.

39 Profile of the Canadian dancer, Celia Franca, photographed in Rome in the early sixties.

40 Marble bust of a young noblewoman by Desiderio da Settignano (*c.* 1430–64), the Bargello Museum, Florence.

41 *Amor-Atys*, 1440s–50s, bronze statue by Donatello, the Bargello Museum, Florence.

42 Masked child playing in Trastevere, old Rome.

43 Bronze feet of the Charioteer of Delphi, a life-size fifth-century BC statue discovered in Greece.

44 Monolithic stone image of the sleeping Buddha from the sacred site of Polonnaruwa in central Sri Lanka.

Artists
and Architects

ROLOFF HAD CARVED OUT A SUCCESSFUL CAREER AS A painter and printmaker by the mid-fifties when he decided to settle permanently in Rome. He exhibited his work widely in galleries across Europe and North America and it was collected by a number of leading museums. Prompted, however, by Peggy Guggenheim and the scholar and art critic Herbert Read, who felt his deeper talents lay in other directions, Roloff gradually abandoned painting and turned to photography and the creation of books, although his keen interest in art and art history remained throughout his life.

Wherever he travelled, Roloff would haunt museums, photographing sculptures for his books, and he would always try to attend as many gallery openings as he could. A keen collector of the works of late nineteenth- and twentieth-century artists, Roloff arranged, in 1982, through an endowment from his home province of Alberta, for his collection to be presented to The University of Lethbridge Art Gallery.

With a base in Rome, Roloff was naturally interested in the works of his colleagues and neighbours such as Gino Severini, Alberto Burri and Afro Basaldella, with whom he would exchange photographs for works of art. Foreign artists were drawn to the life and light of Italy and Roloff was able to capture the Dutch artist, Willem de Kooning, and the American, Andy Warhol, on visits to Rome and Venice, respectively. In 1966, Roloff convinced his friend, Henry Moore, to sell his monumental bronze sculpture, *The Archer*, to the city of Toronto, following a convivial session of gin and tonics at the Athenæum in London.

Roloff is perhaps best known for his striking photography of ancient and classical architecture. During our trips together in India, Iran and Egypt, Roloff would now and then stand quietly before an architectural masterpiece and say, rather wistfully, how he had always dreamed of becoming an architect, but just couldn't face the mathematics.

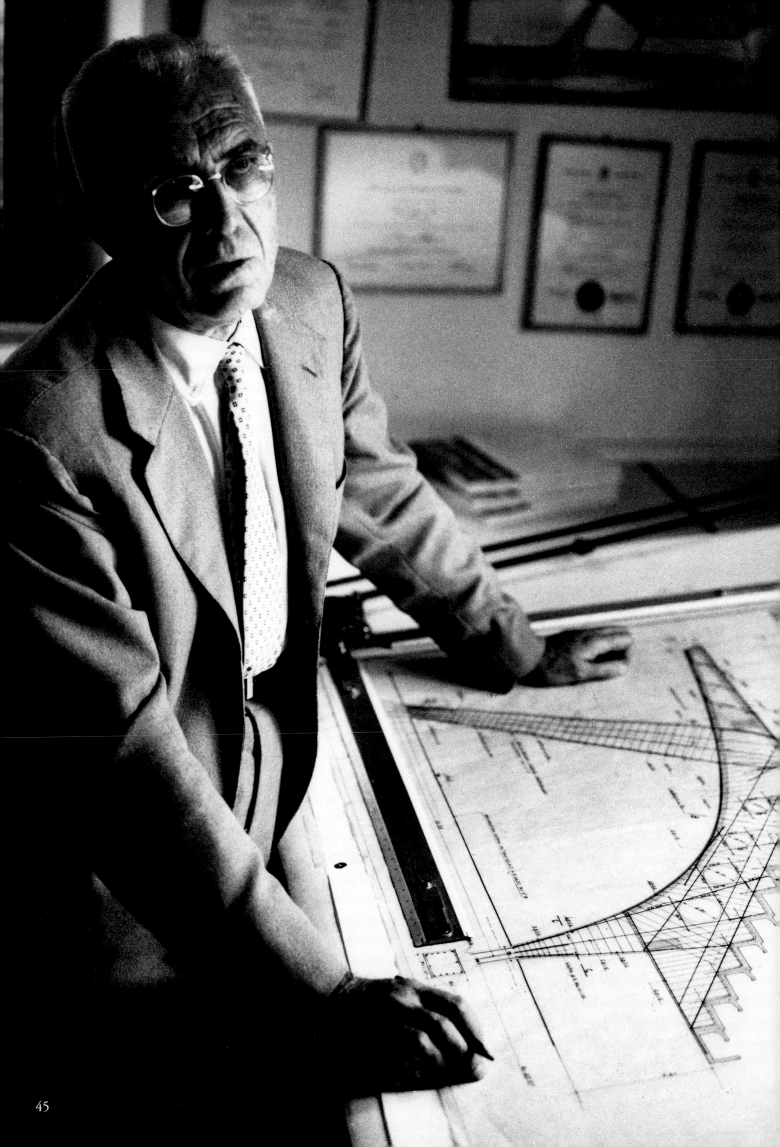

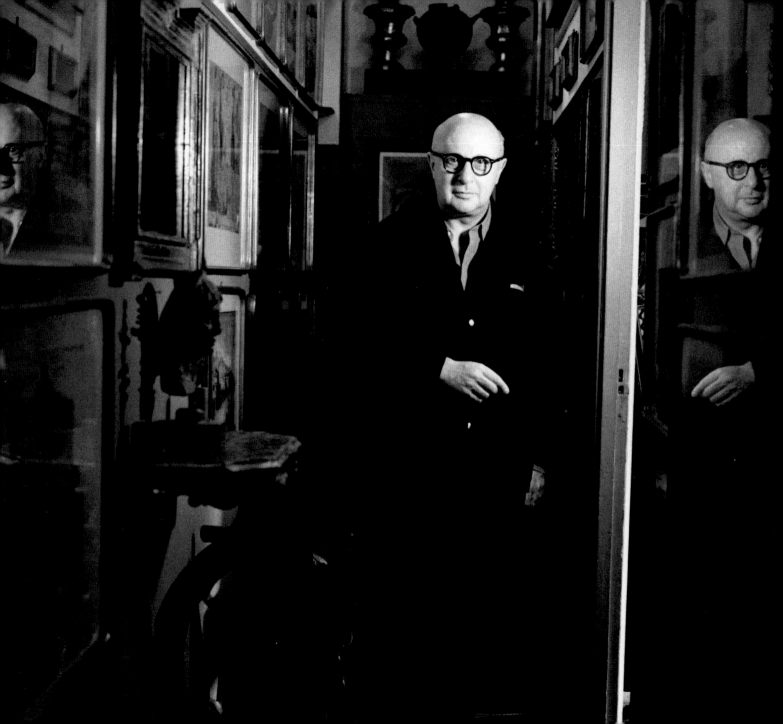

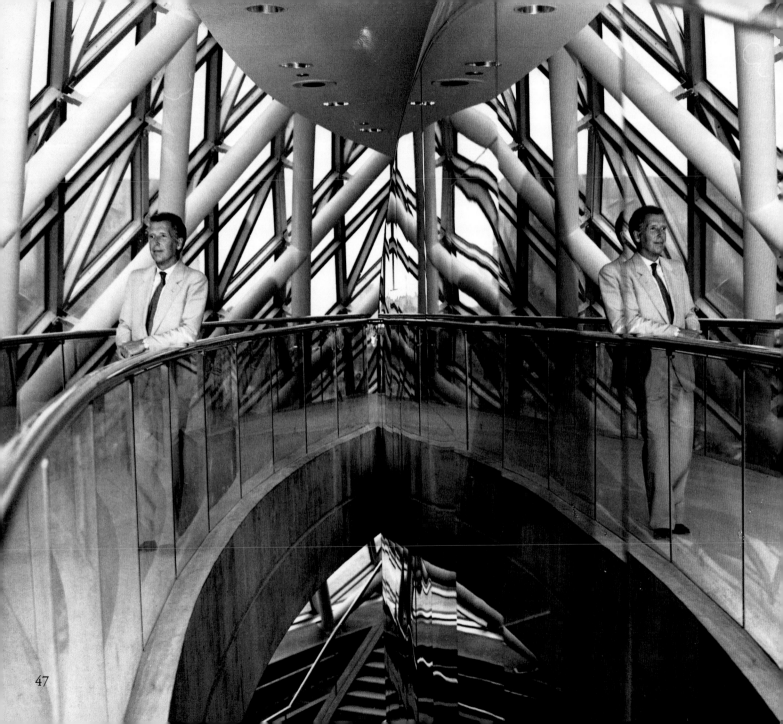

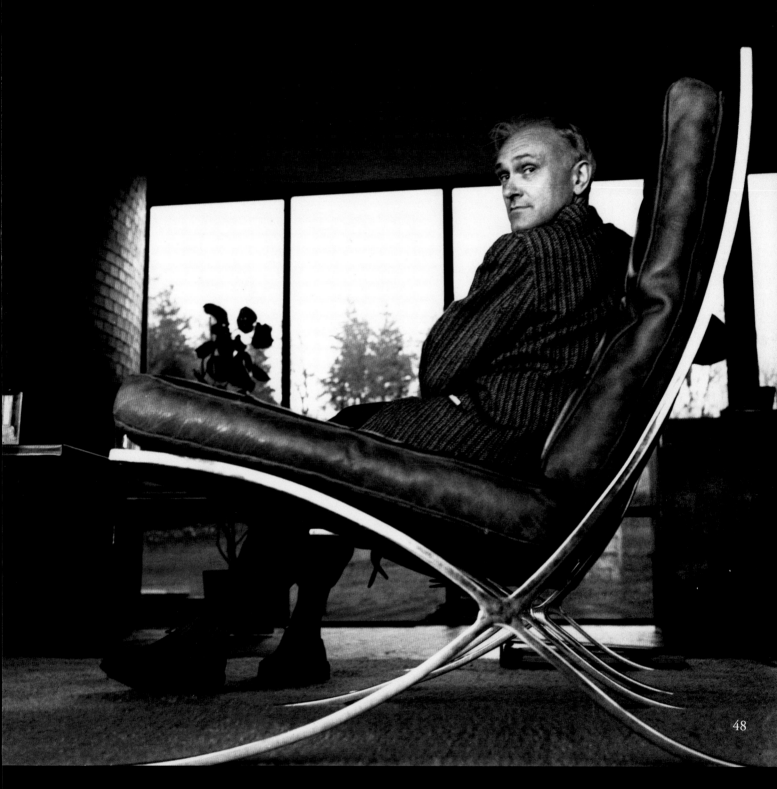

48

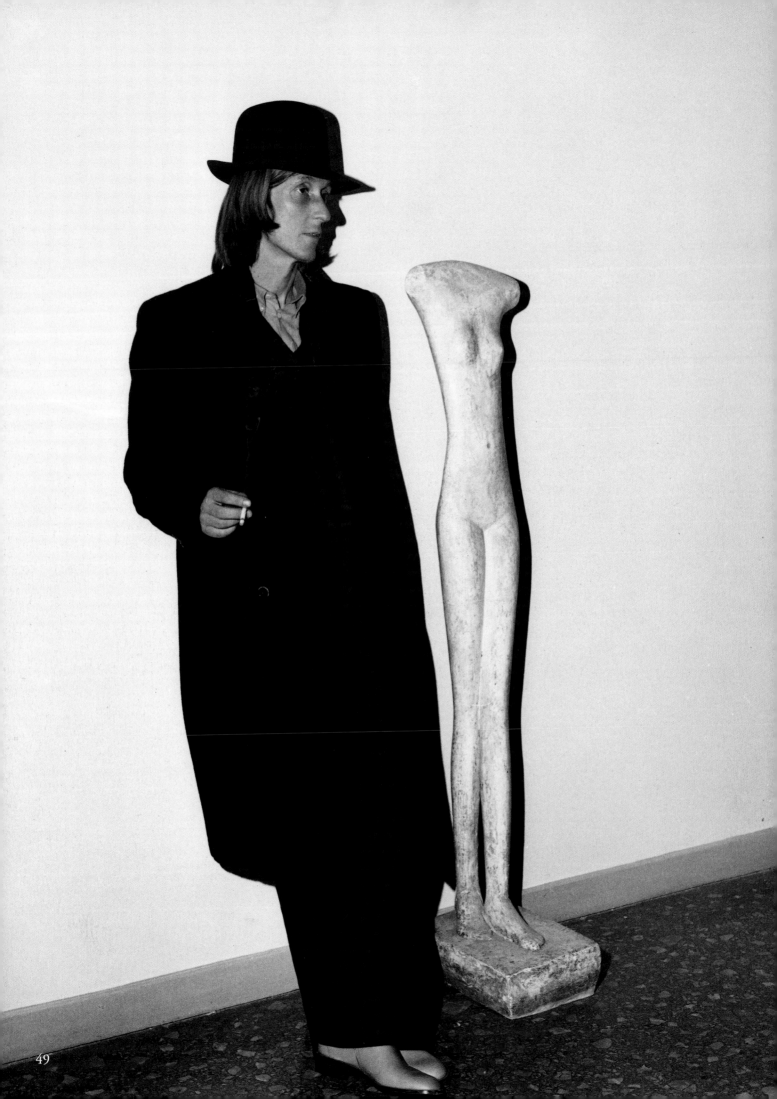

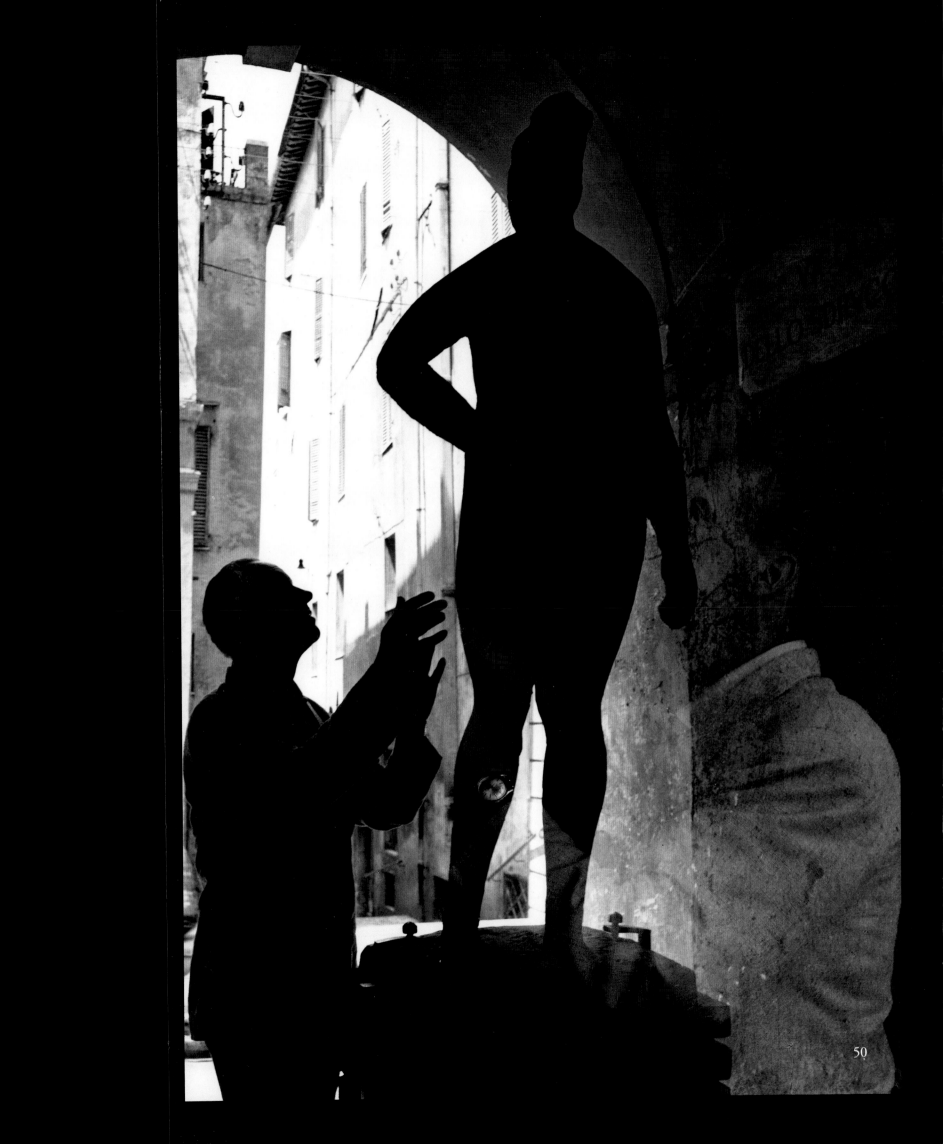

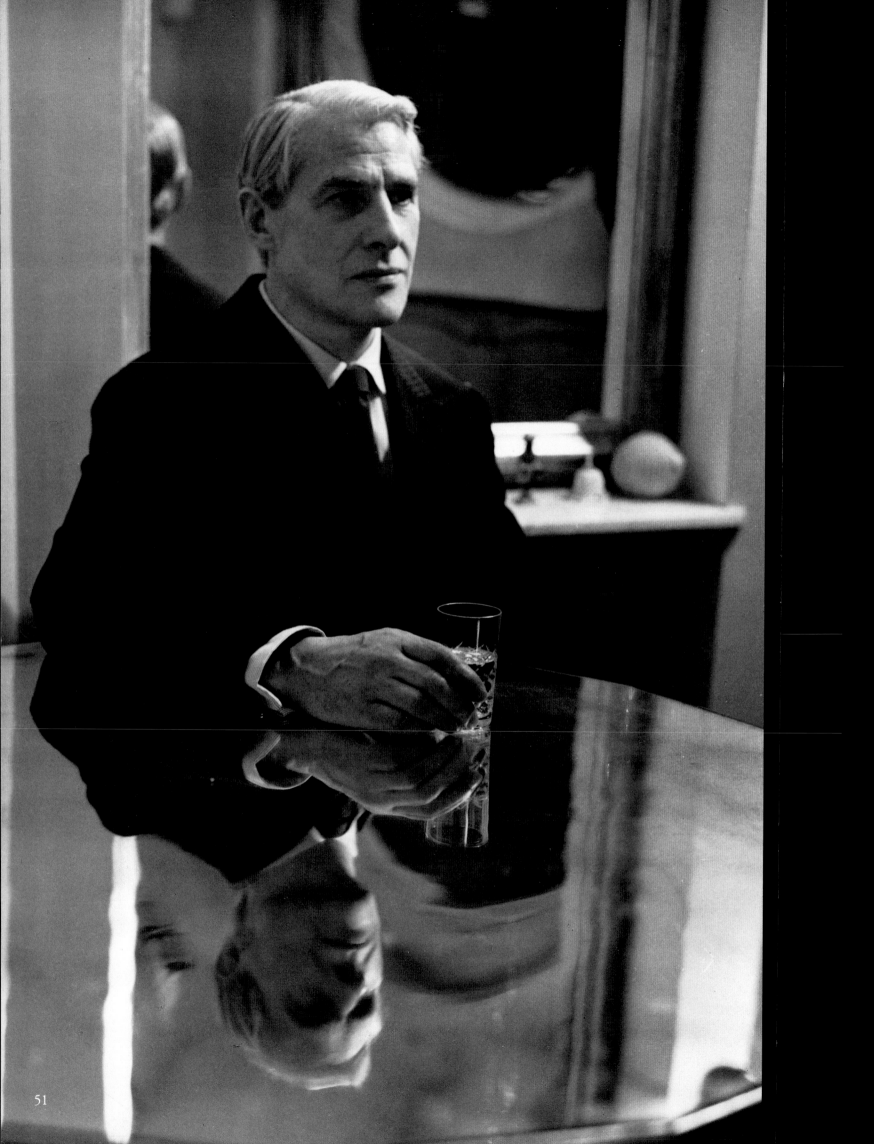

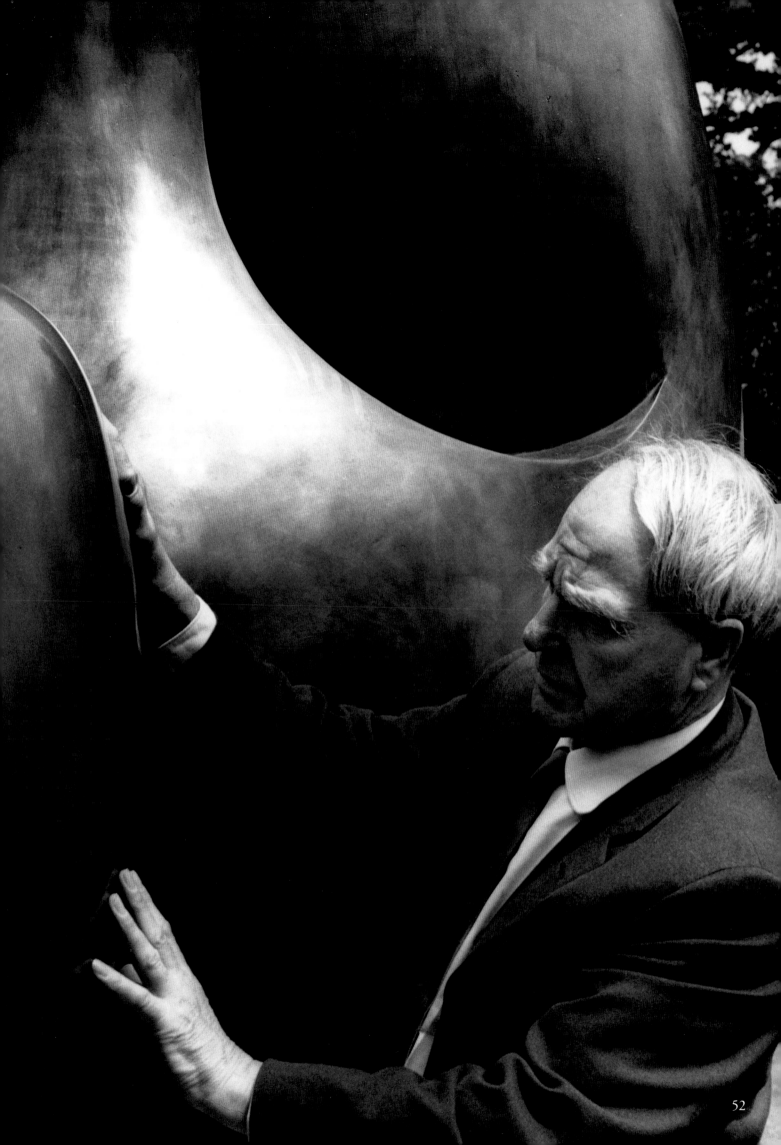

52

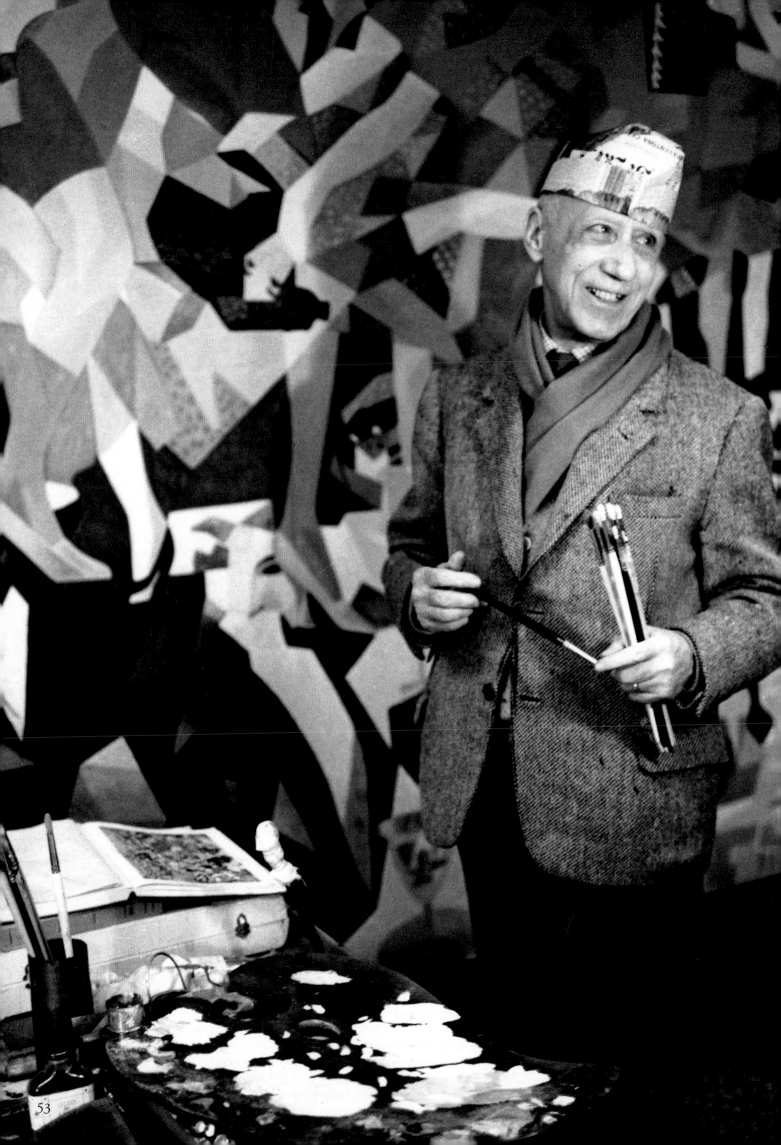

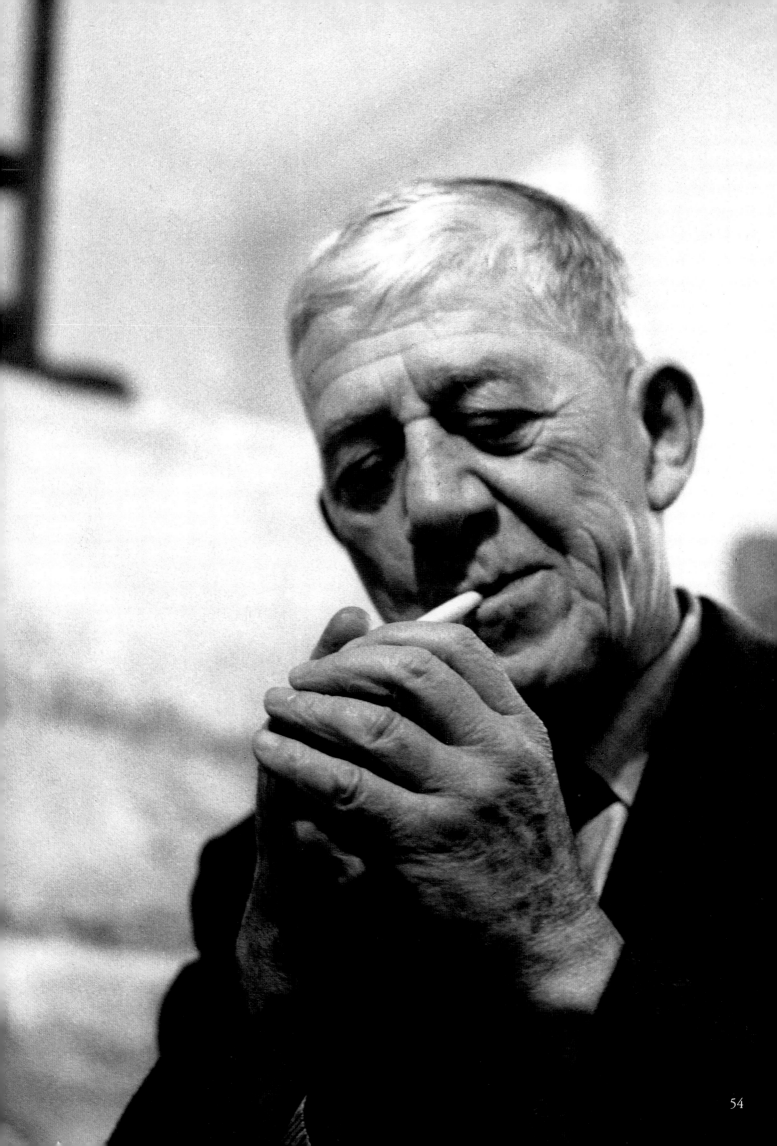

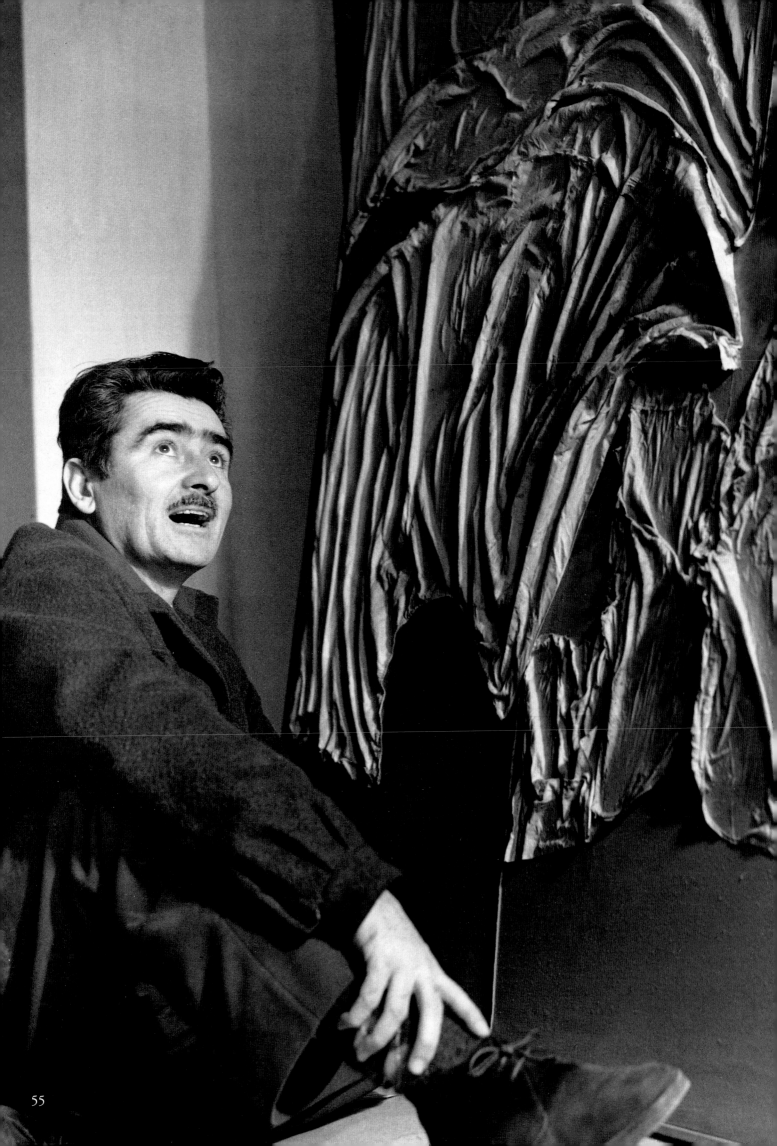

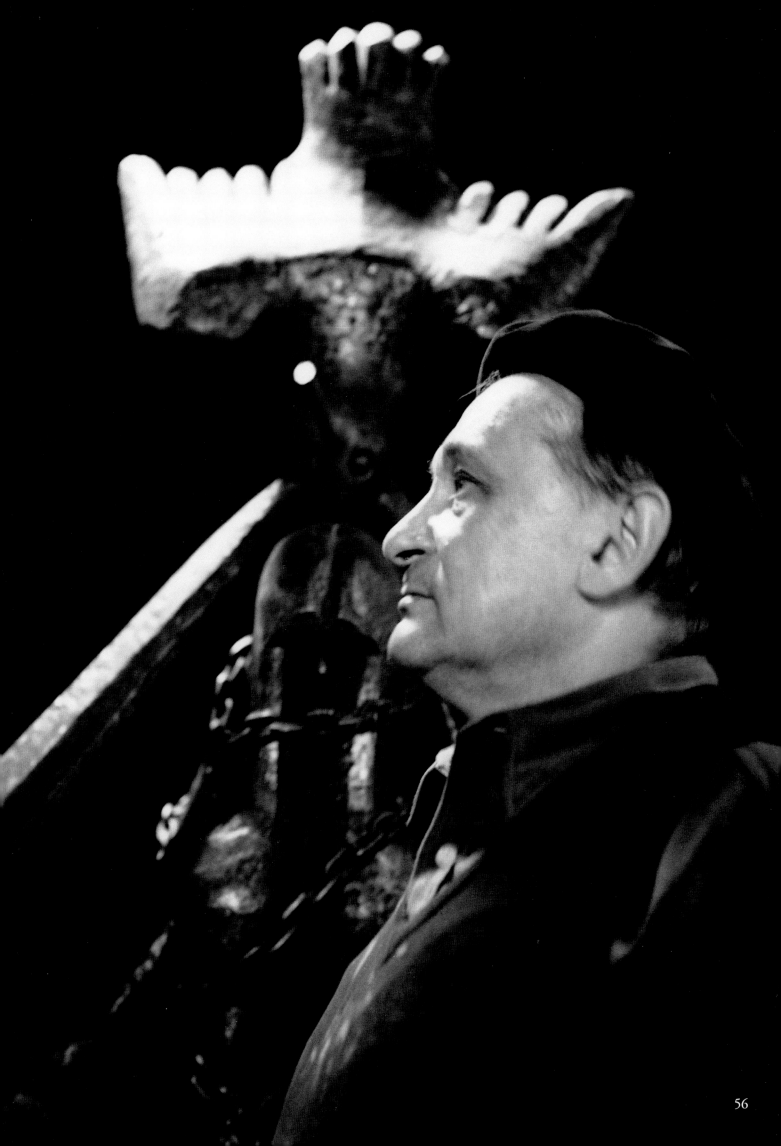

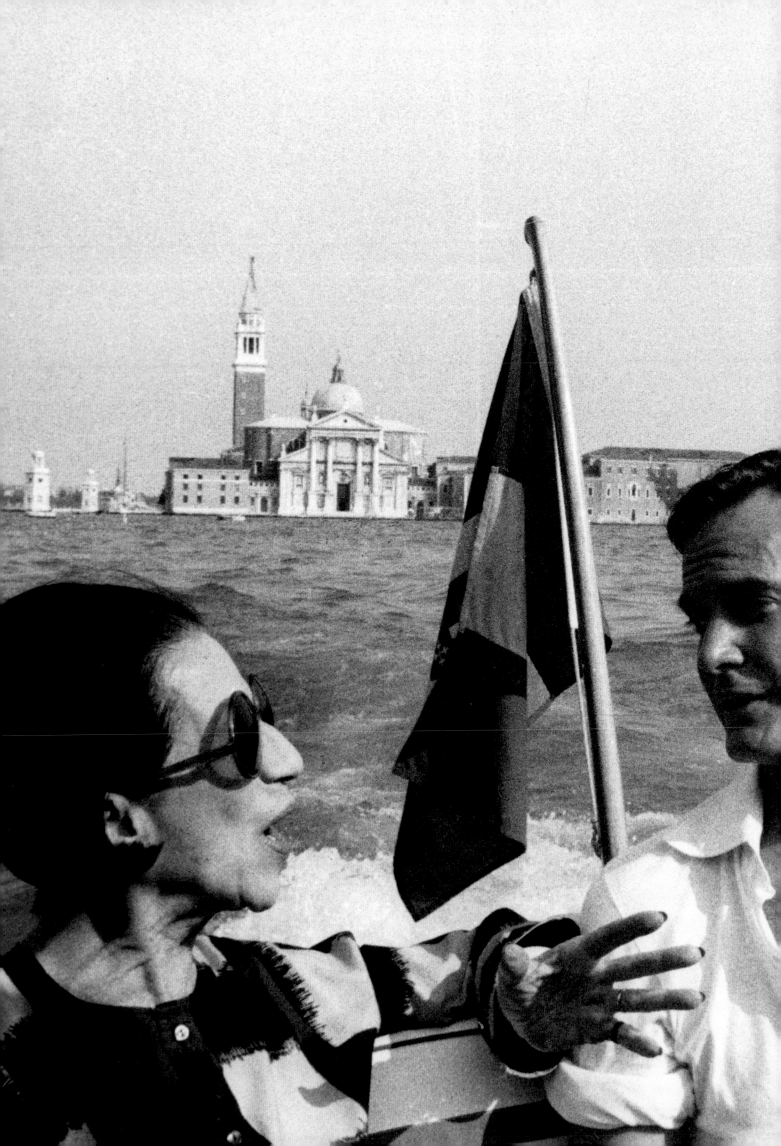

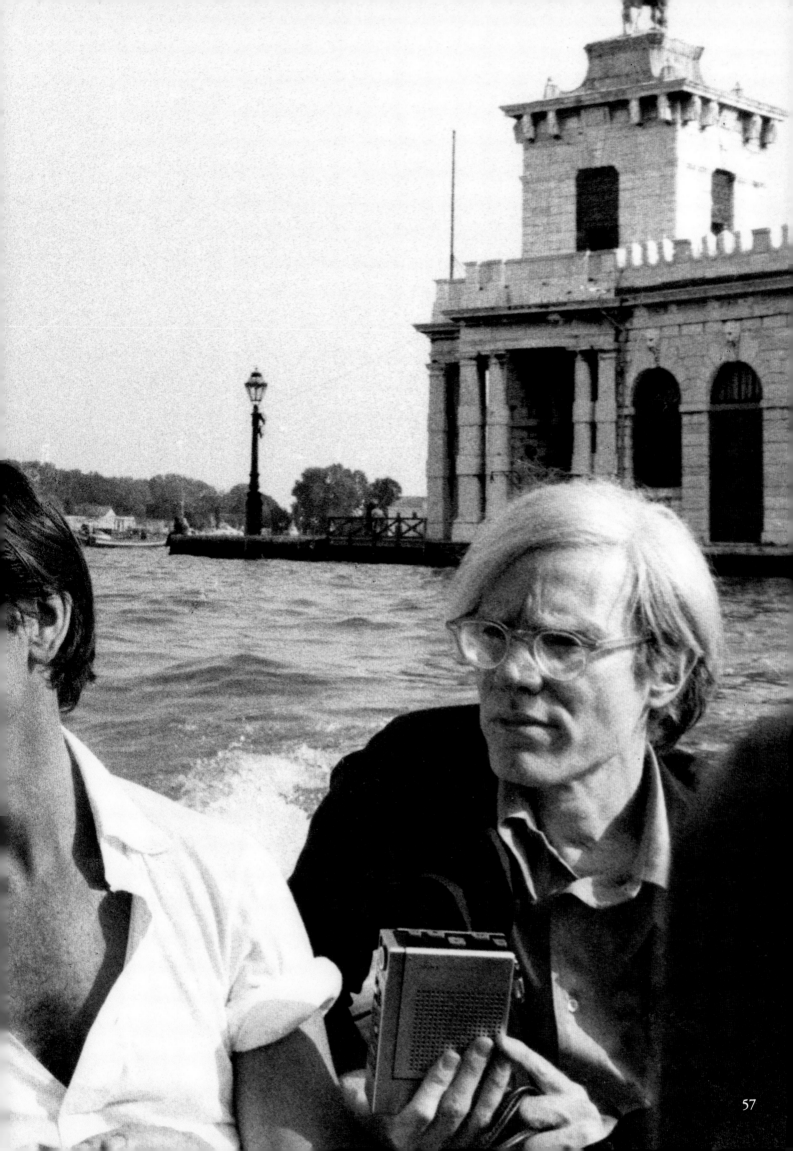

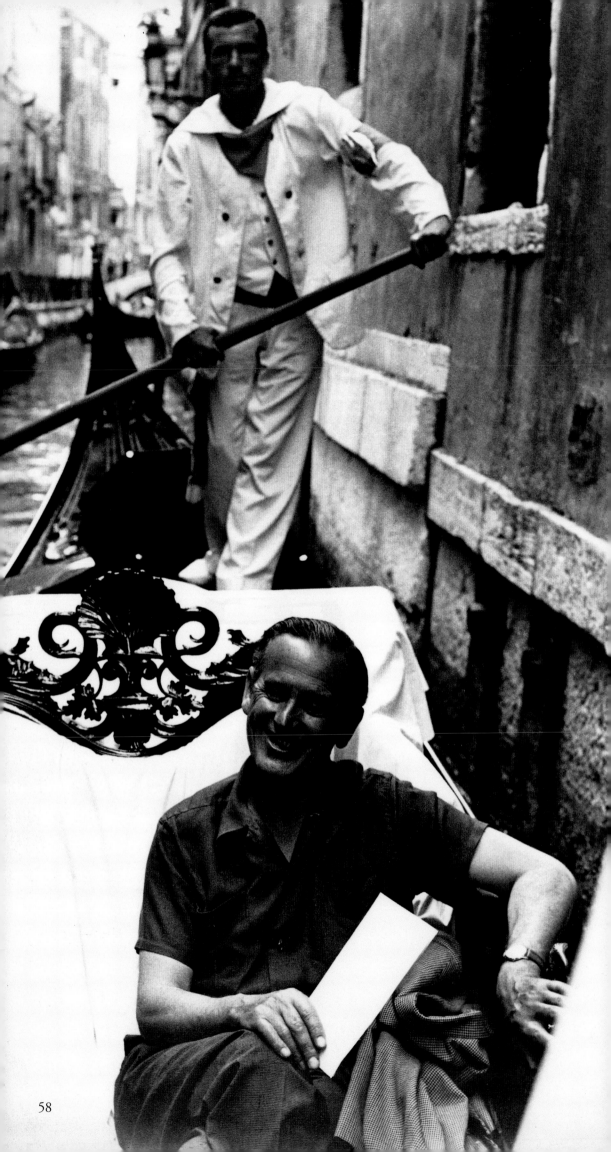

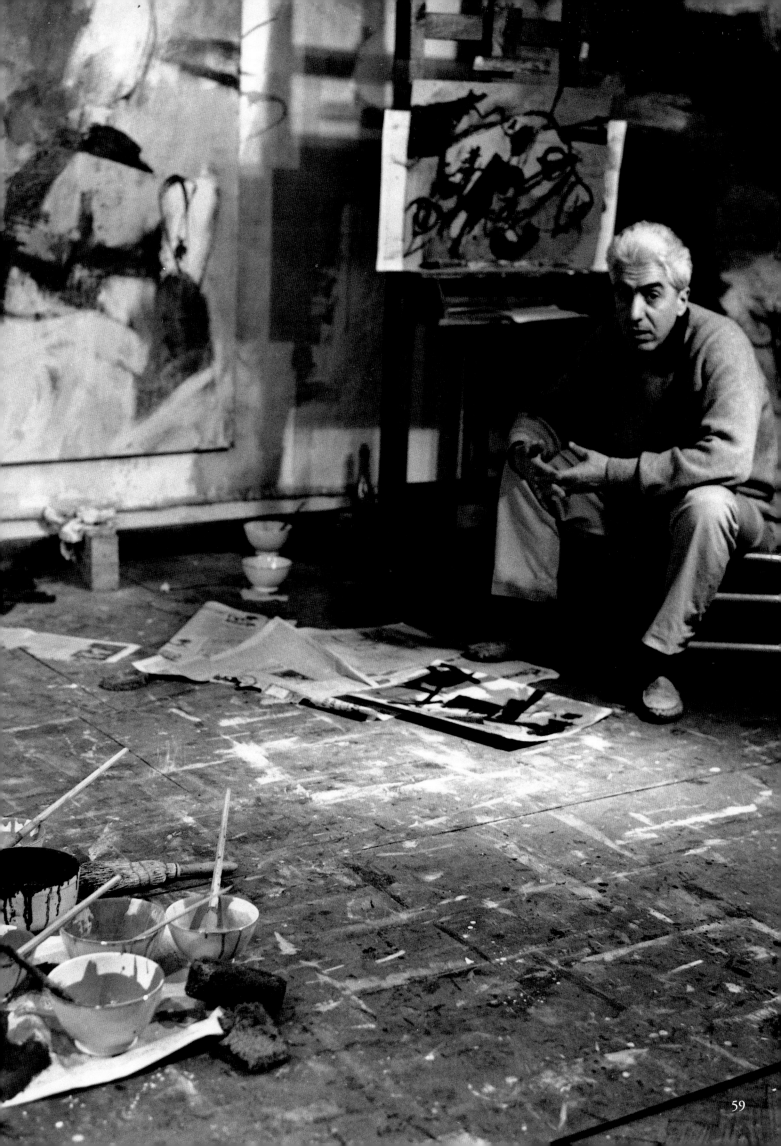

45 Luigi Nervi, Italian architect, at the drawing board in his Rome studio in the early sixties.

46 Eugene Berman, American artist, Rome, 1959.

Eugene's own obsessions return to haunt him like framed ghosts here in this corridor of his Palazzo Doria apartments. His vast and dusty collection of Etruscan sarcophagi, masks and pottery invaded the shadowy rooms and the only place to dine was on a wooden trestle table in the kitchen, served by his peasant housekeeper, a marvellous cook, when she wasn't acting as curator to his artifacts.

47 Arthur Erickson, the internationally acclaimed Canadian architect and a lifelong friend and ally of Roloff, standing inside his creation, the Roy Thomson Hall, home of the Toronto Symphony, shortly before the inaugural ceremonies in 1982.

48 Philip Johnson, American architect, in the late fifties.

A gifted architect seated in his famous glass-and-steel house, the 'Glass House' at New Canaan, Connecticut, perhaps one of the most 'erudite' residences ever constructed. Philip very much encouraged me in my work as a photographer.

49 Fabrice Hélion, grandson of Peggy Guggenheim, stands beside a Giacometti sculpture, one of the many remarkable works of contemporary art bequeathed by his grandmother to the city of Venice, in the Palazzo Venier dei Leoni on the Grand Canal, 1980.

50 Marino Marini, Italian artist and sculptor, Spoleto, 1960.

Marini greets one of his works included in 'Sculpture in the City', part of the 1960 Spoleto Festival of The Two Worlds. A decade earlier, I was fortunate enough to have my paintings hung at the same time as his in 1952 at the Galleria Il Milione in Milan. Then we exchanged a painting for a book; a habit I cultivated.

51 Willem de Kooning, Dutch artist, Rome, 1960.

De Kooning often exchanged studios with the Italian painter, Afro, and it was in Rome that I met him. My father, amazingly for father, said he was the most beautiful man he had ever seen, breaking his prairie rule that only women can be beautiful.

In this moment of stasis and reflection, in Rome's Café Greco, glass in hand and reflected in a glass-top table, De Kooning seems far from the violent and cataclysmic force of his abstract expressionism. His serene Dutch beauty seems far, too, from the 'melodrama of vulgarity' which he says has always obsessed him, though his eyes do have a haunted shadow and the face is tense.

52 Henry Moore, British artist and sculptor, Arnhem, the Netherlands, 1966.

Henry and I met several times over The Archer *and once spent an entire afternoon discussing aesthetics over gin and tonic. Finally after lengthy negotiations at the elegant Athenæum Club in London, I cabled Canada that I had obtained Mr Moore's gracious consent to sell his sculpture. The photograph of Moore with* The Archer *was taken in Arnhem, where Moore saw it for the first time when it arrived from the foundry in West Germany. He was simply carried away, gave a little gasp, but all he said was 'Ah, there it is.' He spent a long time studying every angle, nook and cranny, and breathing very deeply, at last pronounced, 'I am so thrilled with this casting!'*

53 Gino Severini, Italian painter, at work in his studio, Rome in the early sixties.

54 Oskar Kokoschka, Austrian artist, London, 1959.

55 Alberto Burri, Italian artist and leader of the 'informal' school, in his Roman studio, 1960.

Burri once claimed to have developed his 'vision' while interned in Texas staring at burlap bags during the war. His burlap surfaces, burnt and twisted cellophane, opaque tar and pitch, and fabrics dipped in plastic and paint, caused scandals and transformed post-war Italian art.

56 Jacques Lipchitz, Lithuanian-born sculptor who lived in France, photographed in New York in the early fifties.

I went out to Jacques Lipchitz's foundry in Hastings-on-Hudson and spent all day watching him prepare the memorial gate for the famous 'roofless church' in New Harmony which had been designed by Philip Johnson. I later did the jacket for his autobiography, My Life in Sculpture.

57 Andy Warhol, American artist, on a Venetian holiday, boating on the Grand Canal with Diana Vreeland and Philip van Rensselaer, 1965.

58 Graham Sutherland, British artist, in a gondola on his way to visit Peggy Guggenheim at her palazzo in Venice, 1957.

Graham relaxing in Venice from the weaving of his monumental tapestry for Coventry Cathedral. We often met at Peggy's and one of my first investments in art was a large wash of his 'Thorn Tree' period.

59 Afro Basaldella, Italian neo-cubist and abstract painter, displaying a painting at his home and studio, Rome, 1960.

Writers

ROLOFF REMAINED A VORACIOUS READER THROUGHOUT HIS life and surrounded himself with scholars, poets and writers, who often collaborated on his various books. He suffered from acute insomnia and his night-time reading would carry on until the early hours of the morning. On the nearly fifty trips we made together to Iran during the seventies, Roloff would always carry an extra suitcase filled with an assortment of the latest novels, books on art history or literary criticism, plays and Persian poetry to inspire him for the photography ahead.

From the age of seven when I first discovered an encyclopedia I fell in love with books as works of art. I loved the smell of ink, of glue and paper and the inspired words of the author. Both books and objects have always fascinated me. My first book, an Aegean note-book, *was printed and bound in one hundred copies completely by hand. This physical contact, this sensual counterpart, is very important for me. It was like a revelation. But there is another more profound reason at the base of my love for books — it is the silence that ties the image to the written word.*

Roloff insisted that his own books, rich in visual imagery, should express the literary and poetic traditions of the country or culture portrayed and provide a broad art-historical overview to secure the reader in time and space as well. For his first photographic book, *The Thrones of Earth and Heaven*, published by Thames and Hudson in 1958, Roloff charmed and cajoled six internationally renowned authors into agreeing to write the texts that accompanied the pictures. The original team of Jean Cocteau, Freya Stark, Bernard Berenson, Stephen Spender, Rose Macaulay and Herbert Read are all reunited in this chapter.

Other portraits include those of Gore Vidal, a neighbour across the Tiber, who contributed a witty epilogue to the *Italy* book, and Lesley Blanch, a much beloved companion through the bazaars and caravanserais of Persia. The studies of Ezra Pound during his last days in Venice and Tennessee Williams lounging on the beach at Positano are among Roloff's most expressive works.

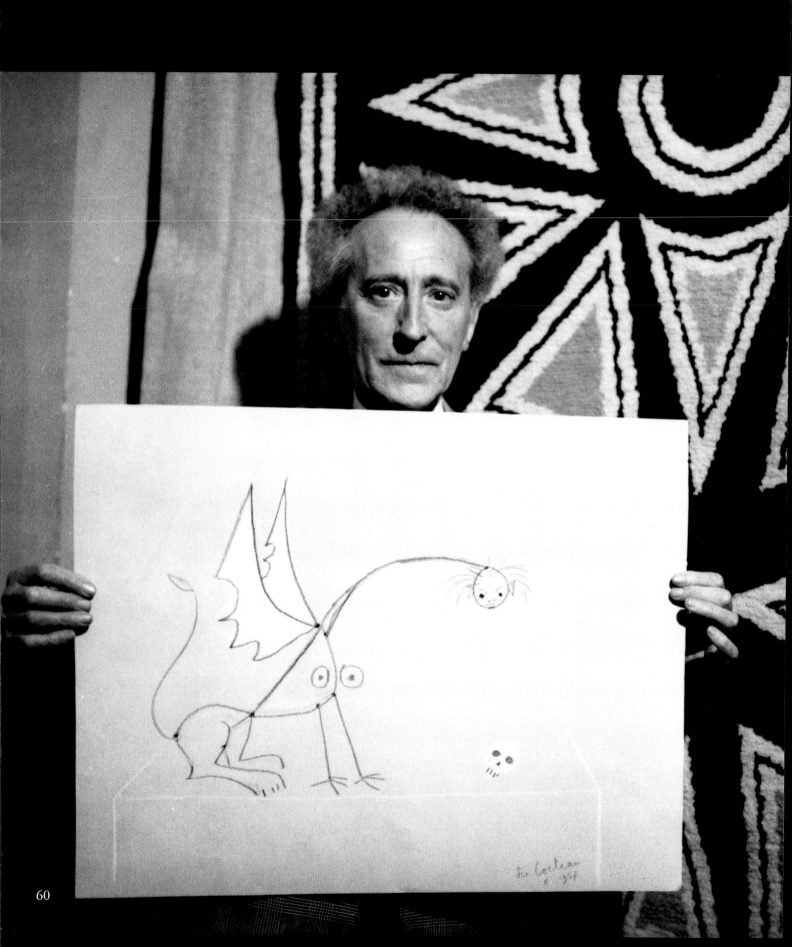

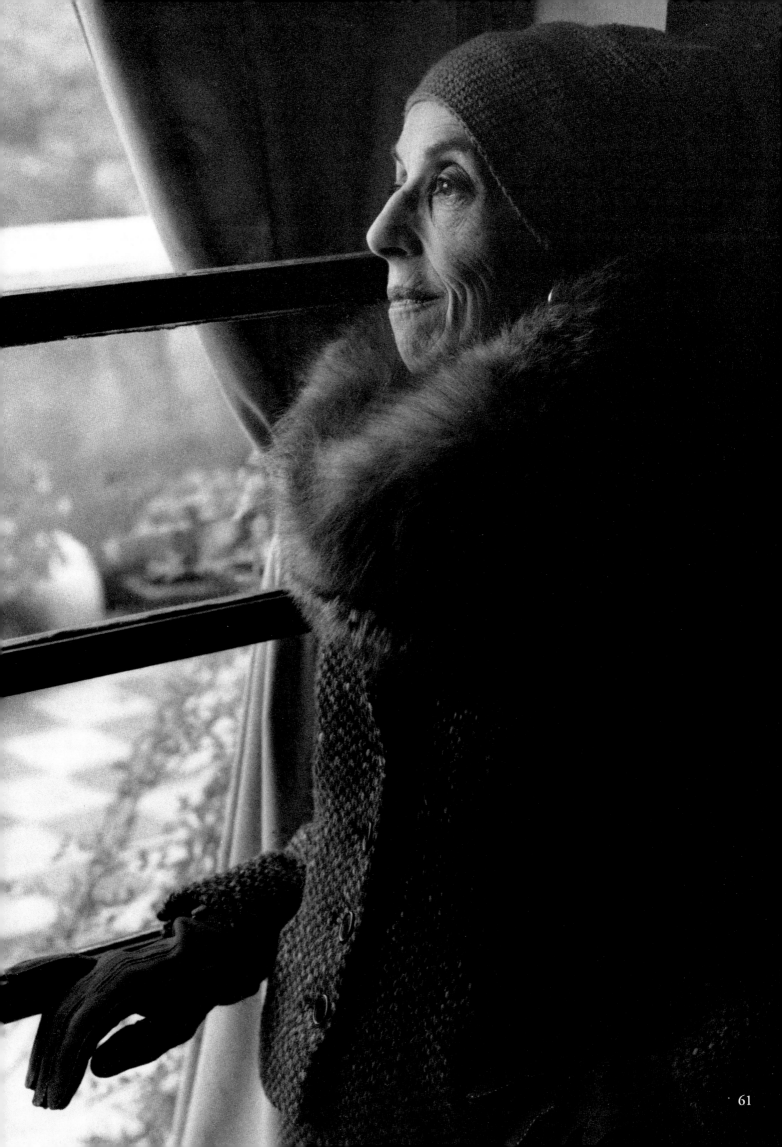

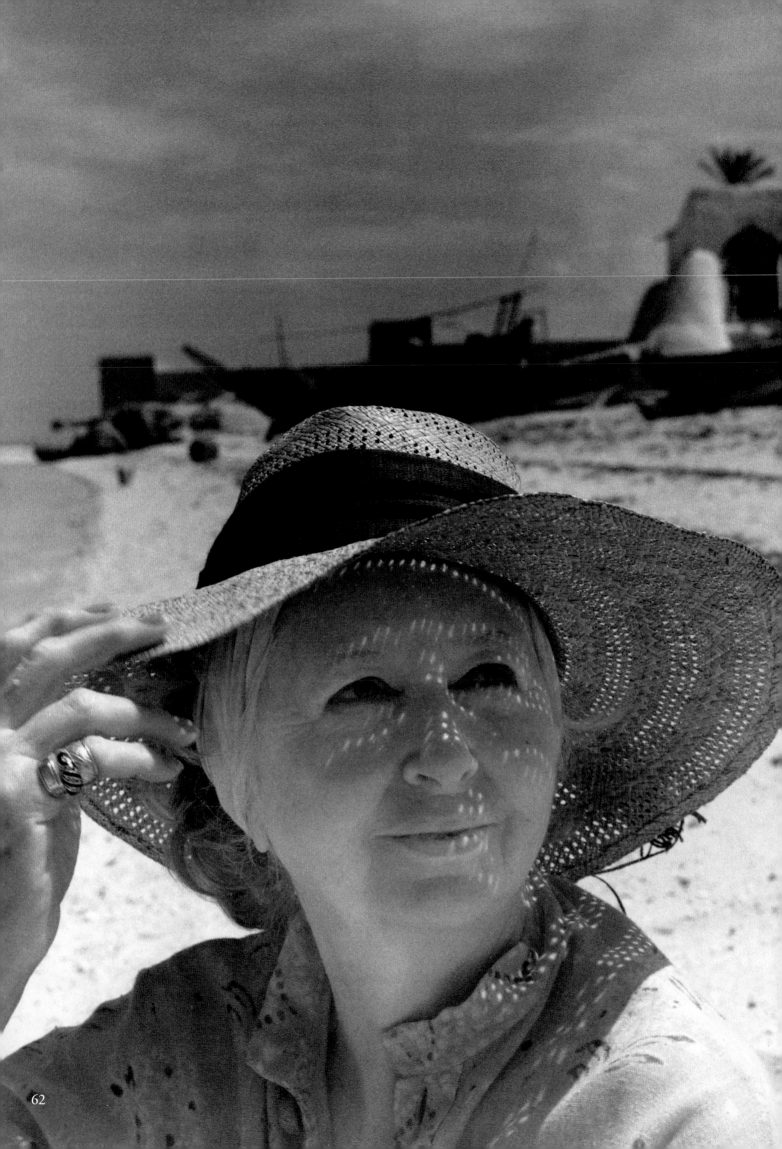

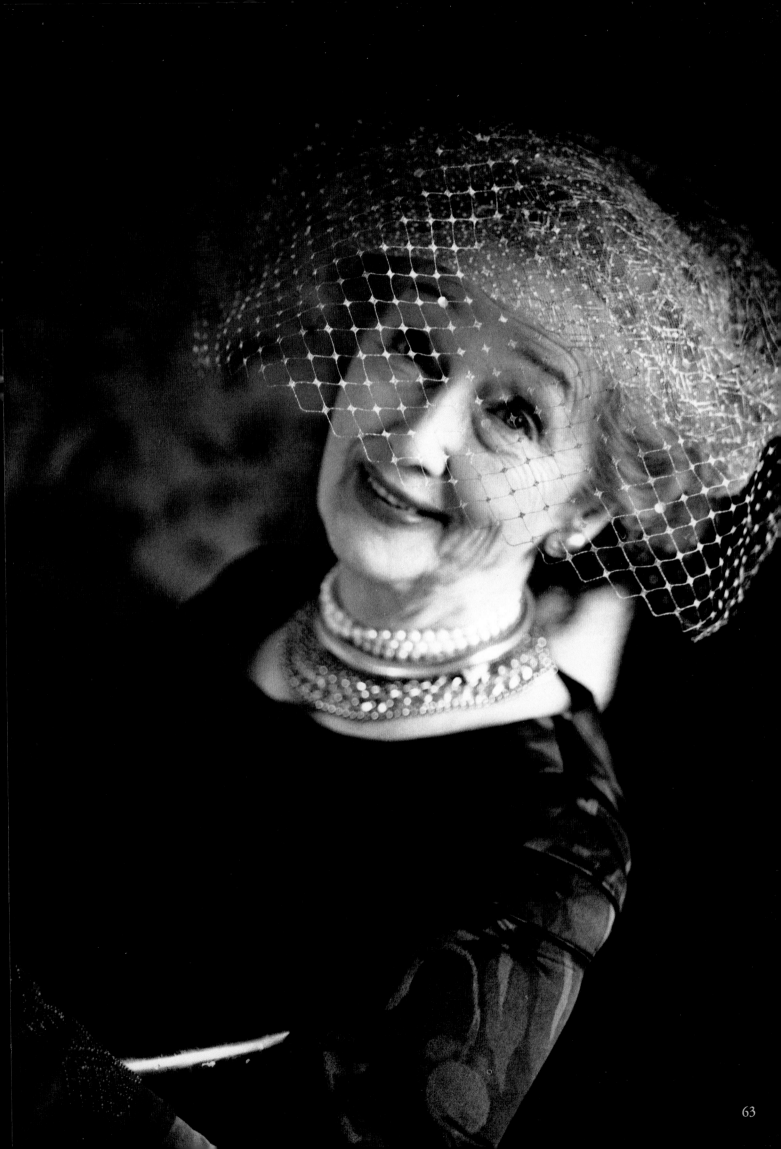

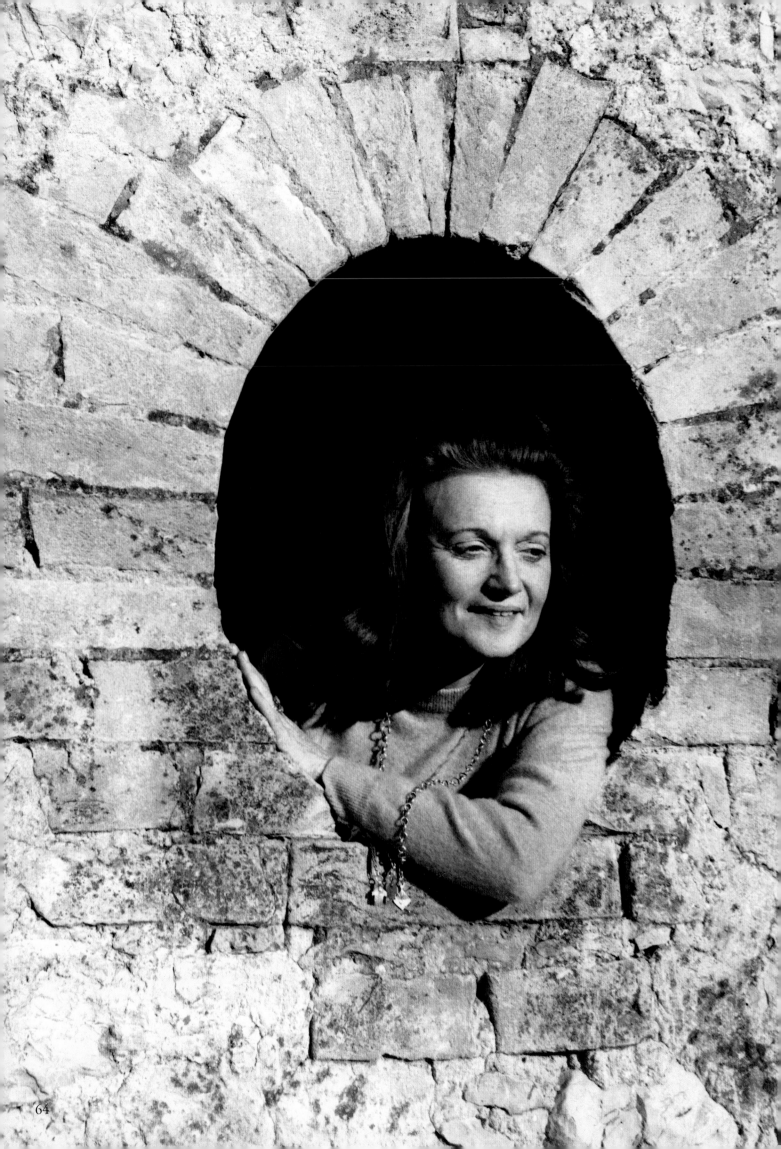

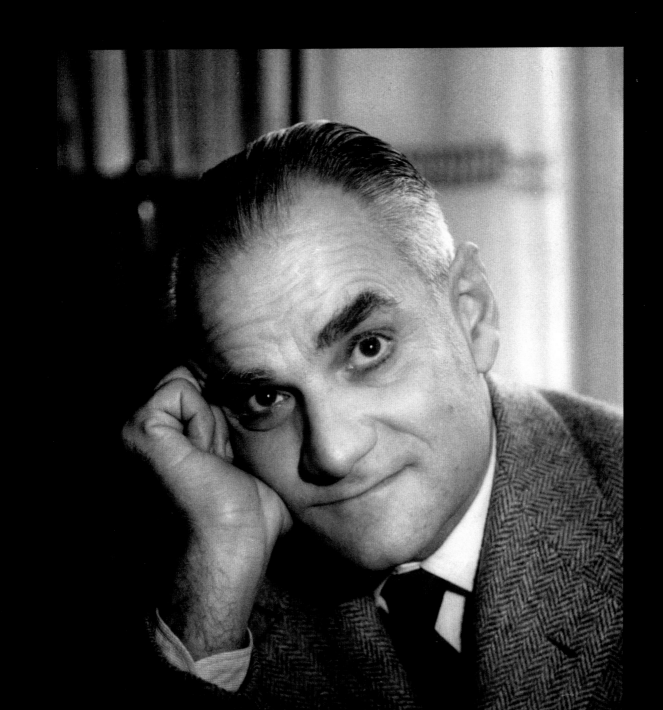

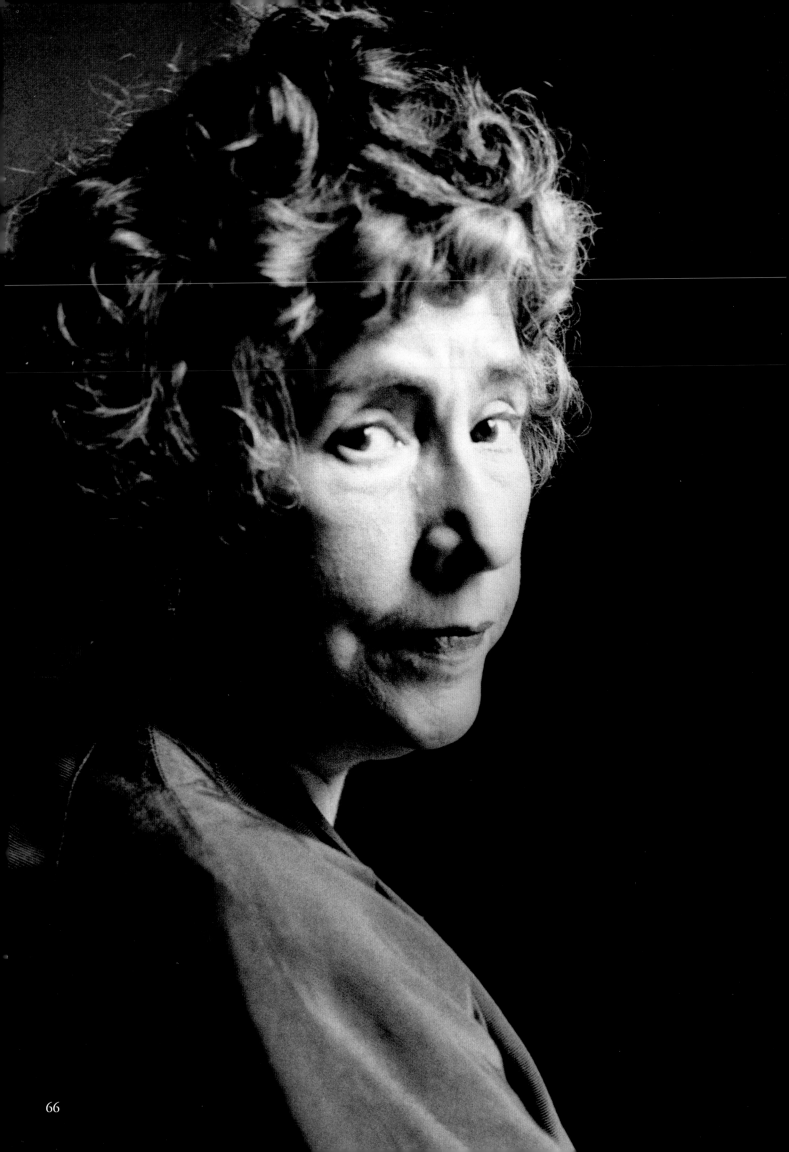

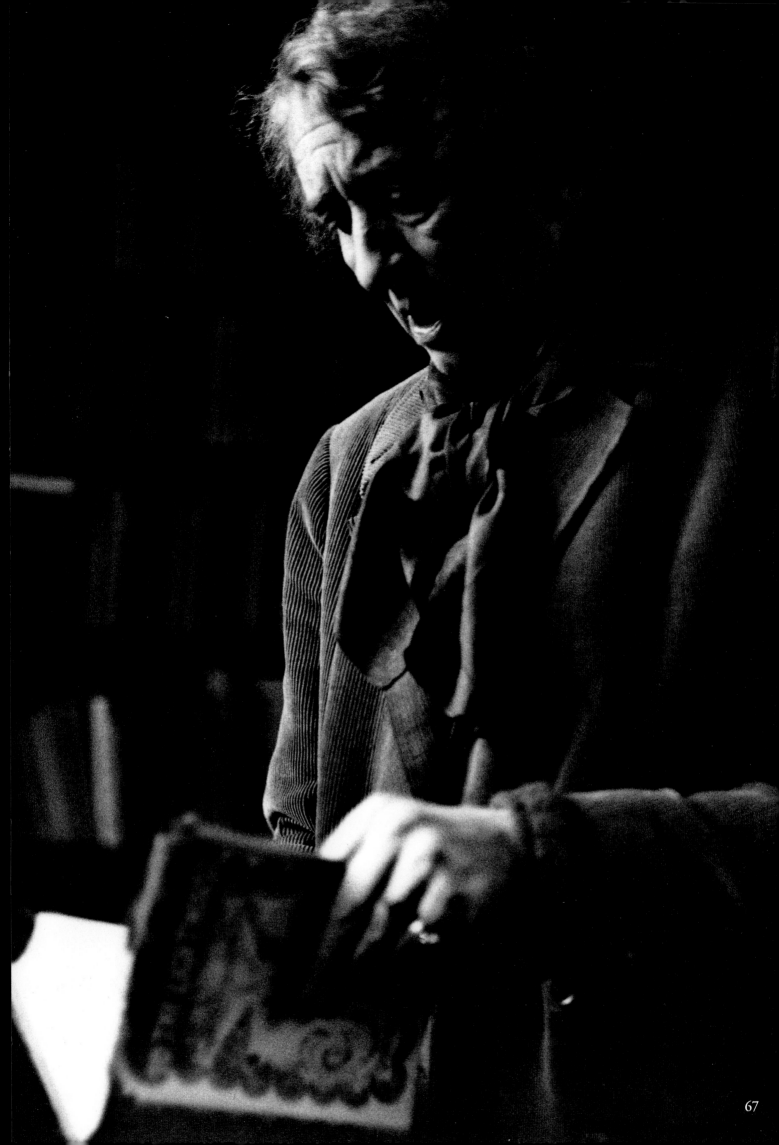

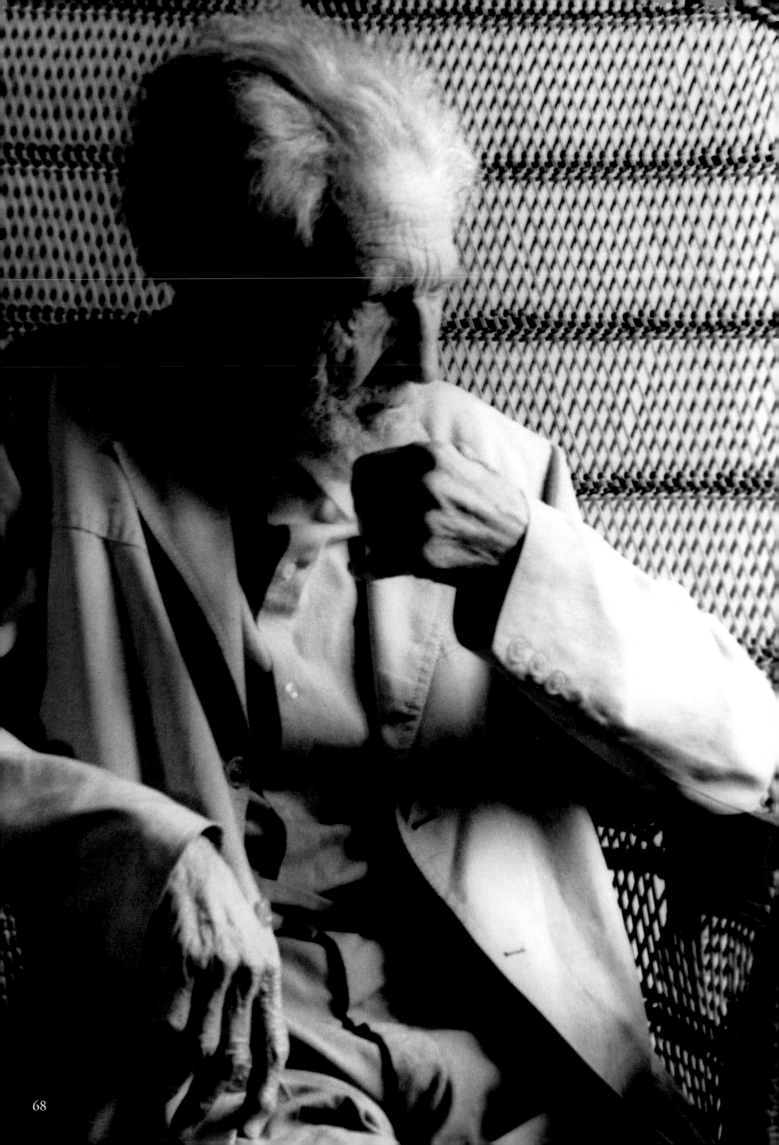

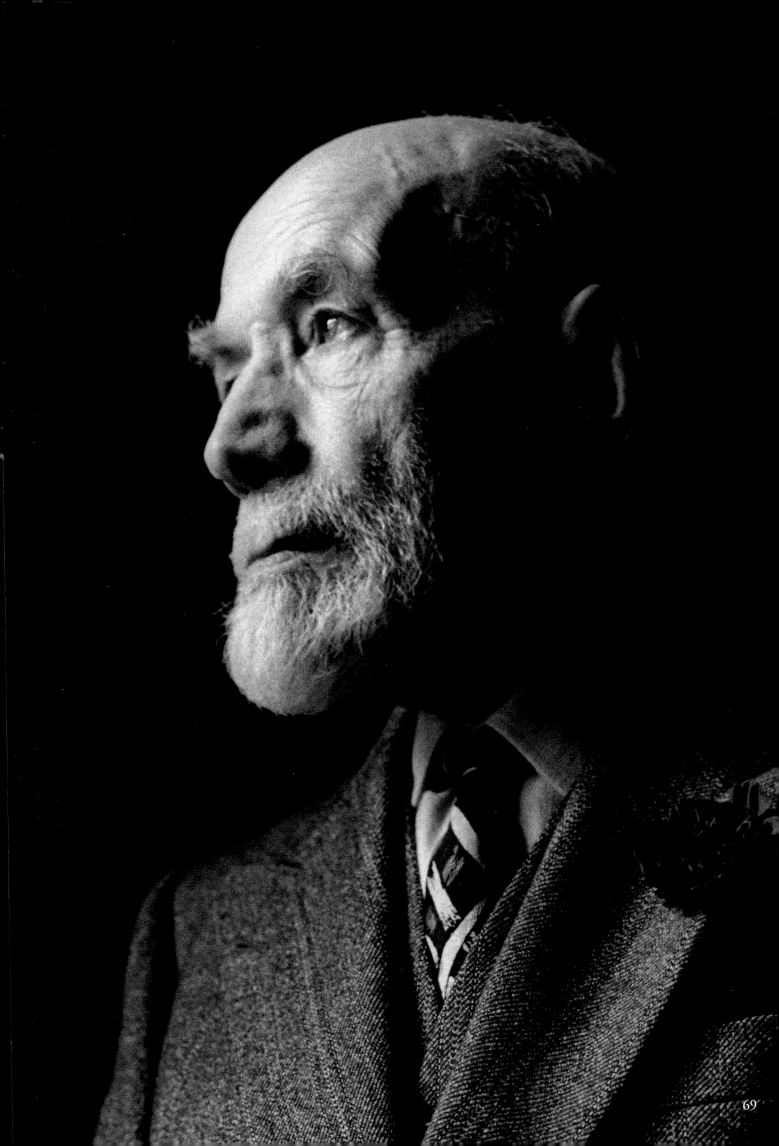

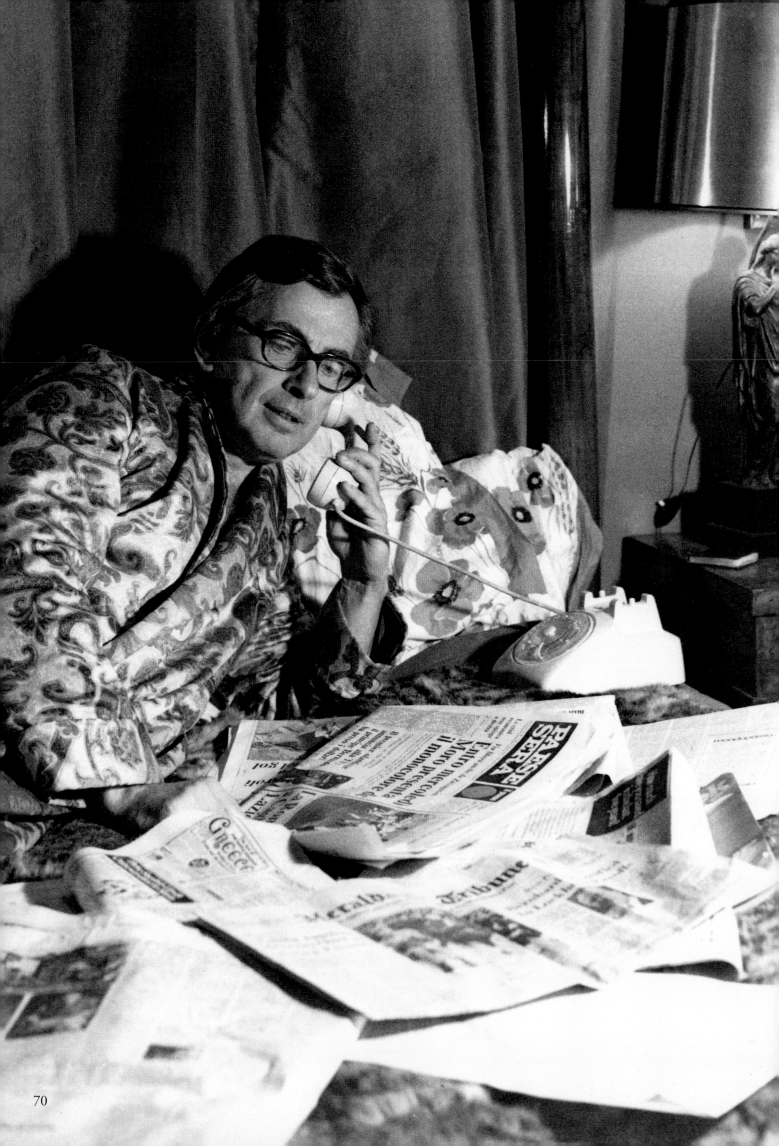

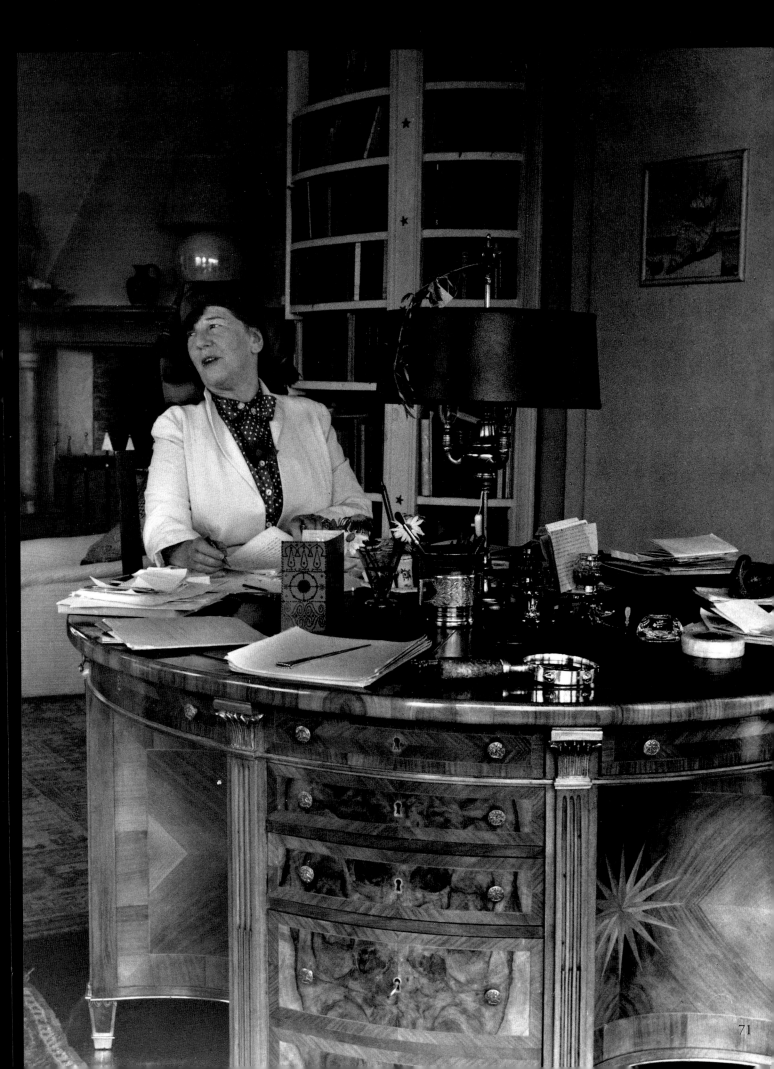

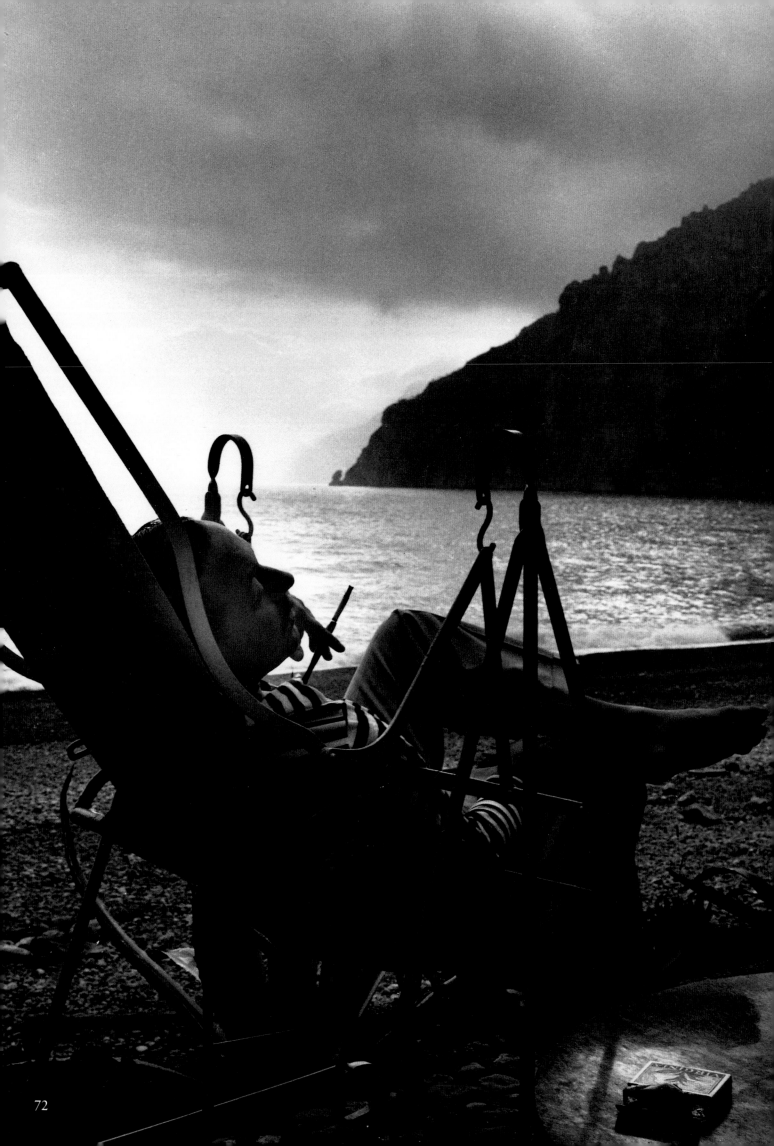

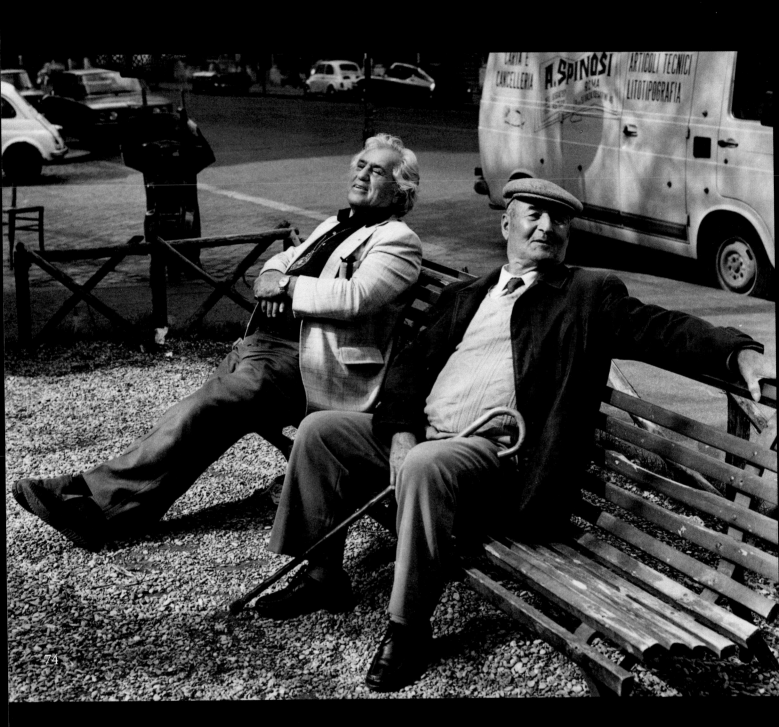

74

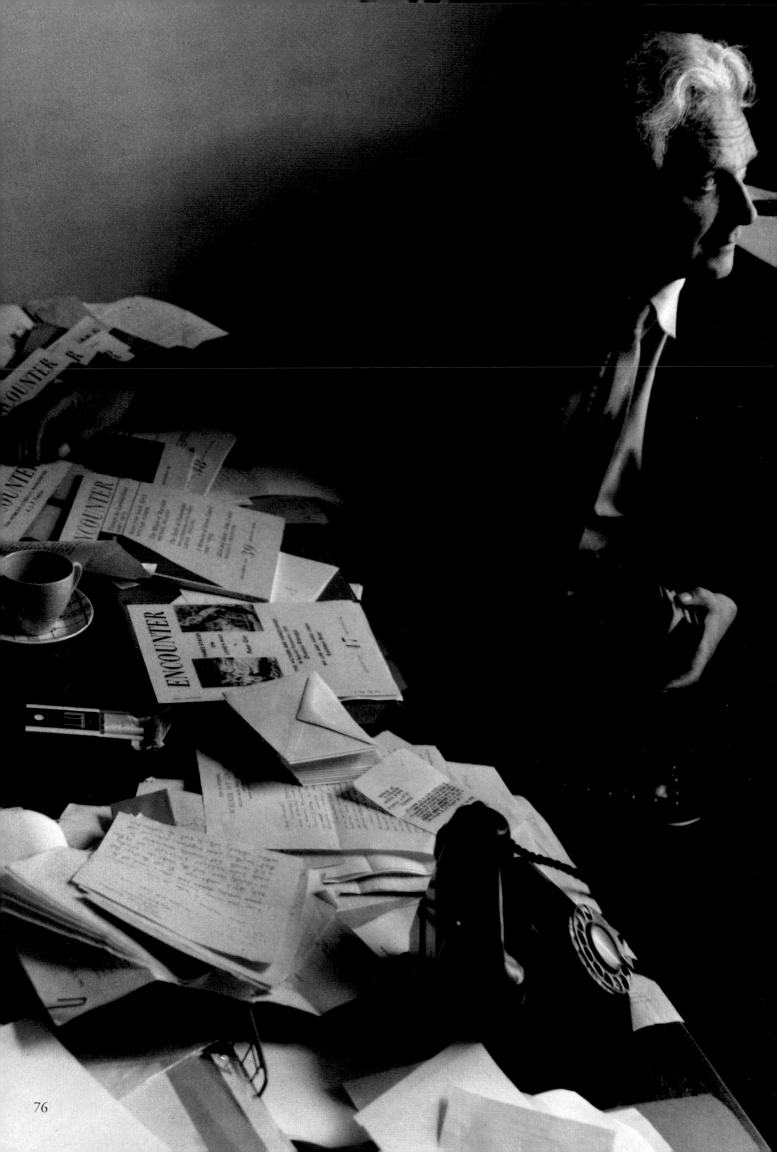

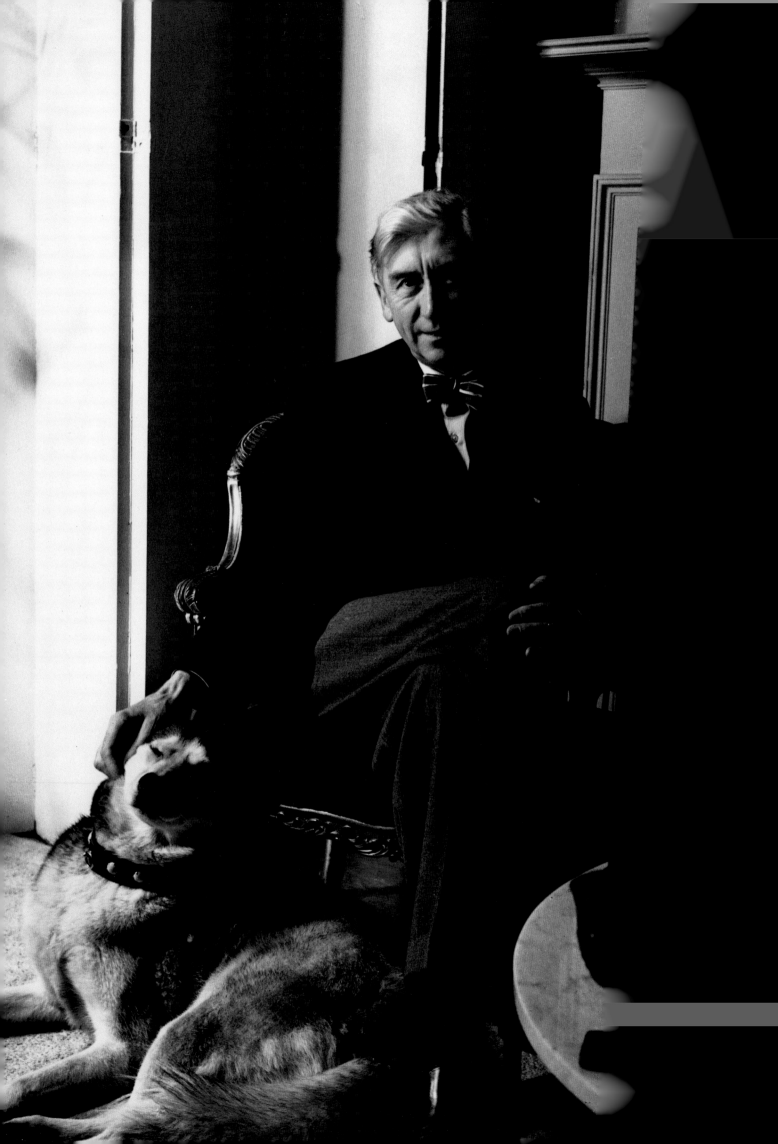

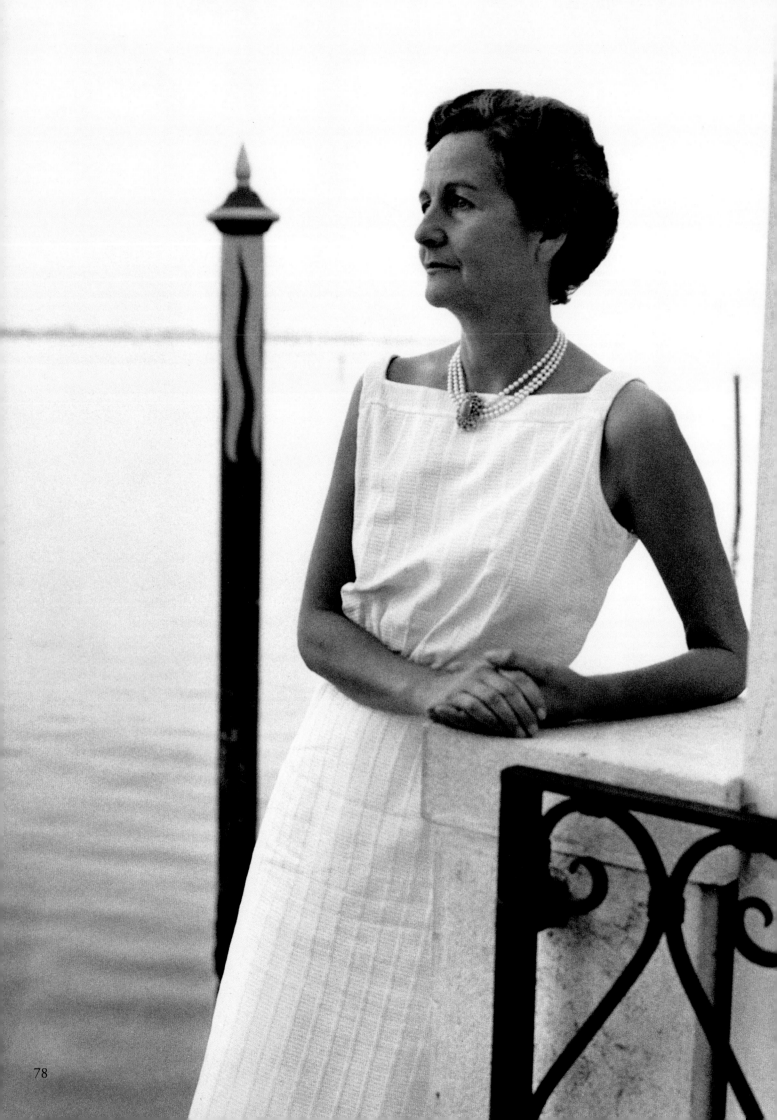

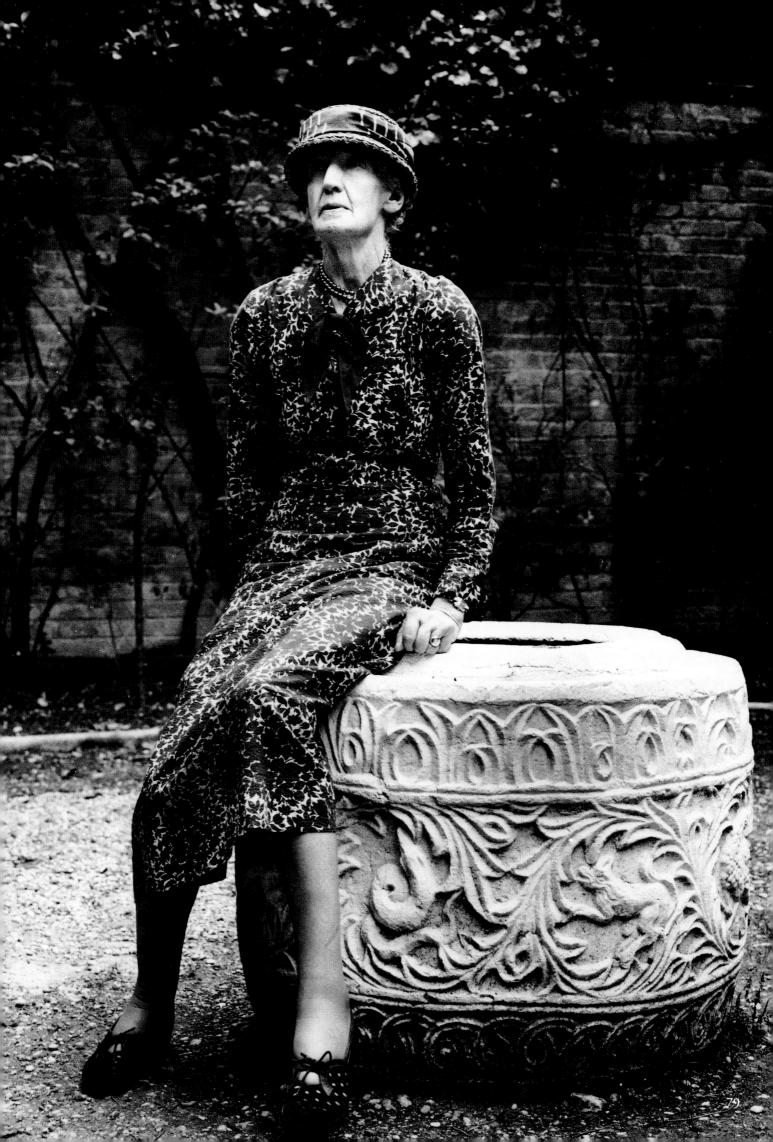

60 Jean Cocteau, French writer and artist, Paris in the early fifties.

In collecting authors for The Thrones of Earth and Heaven, *I first turned to Jean Cocteau who in the early fifties had been the key to everything in Paris. He arranged my first Paris show at the Palais Royal, just under Colette's apartments.*

Cocteau turned everything he touched into magic, and helped people to discover themselves. His virtuosity was his charm, and almost seemed a form of irresponsibility. When I asked him to write on Egypt, he said, 'But Roloff, I've never been to Egypt ...', then the seraphic smile, 'but now I shall go there – through your images.' In my photograph taken in his Paris studio, he looks like his own Sphinx, fresh off the easel.

61 Isak Dinesen, Danish writer, Rome, 1958.

Seeing her pencil-thin legs, I was amazed she had climbed the Tiber Terrace stairs, but her wit was as sparkling as her eyes. Her aristocratic hauteur and capricious patrician arrogance are reflected in the fine fragility of her profile. In later years she ate almost nothing and reputedly lived on oysters. She died in 1962 of emaciation and malnutrition.

62 Lesley Blanch, British novelist and travel writer, on the beach at Kish Island in the Persian Gulf, 1976.

Lesley has portable charisma. The instant she enters a room, you know she is there, no matter how many people are crowding around. She carries her settings with her, and instantly turns the most anonymous hotel room into an oriental bazaar. She turns life into romance. We worked together on the biography of the Shahbanou, and have found ourselves, at various times, sharing many strange places and dishes.

63 Hedda Hopper, American Hollywood columnist, in her Waldorf-Astoria suite on a visit to New York, 1960.

'All my life I've wanted to meet someone who came from Medicine Hat!' she exclaimed. 'Now one of my life's ambitions is realized.' I remember last seeing Hedda in her mansion in Beverly Hills. She served her traditional caviar and champagne. Her drawing room was bursting with Christmas gifts – potted palms, lemon trees, jumbo baskets of fruit, bunches of orchids. ... All from fans, or aspiring starlets, or disappointed social climbers. 'It's an annual agony', she explained, 'dating back to the years when one adverse remark in my column could ruin a career. I open

each gift, write a thank-you note, and send it all to orphanages for Christmas Day.'

64 Muriel Spark, British novelist, at Todi in Italy where she was looking for a country house, 1965.

Muriel was a fastidious dresser, always having fur coats recycled by Fendi. Like me, she never found Rome a debilitating place to work – in fact the term workaholic might have been coined for her. Nothing interrupts the flow of prose, wherever she is.

65 Alberto Moravia, Italian novelist, at home in Rome, 1965.

66 Violet Trefusis, British author and hostess, in her Paris drawing room, 1958.

Romantic, pagan, sensual, she was Vita Sackville-West's lover in the late teens, and it was whispered she was the illegitimate daughter of Edward VII. Peggy Guggenheim was dying to meet her and asked if she should curtsey or not.

67 Victoria Sackville-West, British poet and novelist, Sissinghurst Castle, England, 1959.

After lunch and a tour of the famous castle gardens, I photographed Vita in the tower library, wearing knee-high riding boots, jodhpurs and carrying a riding crop – which had been with her through lunch – and holding the manuscript of Virginia Woolf's To the Lighthouse.

68 Ezra Pound, British author and poet, in his study in Venice in the early seventies.

Caresse Crosby and I had lunch with Ezra Pound in Venice. He didn't speak at all, and afterwards, he leaned over to me and whispered, 'You see, I didn't say anything.'

69 Bernard Berenson, American art historian and author, at I Tatti, his home, near Florence, 1958.

Berenson disapproved of my photographs which 'interpreted' classical sculpture, so Anna Maria Cicogna hid the most offensive examples. 'You are certainly a very perverse young man, but I have no doubt you will go far!' Ultimately, he agreed to write for The Thrones of Earth and Heaven.

70 Gore Vidal, American author and novelist, relaxing at home in Rome, 1976.

Gore is my neighbour across the Tiber and gives the most marvellous parties and is always ready with good advice.

71 Freya Stark, British travel writer, at her home in Asolo, Italy, in the late fifties.

One of the world's great travel writers, Dame Freya Stark never passed through Paris without buying at least six hats, which she then proceeded to exhibit. She exercised on an enormous globe, as if it were a hobby-horse and sat before a complicated round desk. When I asked her if she wanted to change her contribution to Thrones *for a recent reprint, she said, 'Not a jot, not a whit!'*

72 Tennessee Williams, American author and playwright, Positano, Italy, 1958.

Slouched in a languid twilight mood on the beach at Positano. In spite of his themes of cannibalism, rape, violent sex and eternal frustration, Tennessee was a gentle and most obliging man, with a curiously upper-class British accent. He wrote brilliant dialogue, but in conversation he wandered so, that I can't remember anything he said.

73 Robert Graves, British scholar and author, Mallorca, 1979.

I first photographed Robert Graves at the Athens Festival in 1961. Years later I photographed him in Mallorca where he was dozing in the sun. I reminded him about the times we had had in Greece nearly twenty years before – but he had already suffered a stroke and he did not seem to know I was there.
 There are few things sadder than a body which outlives the great mind that dwelt in it. I remember also with fear and pity Berenson's last words to me: 'If only I could transplant this matchless brain of mine from this mummified body!'

74 Irving Layton, Canadian author and poet, Rome, 1981.

Canada's most pugnacious poet, photographed on a bench in a small piazza while on holiday. Irving posed first beside a vagabond who looked at him rather quizzically, but was pleased by the fuss, then next to two lovely giggling Swedish tourists, and finally by himself. Afterwards we had a long Roman lunch in a local trattoria where he proudly proclaimed he was about to become a father – 'Maybe I'm the oldest procreating poet!'

75 Cyril Connolly, British critic and author, Venice in the mid-seventies.

Cyril Connolly, the famous critic and mandarin of English letters, against the backdrop of the Grand Canal. He complemented the Ming Horses on the gondola landing. Contessa Natalie Volpi thought the horses were to be hers, but Peggy Guggenheim was quicker with the greenbacks. The feud ended when Peggy was made an honorary citizen of Venice.

76 Stephen Spender, British author, poet and publisher of *Encounter*, in his London office, 1958.

77 Herbert Read, British scholar and art critic, at his home in London, 1958.

Sir Herbert Read tutored Peggy Guggenheim in modern art, and was a frequent visitor to Peggy's palazzo. When he saw the photographs I had taken of Spain, he suggested that I hold a show at the Institute of Contemporary Art in London, of which he was President. The show at the ICA led to my meeting Walter and Eva Neurath, to the proposal for The Thrones of Earth and Heaven, *and to my life-long relationship with Thames and Hudson.*

78 Nancy Mitford, British writer, at the Hotel Cipriani, Venice, 1957.

Peggy preferred the company of men, but Nancy Mitford was one of her favourite people. When the three of us floated in a gondola on the Grand Canal, I felt I was walking through one of her novels. Her conversation was so clipped, precise and elegant.

79 Rose Macaulay, British author and travel writer, 1958.

Behind the austere demeanour, astringent wit and very sensuous mandarin style, Dame Rose Macaulay was a very shy and vulnerable person. An adventurous and refined hedonist, her books abound in the word 'pleasure', like her famous travel book Pleasure of Ruins. *We were planning a photographic version of this book when she died in 1958 and, after an around-the-world tour, I completed the book six years later.*
 I had known Dame Rose since she had first been 'captured' for my birthday party years before. Here she is photographed after luncheon in Peggy's Venetian garden sitting on the Byzantine well at the gate. Peggy had offered to send her gondola, but Dame Rose said, 'No, I'll sprint over from my pensione.' So, thus she arrived in her gum shoes and inevitable hat.

Music
and Dance

WHETHER HINDU, BUDDHIST, PERSIAN OR WESTERN, ROLOFF made considerable efforts on his travels to attend concerts and performances of all forms of classical and contemporary music and dance. Back in Rome, he was a frequent visitor to the nearby Spoleto Festival of The Two Worlds and also visited the art and culture festivals in Athens and Dubrovnik.

Roloff admired the beauty and movement of ballet and modern dance and one of the first friends he made in Europe was Margot Fonteyn, with whom he went fishing on the River Arno in Florence. He later tracked down her famous partner, Rudolf Nureyev, shortly after his defection from Russia, and again some years later, when the star had become an institution and was less willing to be photographed.

Roloff was a slow and studied photographer and the quick movements of dance eluded him. He preferred to capture the dancers in static, sculptural poses such as his photograph of the Yugoslav dancer, Milorad Miskovitch, intertwined within the lines of a Calder sculpture at Spoleto, or John Butler, a leading American dancer and close friend of Roloff, resting against a column at Tiber Terrace, his powerful face sliced by shadows. Late in his life, the brilliant dancer and choreographer, Anton Dolin, visited Roloff in Rome and posed before a dark curtain – a brooding, dramatic image that embodies the spirit and complexity of the man.

Among the other photographs in this chapter are those of the reclusive Canadian pianist, Glenn Gould, who was photographed for Roloff's *Canada* book, and Roloff later added the singer and poet, Leonard Cohen, to the archive. Leontyne Price was draped in black lace at Tiber Terrace, while on European tour, and the result was vintage Roloff – a stunning portrait lifted beyond time and space. Roloff seldom took a holiday, but one weekend he was persuaded to journey to the Island of Ischia where he photographed the British composer, Sir William Walton, and his wife, Susannah, sunning themselves in the garden.

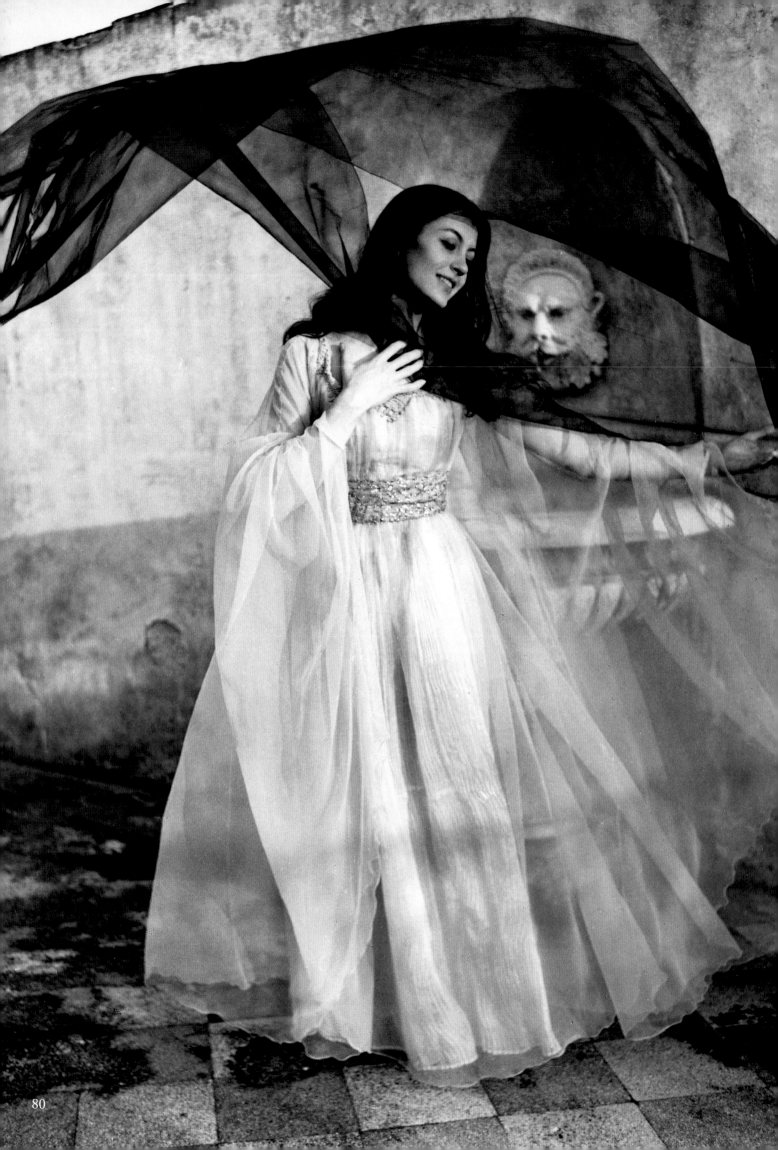

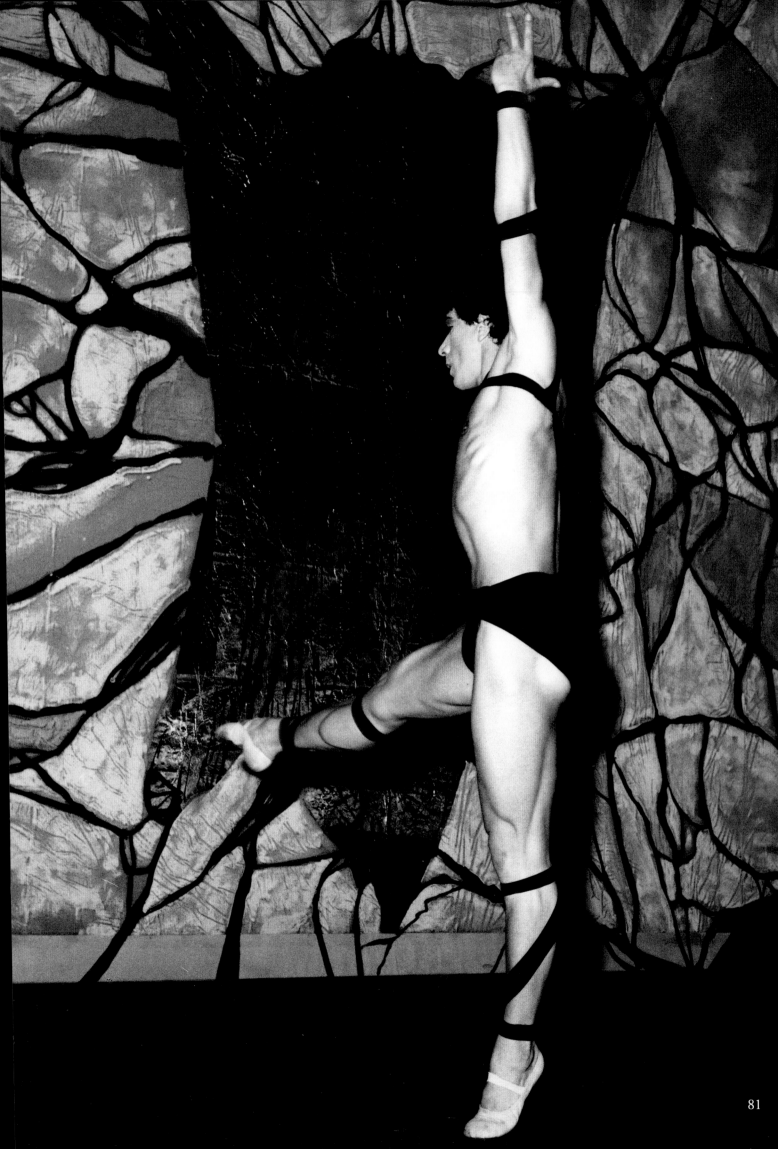

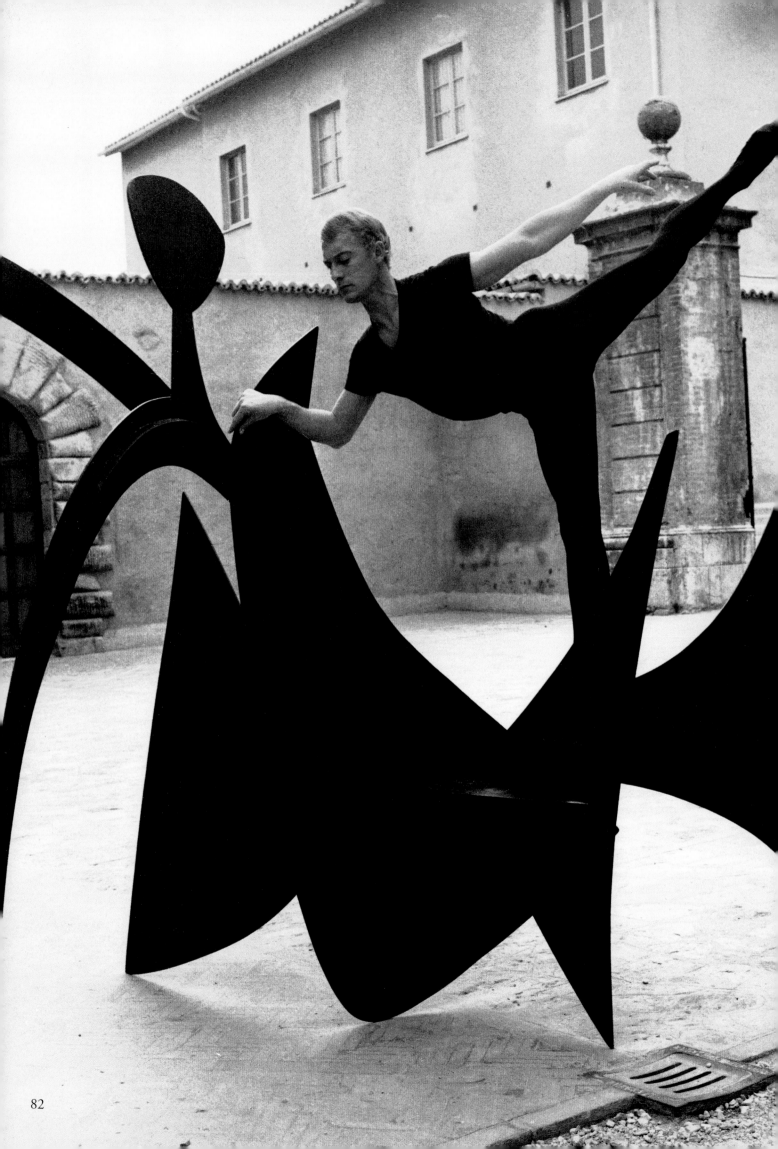

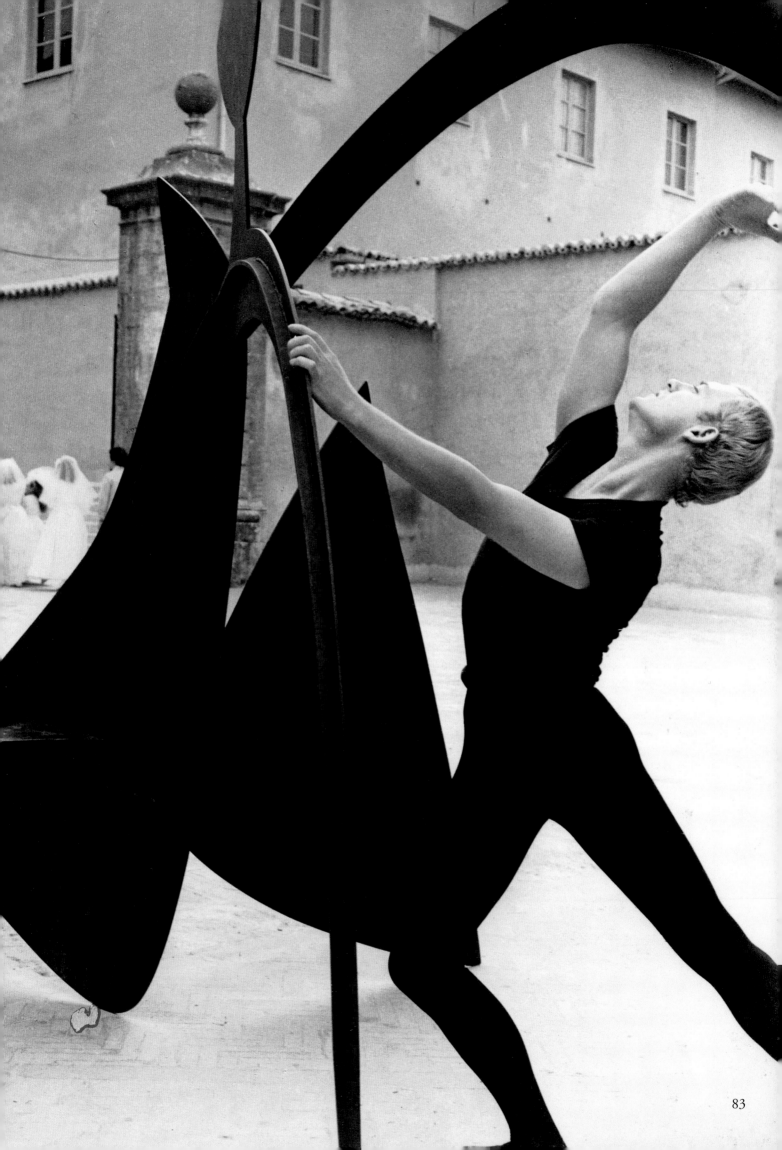

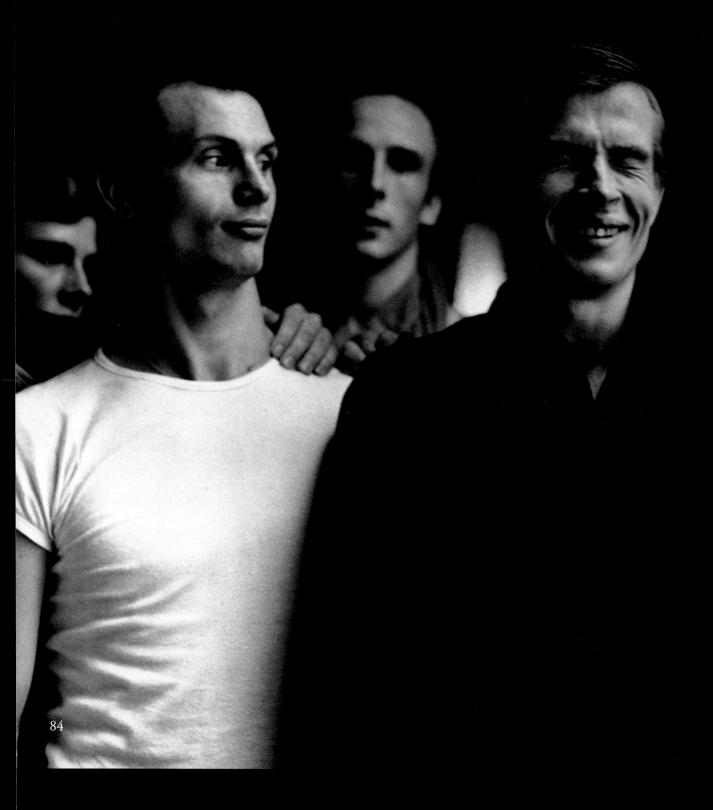

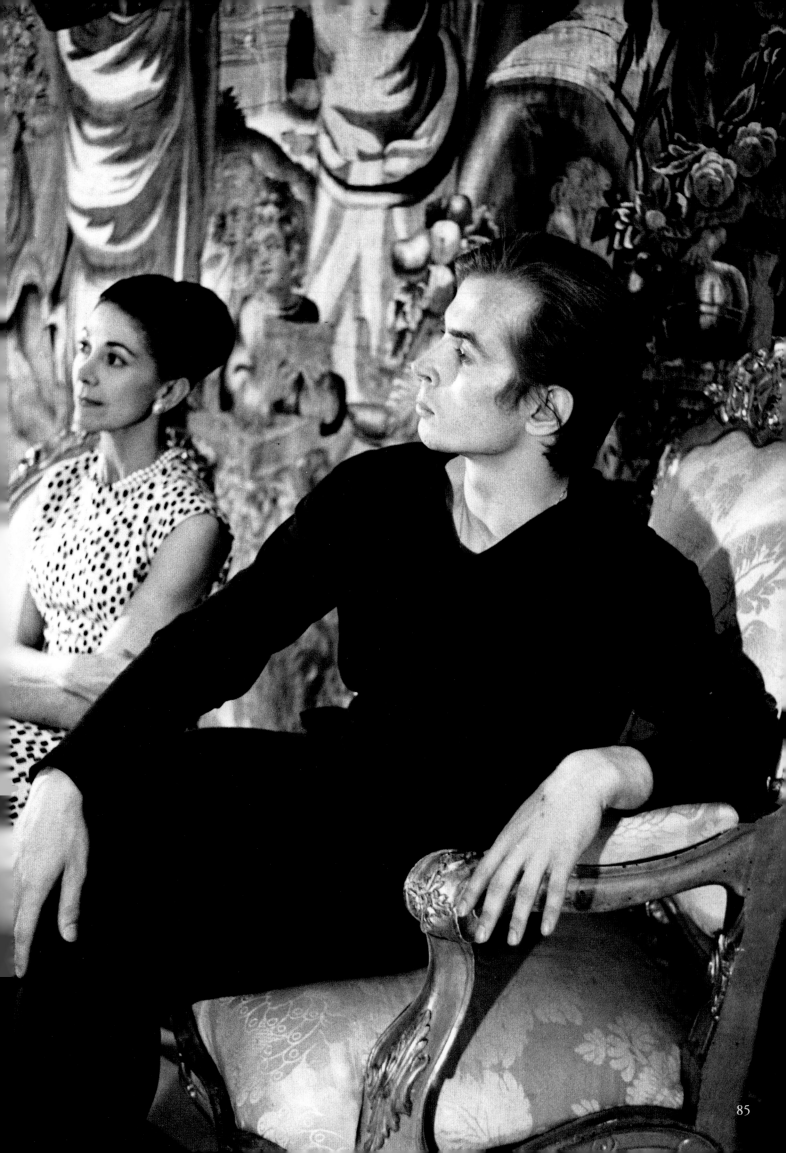

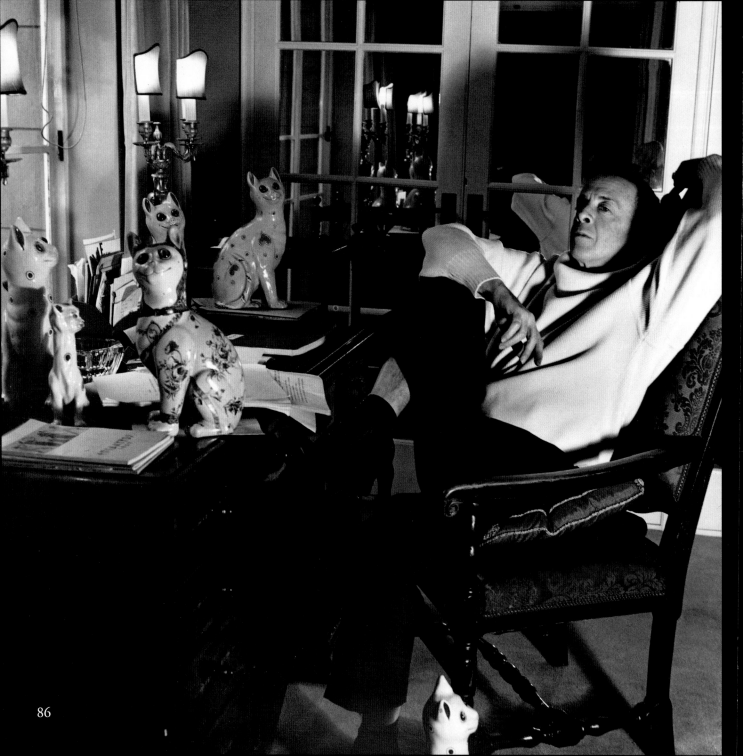

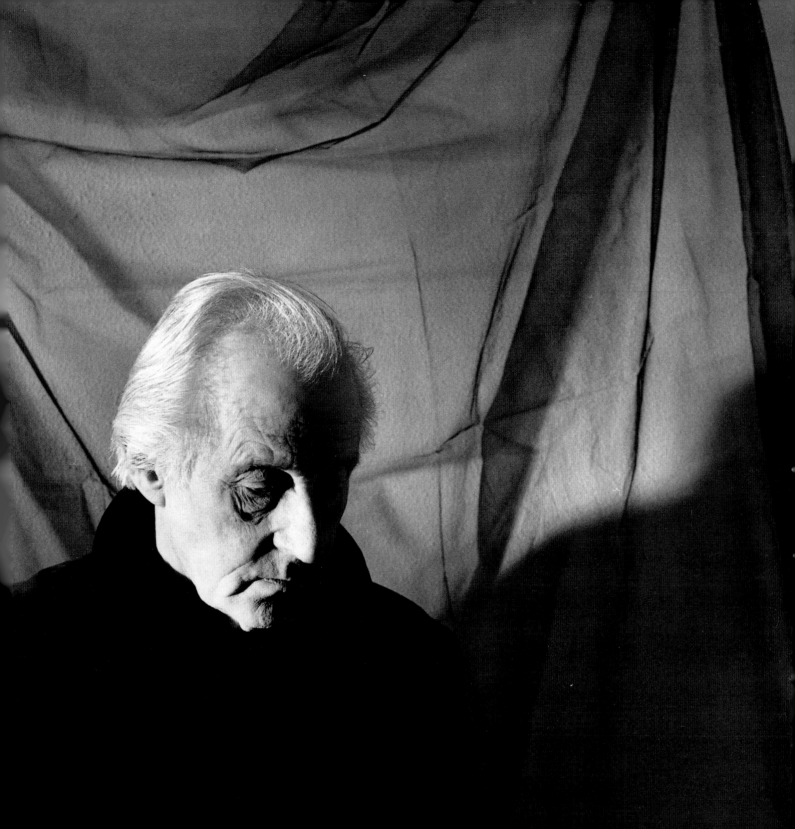

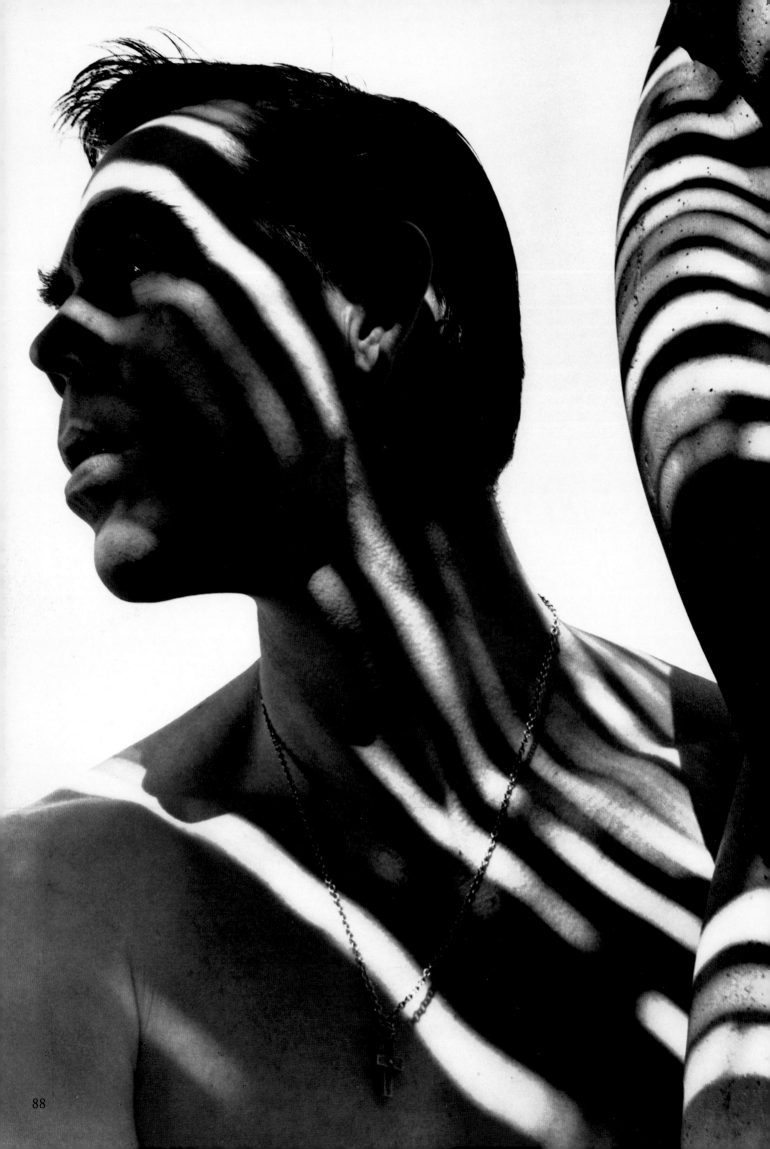

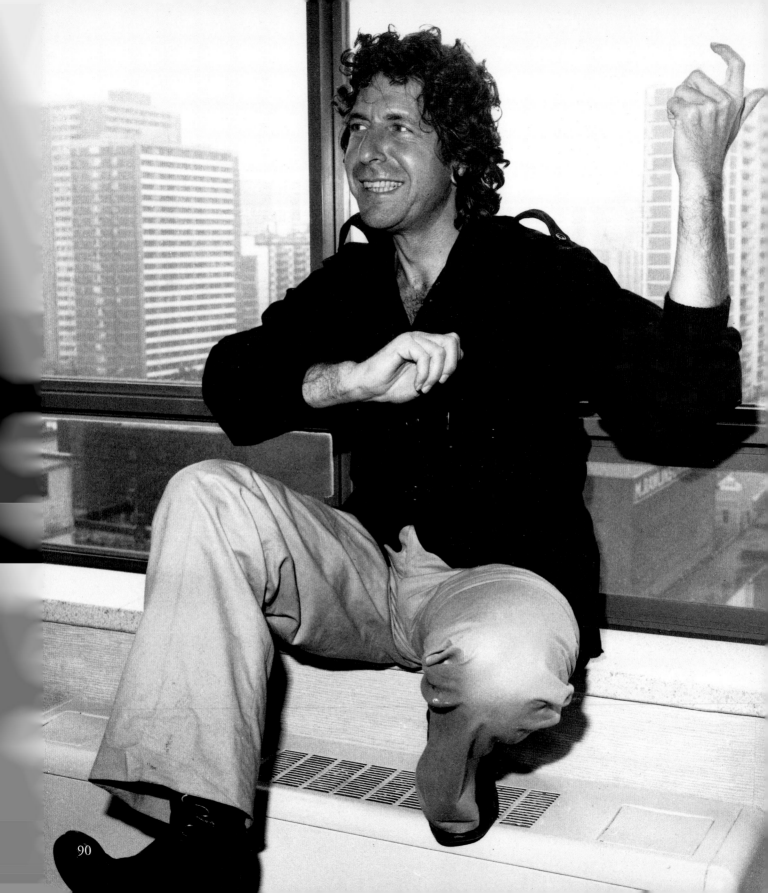

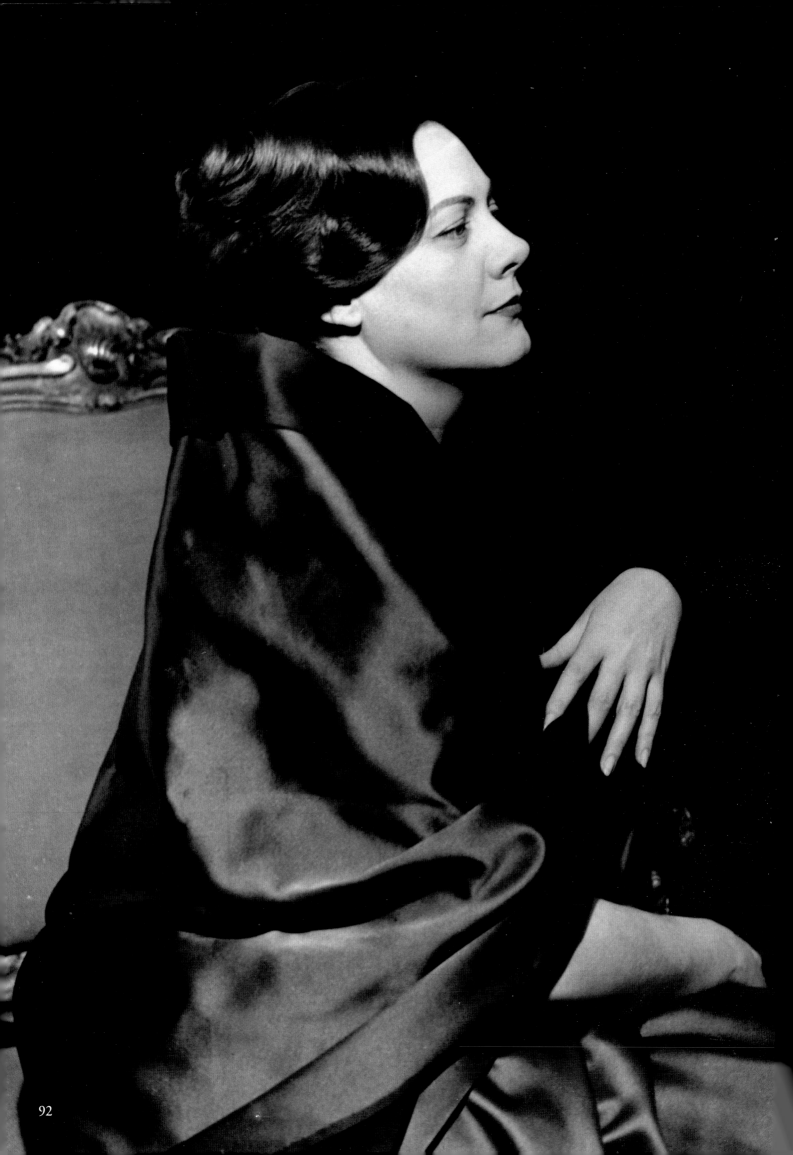

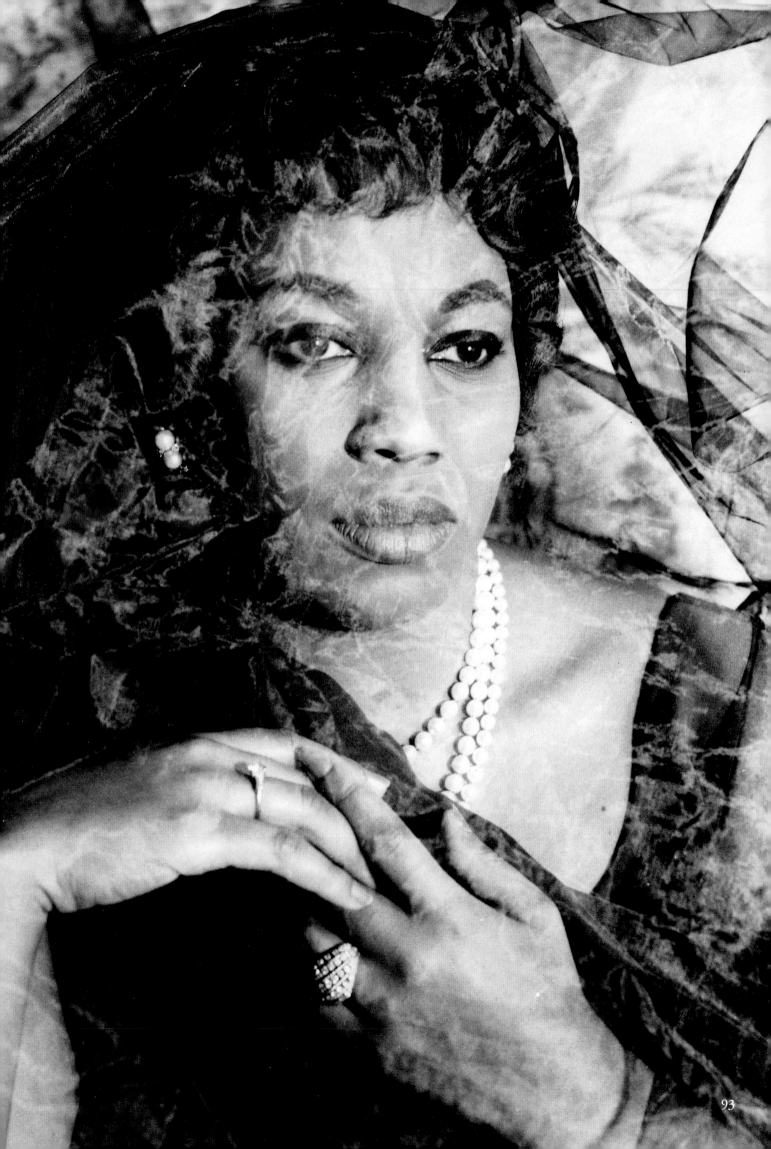

80 Carla Fracci, Italian dancer, at the 1962 Spoleto Festival of The Two Worlds.

The new-born Festival of The Two Worlds at Spoleto was an annual must for the cognoscenti of Rome. I went as often as I could, both for the heady dose of Kultur and for the wonderful people and parties.

81 James Urbain, the French dancer, rehearsing John Butler's *Medea* at Spoleto, 1978.

82–83 Milorad Miskovitch, Yugoslav dancer, Spoleto, 1962.

Milorad fell in love with my camera and is seen here posing at the 'Sculpture in the City' exhibition of the Spoleto Festival with a very plastic form by Alexander Calder.

84 Rudolf Nureyev, Russian dancer and choreographer, after rehearsing with the ballet of the Marquis de Cuevas at the Paris Opera House, 1961.

When I first met Rudolf Nureyev in Paris he had just escaped from Russia and was still shy and accommodating: he willingly posed for me in the rain. Gradually, however, he developed a Star Personality which made him harder and harder to approach.

85 Margot Fonteyn, British dancer, and Rudolf Nureyev at the Rome Opera House, 1964.

I first photographed Nureyev when he had just been granted political asylum in the West. Now, become a star, he was much more petulant and difficult. He refused to grant me permission to photograph him. My old friend, Dame Margot Fonteyn, seeing I was utterly destroyed, prevailed upon him, and announcing he would grant me three seconds – he counted them out – struck a pouting affected pose and on the count of three pirouetted off.
 To console me, Margot stayed on to be photographed, and they both later autographed a set of prints to me. These

were eventually borrowed and 'lost' – retained under dubious circumstances by someone at Cinecitta. Altogether, a jinxed session.

86 Robert Helpmann, British dancer, choreographer, actor and director, at his London studio, 1961.

87 Anton Dolin, Russian dancer, choreographer and the first artistic director of the London Festival Ballet, photographed during a visit to Tiber Terrace, Rome, 1978.

88 John Butler, American dancer and choreographer, at Tiber Terrace, Rome, 1961.

John always turned up at the right place at the right time with the right dance – New York, Athens, Spoleto, and on my terrace in Rome. He is totally photogenic and fell in love with my camera and I photographed him everywhere.
 Perhaps my best-known shot of him was taken in an abandoned church in Spoleto. He posed with a tatty workmen's curtain, turning it into magic, and this photograph was used as the poster for the 1964 Festival.

89 Geoffrey Holder, Anglo-American dancer and choreographer, posing in front of a photograph at Roloff's 'A Visual Odyssey: 1958–1968', an exhibition held at New York's Gallery of Modern Art in the Huntington Hartford Museum, 1968.

90 Leonard Cohen, Canadian singer, author and poet, Toronto, 1975.

Leonard dropped by for a chat in Toronto while I was on a visit to my publishers and later turned up at Tiber Terrace and managed to seduce my female staff. He is perhaps the most masculine yet gentle person I have ever known.

91 Glenn Gould, Canadian pianist, Toronto, 1959.

Shy, complex and a brilliant pianist, Glenn Gould uses his eccentricities to mask his solitude. He seems the archetype of the performer who struggles to achieve a private revelation in public.

92 Renata Tebaldi, Italian soprano, at Roloff's New York studio, 1963.

I photographed Renata Tebaldi in my brownstone home and studio. She arrived with an entourage that included a make-up lady, a dresser and a hair stylist. The resulting photograph is perhaps the most posed and planned I ever did. But her warm Italian soul overcame any hint of pretence and radiated through the house.

93 Leontyne Price, American soprano, visiting Tiber Terrace, Rome, 1961.

Then – bliss – there was Leontyne Price, met in Spoleto, photographed at Tiber Terrace. The soul of friendliness, she invited me to come with her to Salzburg, and I went on a veritable Price binge. Unlike many of the great I photographed, she not only ordered prints from me – but also paid for them!

94 William Walton, British composer and conductor, with his wife, Susannah, photographed at their villa on the Italian Island of Ischia in the early seventies.

95 Virgil Thomson, American composer and music critic, taking a break from his duties among the ruins at the Athens Festival, 1961.

At the Athens Festival I met up again with friends from Hydra, who had not seen me since I'd turned jaundice-yellow, and were pleased to find me still alive. The Festival drew many gifted artists and performers and among them was the American composer, Virgil Thomson, clambering over the ruins of the ancient theatre.

Fashion
and Society

'A DREADFUL SNOB, NOTORIOUS NAME-DROPPER, WOULD prostrate himself at the drop of a tiara.' All comments made by Roloff's friends, with which he would no doubt have cheerfully agreed. From a young age, Roloff sensed how to weave together his art and photography with the world of society and hierarchy that mattered so much to him.

On his first trip to Venice in 1948, he met Peggy Guggenheim, the legendary American art collector, and established a friendship that lasted for more than thirty years. They travelled to Greece and India together and Peggy was a frequent guest at Tiber Terrace, while Roloff spent many autumns relaxing in her Venetian palazzo.

In the early fifties, Roloff explored Parisian society, which he adored.

Post-war joie de vivre *and social climbing were at their most feverish. It was compulsive. I, too, was determined to meet the glittering hierarchy of intellect, art, poetry, fashion, theatre and nobility. Of course, I had disappointments – there were salons I didn't manage to penetrate, but I tried hard and generally succeeded. I was becoming the Elsa Maxwell from Medicine Hat!*

Clothes fascinated Roloff and I remember bringing him bolts of brightly coloured Delhi velvet and silk which he would have stitched into flowing kaftans and sculptured dinner jackets. Chanel, Rubinstein, Schiaparelli and the American fashion critic, Diana Vreeland, were sought out by Roloff, who delighted in their charm, wit and talent.

Roloff loved being invited out and was generally good value, but he also demanded centre stage. It's hard to forget one evening in Tehran when Roloff had been invited by a dedicated Iranian doctor and his wife to show slides of his recent trip to the remote southern regions of the country. A local photographer insisted on loudly voicing his critical comments throughout the show, and I noticed Roloff heading for a nearby wall. Through years of travelling together, I instantly recognized the signs and rushed over to him, but was too late, as he slowly slid down the wall into a dead faint. James George, the Canadian ambassador, and Roloff's publisher, Jack McClelland, who had just flown in from Toronto for negotiations with the government, rushed over. Our host checked all his vital signs, and looking up at the circle of anxious faces, reported that everything seemed fine. Roloff bolted upright, opened his eyes wide and exclaimed, 'I am *not* fine!', and fainted back again.

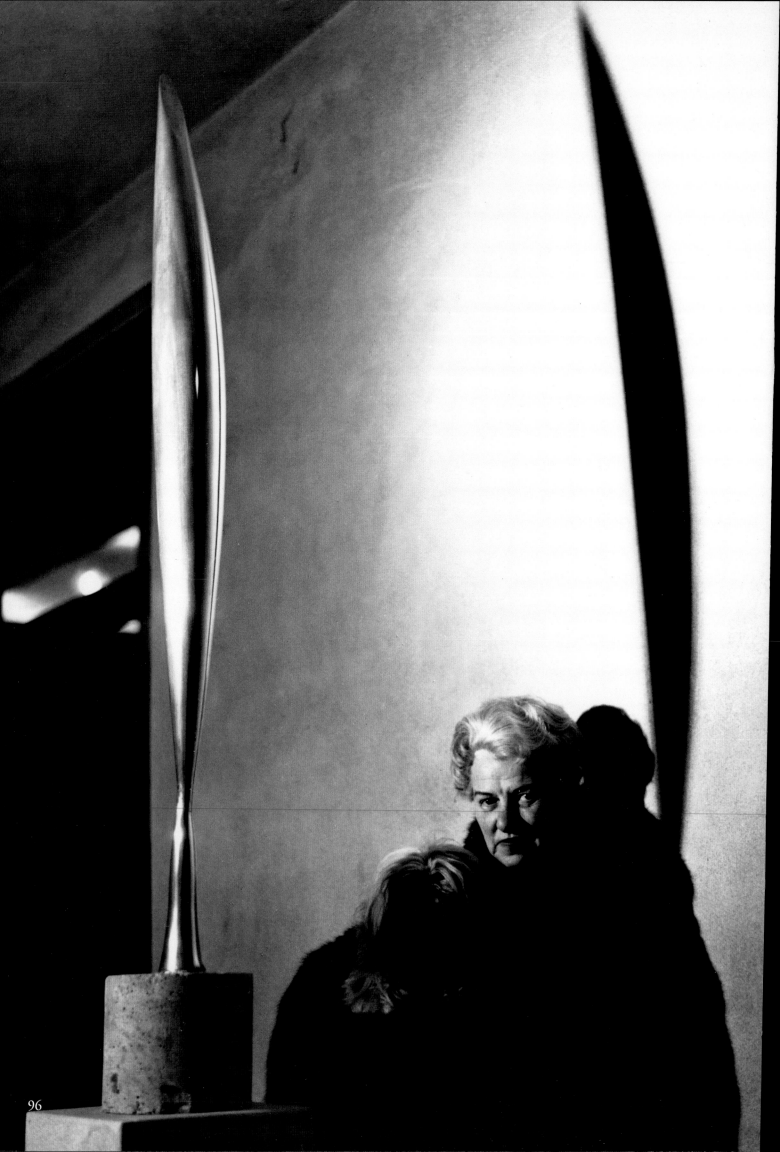

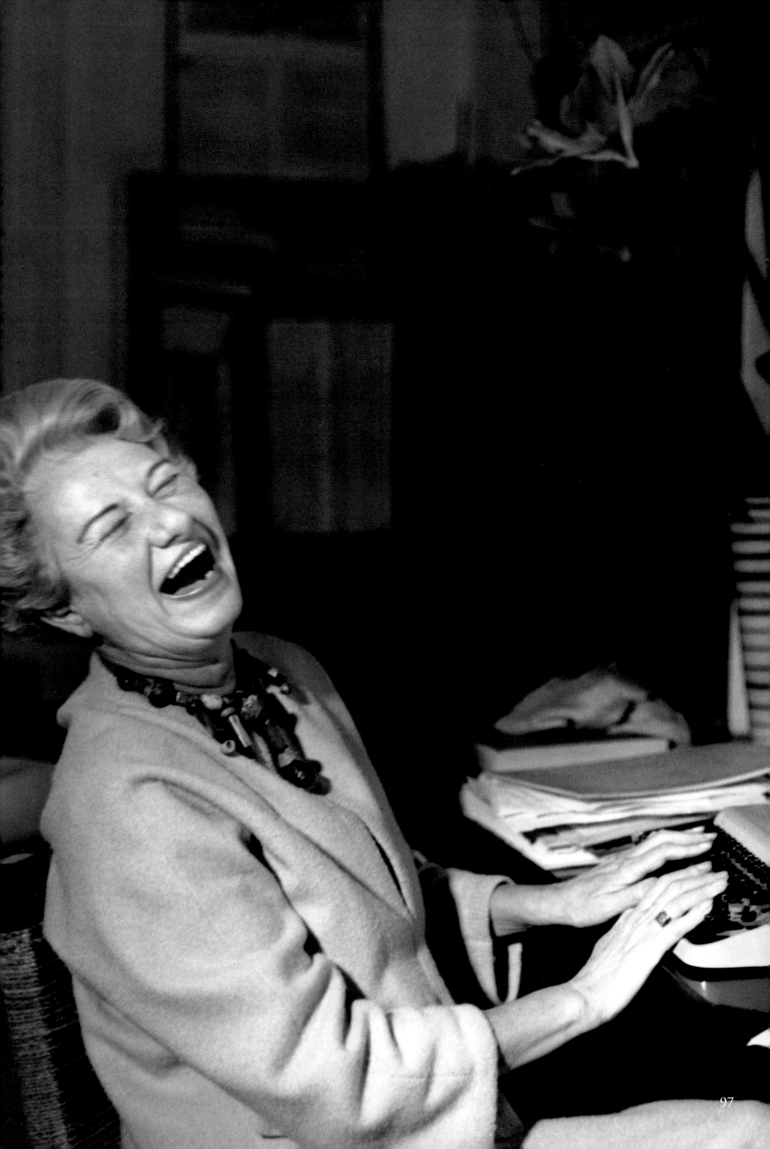

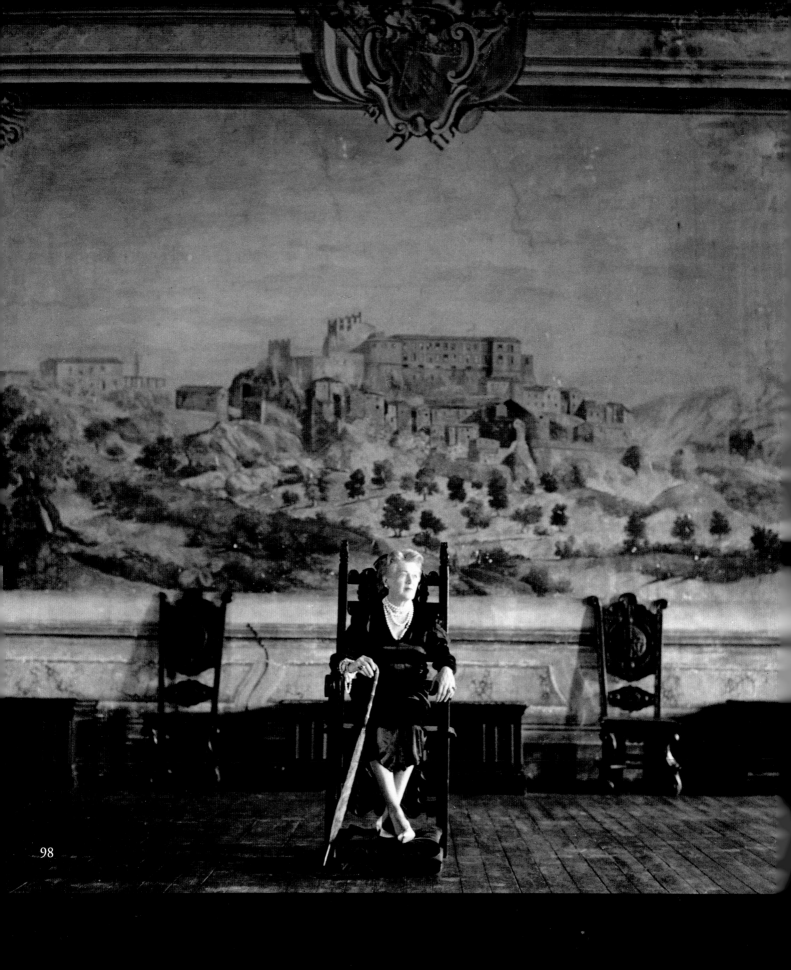

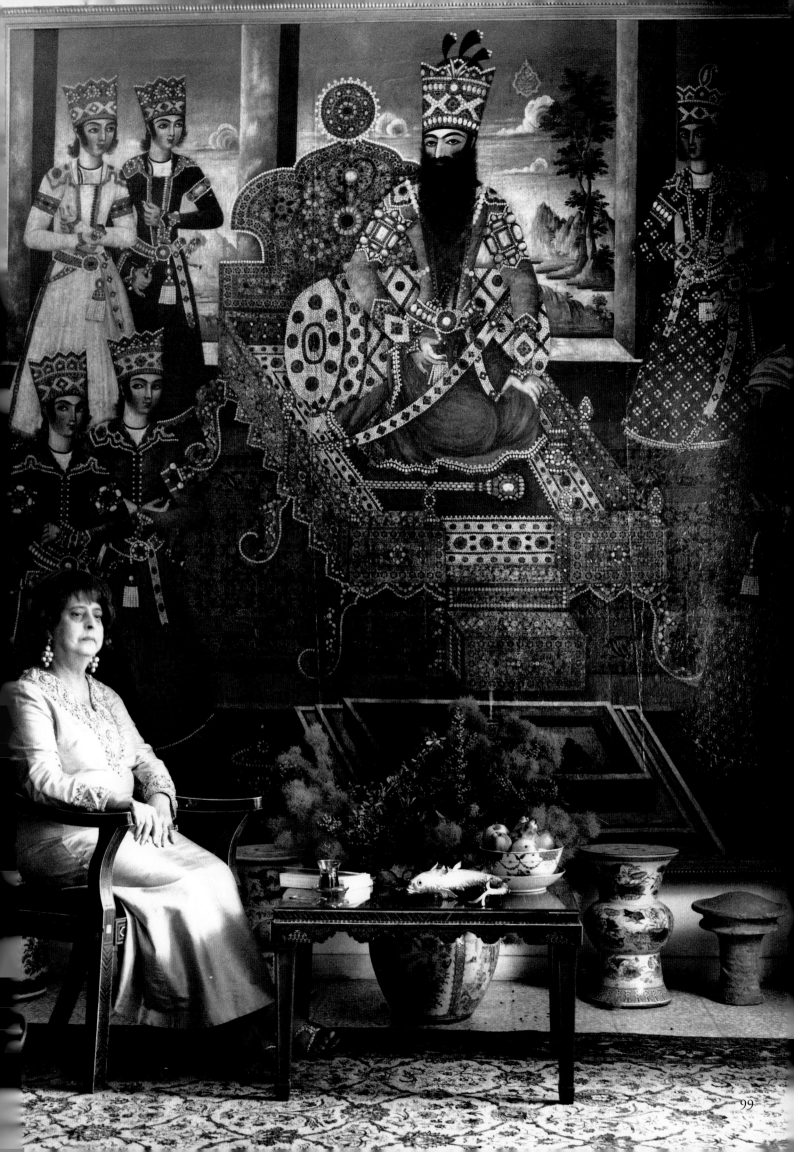

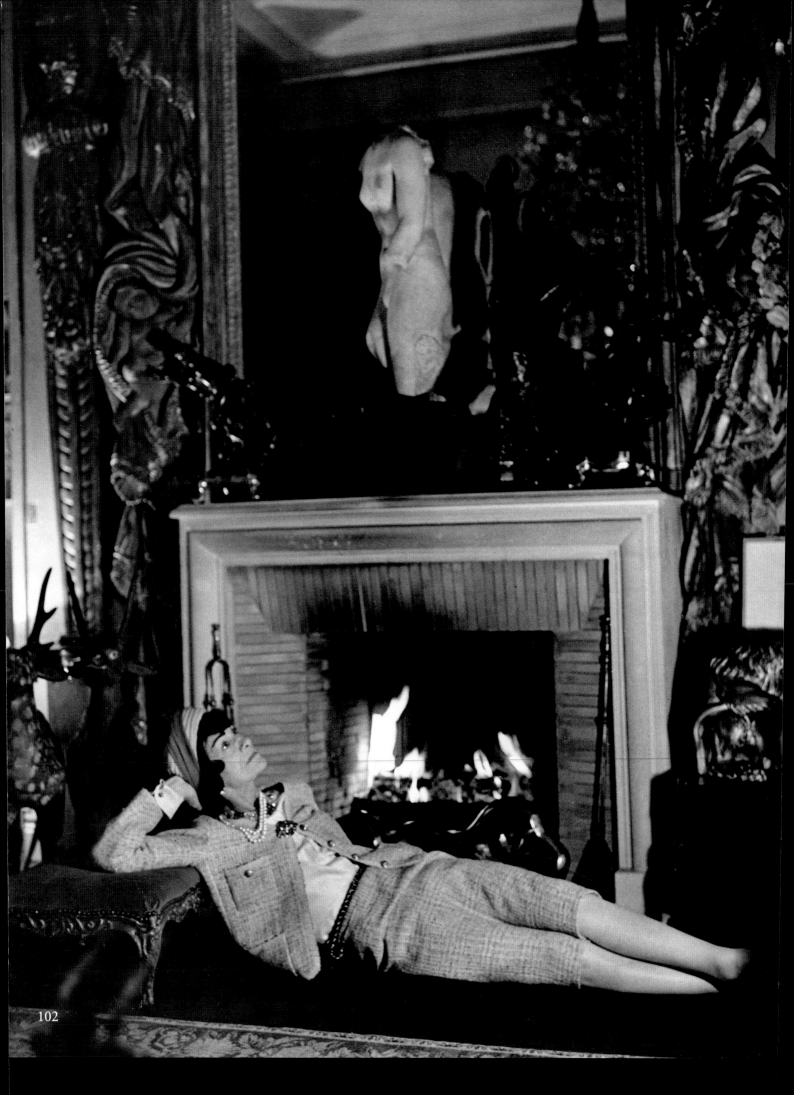

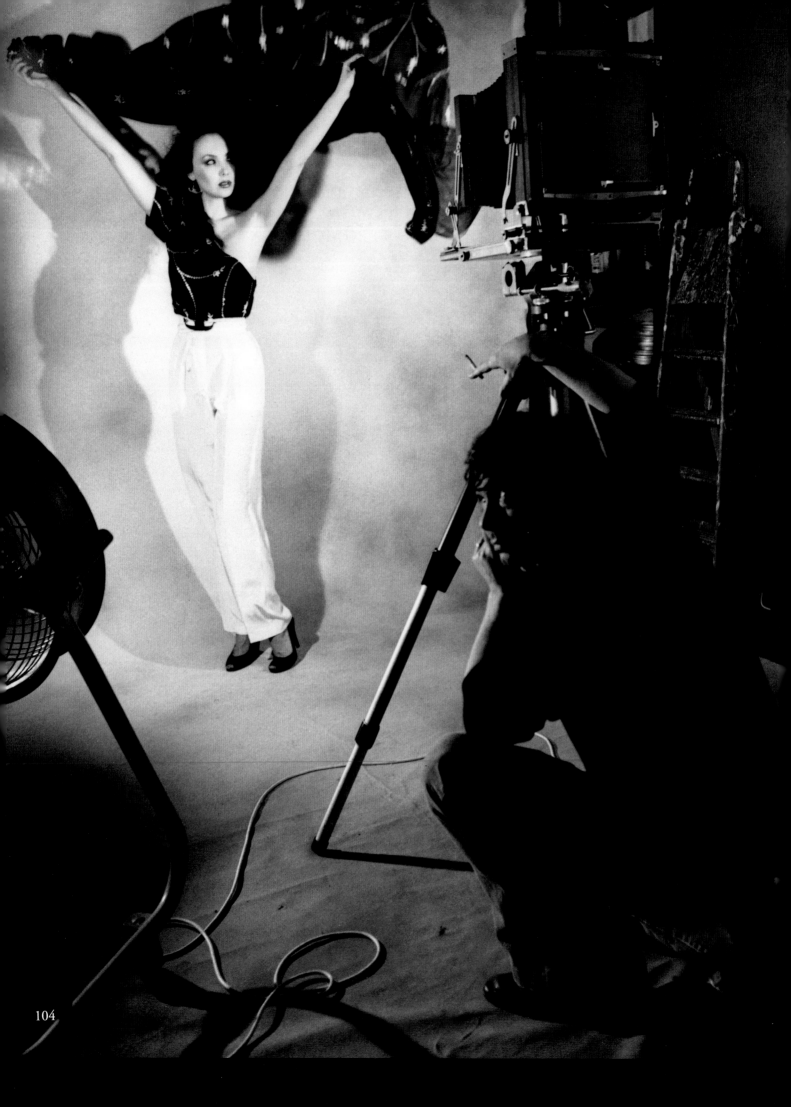

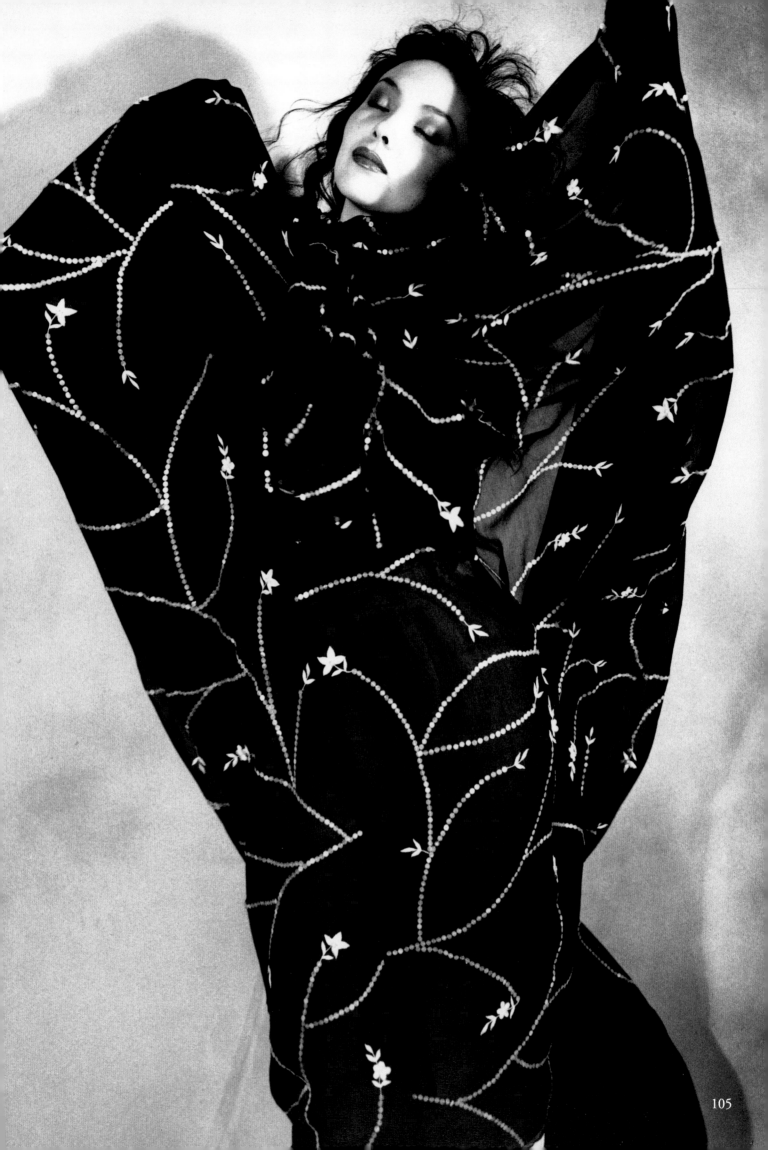

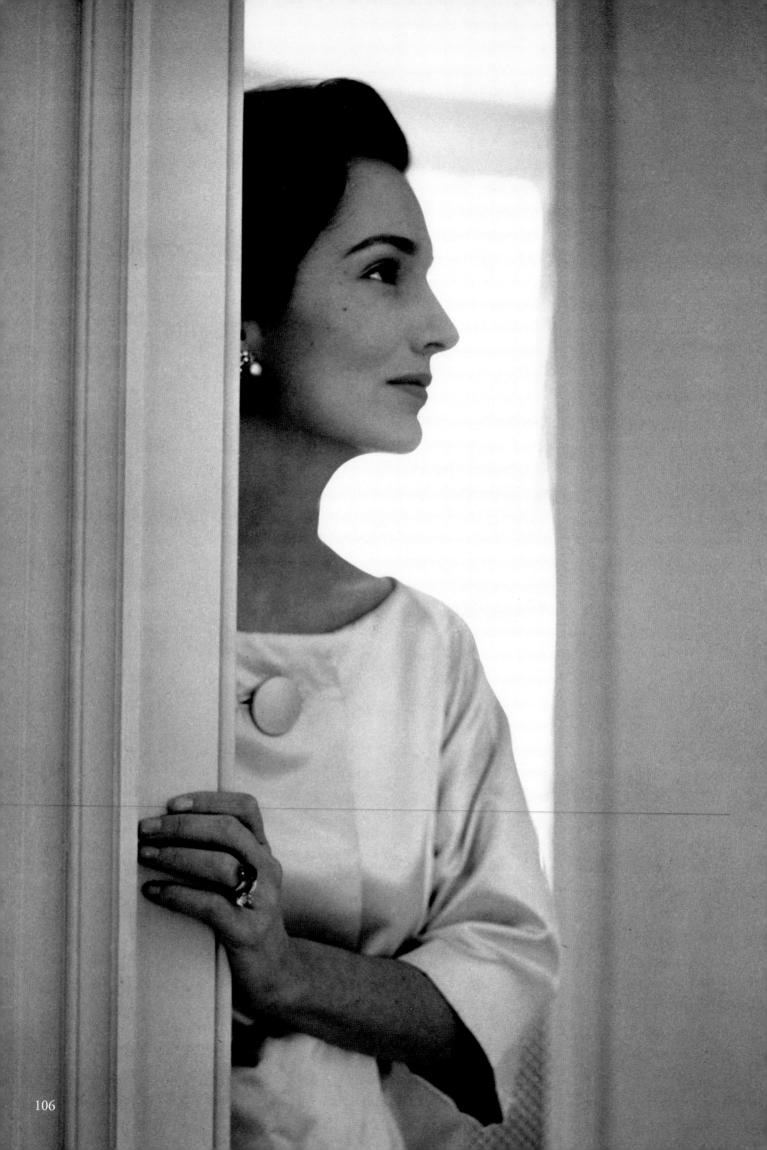

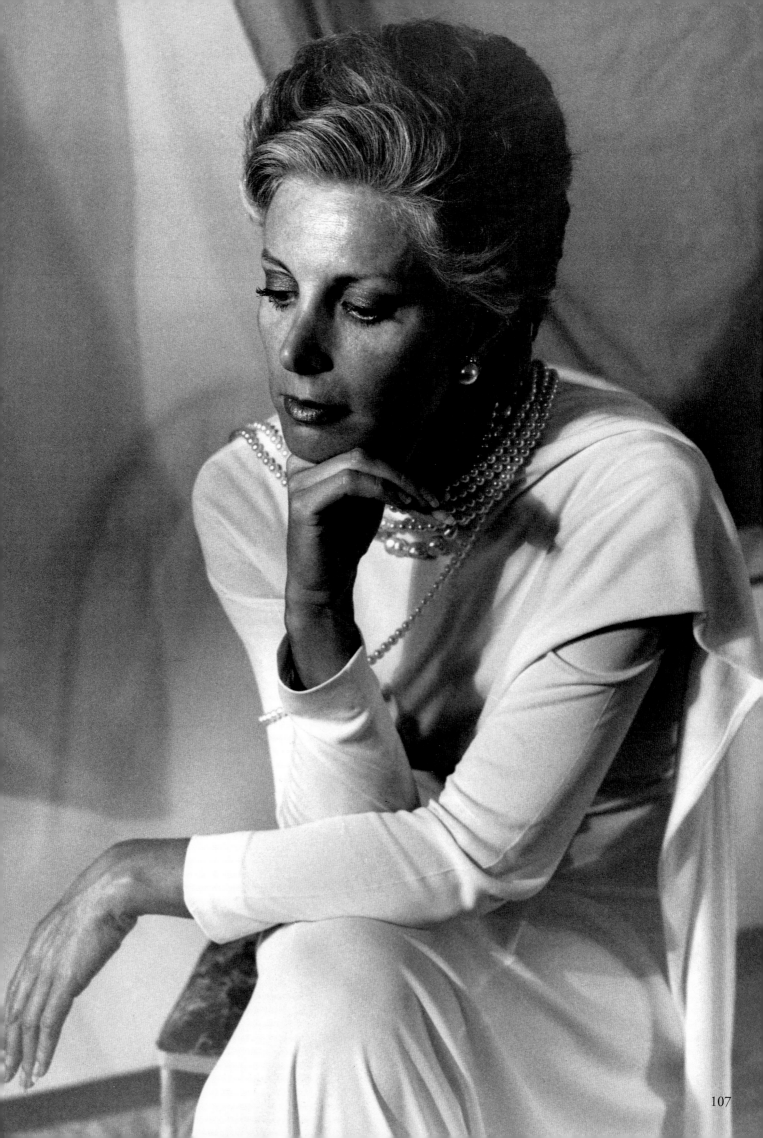

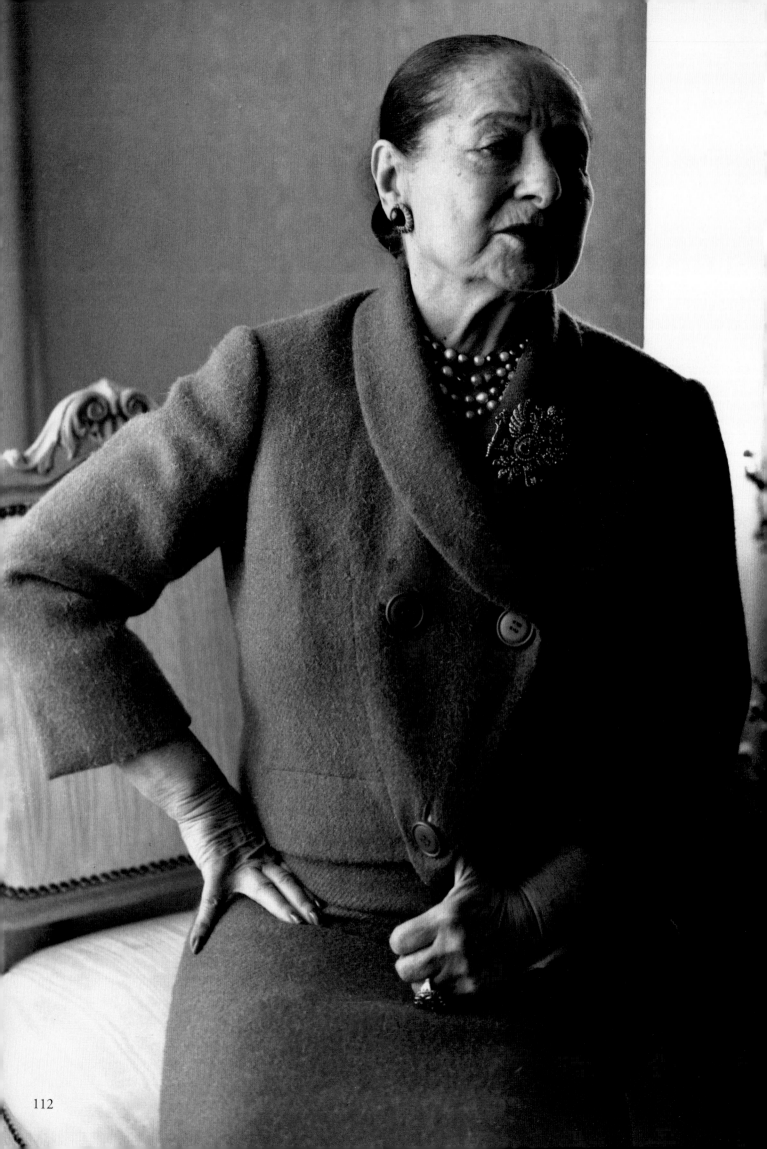

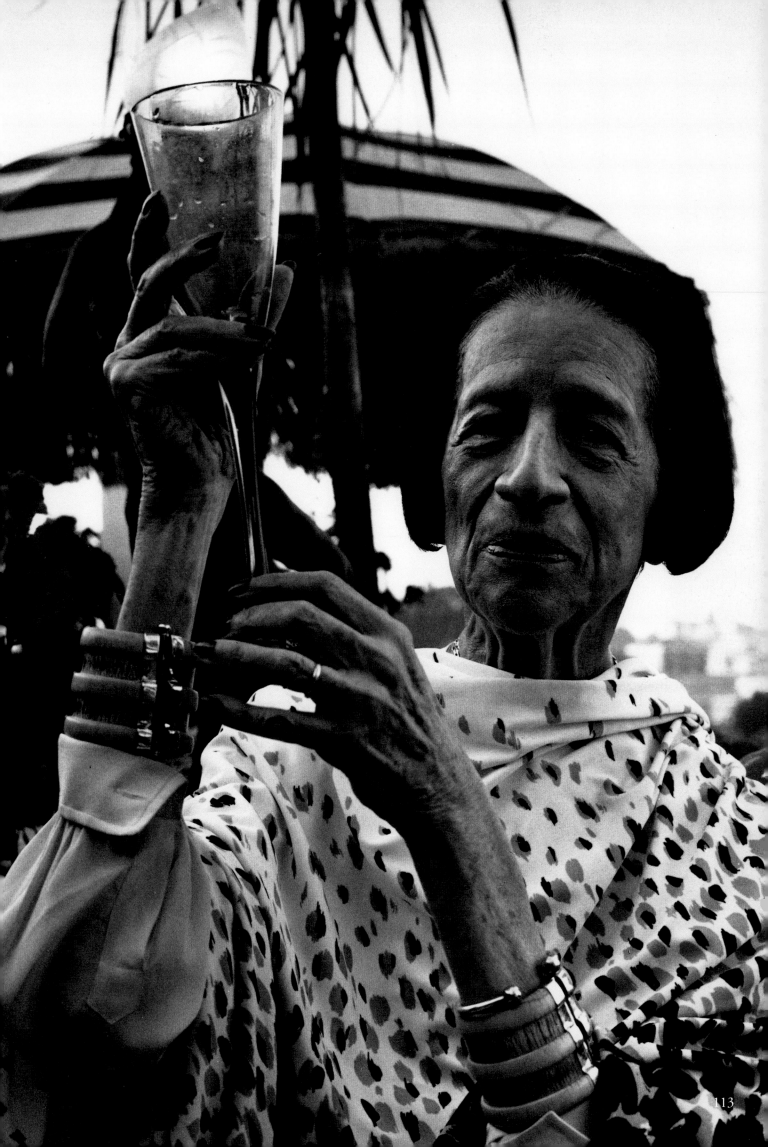

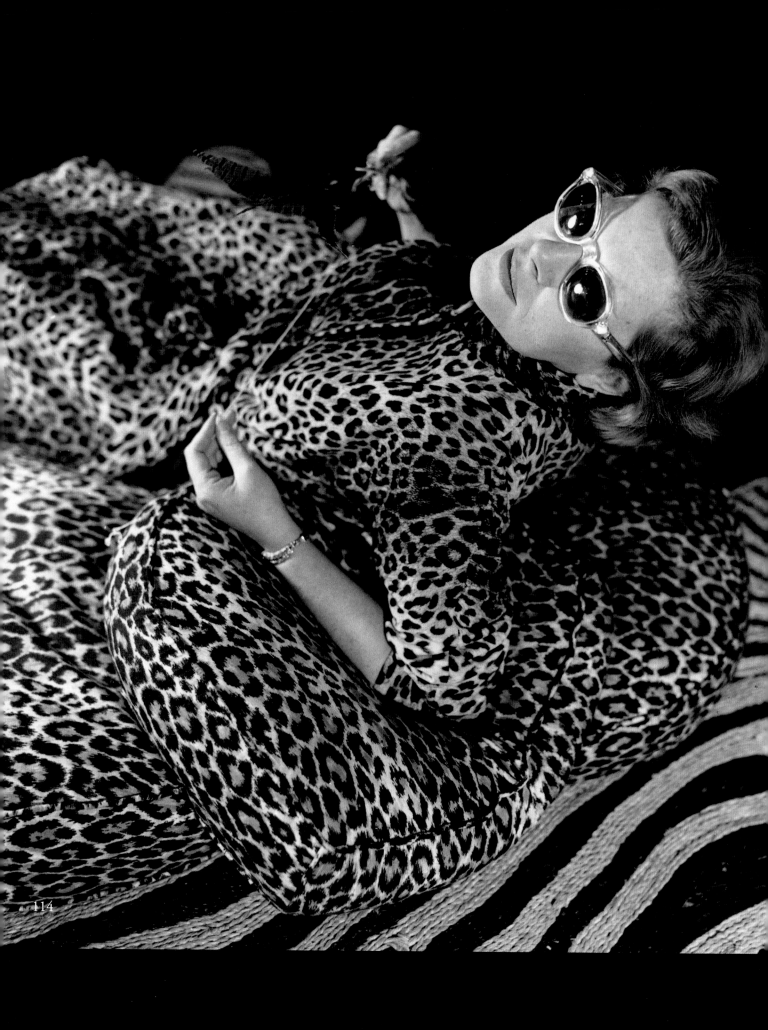

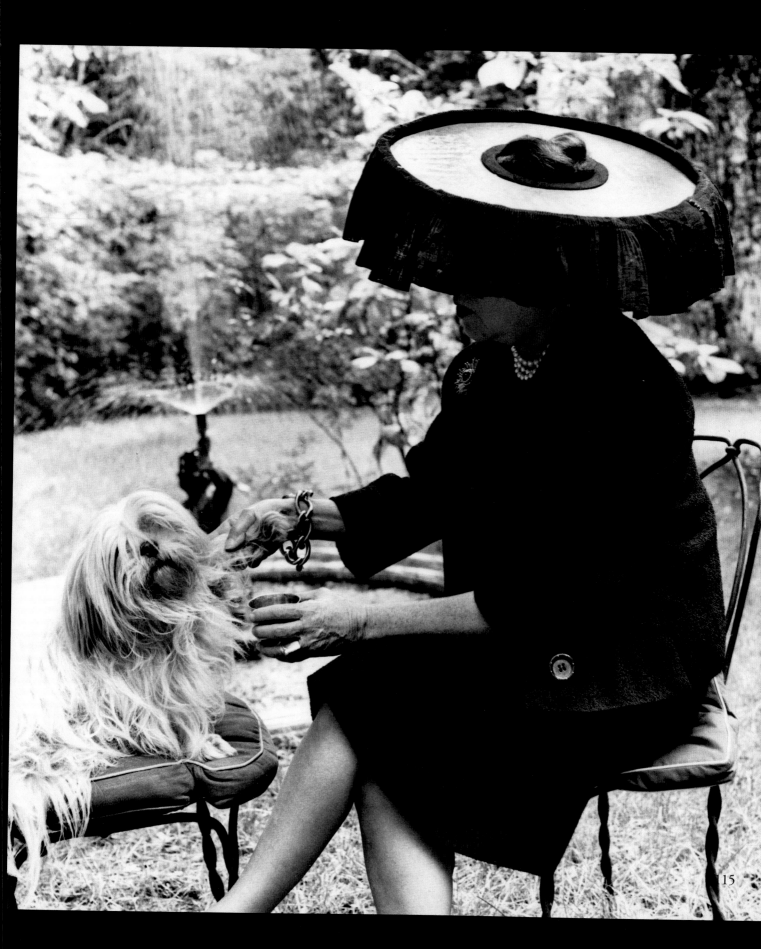

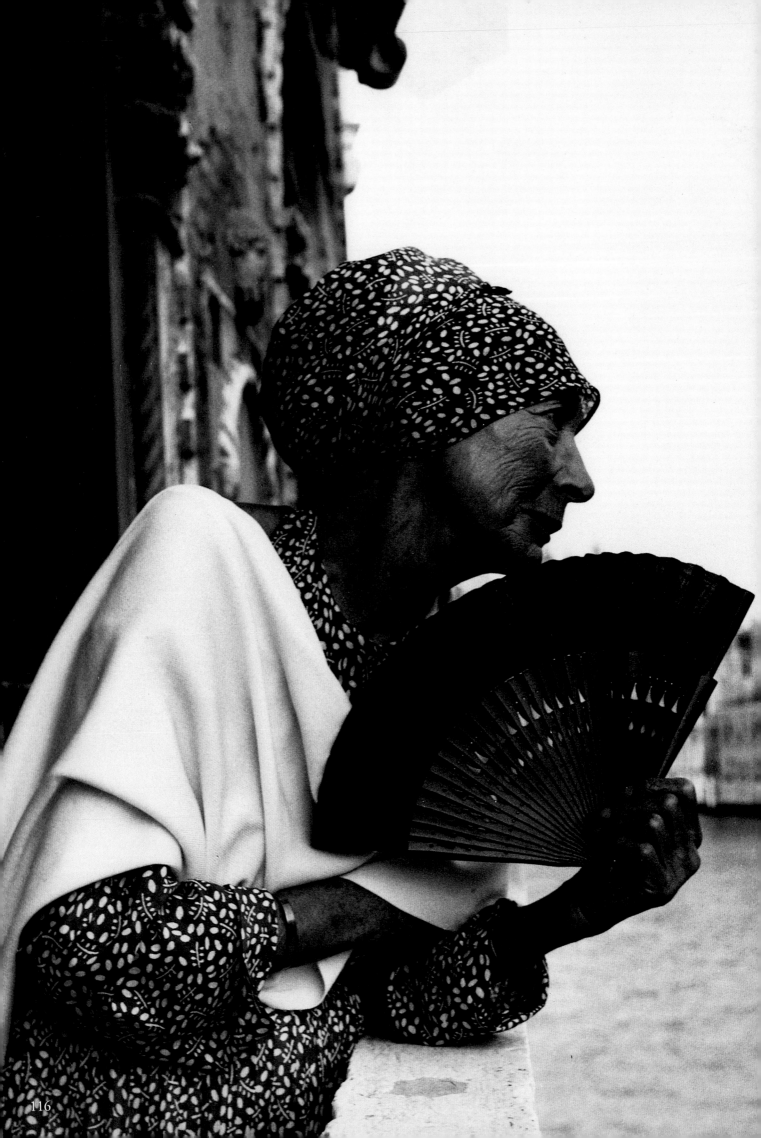

117

96 Peggy Guggenheim, American art collector and a close friend of Roloff, at home in Venice in the sixties.

Peggy was a maverick who collected the people and works of art she liked, and who always remained young and independent. After the war, she set up house, and made her museum, in the Palazzo Venier dei Leoni, on the Grand Canal in Venice. I turned up on her doorstep, unannounced and dripping wet, one rainy winter day in 1948. … We went to dinner, talked all night and I ended up ecstatic, drunk, peeing and throwing violets from a balcony into the Grand Canal. From that moment, we were life-long friends.

In this photograph, Peggy looks austere, next to the sharp blade of her Brancusi, Bird in Space.

97 Peggy Guggenheim at her typewriter in her study at Palazzo Venier dei Leoni, Venice, in the fifties.

For many years I spent each September at Peggy's in Venice, and she often stayed with me at Tiber Terrace in Rome. As the last unofficial 'Dogeressa' of Venice, Peggy had one of the few remaining private gondolas in the city.

98 Caresse Crosby, American heiress and socialite, in the grand ballroom of Castle Rocca Sinibalda, Italy, 1961.

Caresse set up her little kingdom of artists, writers and friends at Rocca Sinibalda, near Spoleto, in 1960. … She declared her little principality a seat of the World Citizen Movement – its flags flew from the battlements – open to artists, film-makers, writers … and at least one photographer! Peggy penning memoirs, Elsa Schiaparelli painting in watercolours, American Robert Mann composing symphonies or replacing bricks and Beatnik poet, Gregory Corso, who woke us up for breakfast with his revolver – one never knew what to expect at Rocca Sinibalda weekends – except that Caresse would be the perfect hostess, patroness and delightful companion.

99 Princess Safieh Firouz, Persian aristocrat and grand hostess, at home in Tehran in front of a family portrait of the Qajar king, Fath Ali Shah, 1975.

Some may be more 'at home' with their pasts, reflections of their travels gathered about them, others with the tangible past, the best that money can buy in the form of paintings, sculptures, carpets, objets d'art *or simply jades or ivories. Others feel more at home surrounded by family trappings like English lords in their country seats or town houses hung with galleries of ancestors, or in the home of a Persian princess, Safieh Khanum, renowned for her exquisite evocation of the period of her family's Qajar ancestors, the Shahs preceding the Pahlavi Dynasty – now, too, a collector's item.*

100 Arianna Stassinopoulos, Greek writer and socialite, in her New York penthouse in the early eighties.

The author of my thirteenth book, The Gods of Greece, *was Arianna Stassinopoulos, beautiful jet-setter and author of a highly regarded biography of Maria Callas.*

I arrived in New York for a working session on the book and was immediately told, 'First, we'll have dinner, then work.' So who should turn up for our 'working dinner'? Terence Stamp, for one. Then Luciana Pignatelli. Then Lord Weidenfeld (our publisher). Finally Marion Javits, who 'told all' about the scandal over her PR work for Iran Air.

It was a splendid evening, and Arianna was a flawless hostess. But we didn't get a lick of work done till next morning over a 'working breakfast'.

101 Sarah Churchill, British actress, author and poetess, on the Appia Antica at the home of one of Roloff's close friends, Peggy Donnelly, 1975.

102–103 Coco Chanel, French fashion designer, at home in Paris, 1959.

Coco was a timeless, witty and arrogant Frenchwoman. When I objected to jewels on tweed, she replied, 'This is real elegance.' She lay down in front of her fireplace, slit open her skirt and said, 'Voilà!'

104 David Bailey while photographing model, Marie Helvin, at his London studio, 1979.

I knew David at the Vogue *offices for some years. His studio outside London is like a vast Piranesi rabbit warren, busy with the comings and goings of his eight acolytes. … He uses a monstrous camera, like a throwback to the Classical era of photography. In fact – unlike me – David is something of a camera bug.*

105 Marie Helvin, British model, photographed by Roloff at the studio of photographer, David Bailey, during a fashion shoot, London, 1979.

106 Princess Lee Radziwill, American socialite, at home in London, 1959.

I attended a charity ball at the Savoy one night, and, as usual, was studying faces when I noticed one of the most beautiful I'd ever seen. … Sometime during the course of the evening I discovered her name: Princess Lee Radziwill, born Caroline Lee Bouvier. I asked to photograph her and finally won consent much, much later. …

The session was held in Prince Stanislas' home at Buckingham Gate. 'You know,' Lee said afterwards, 'you really ought to go to Washington and "do" my sister, Jackie,

and her husband, the young senator from Massachusetts. I believe he's really going places.' Ah, if only I'd paid attention.

107 Princess Luciana Pignatelli, Italian author and fashion consultant, Tiber Terrace, Rome, in the mid-seventies.

108 Elsa Maxwell, American socialite and hostess on holiday in Venice, 1959.

I first met Elsa Maxwell at the new-born Festival of The Two Worlds at Spoleto. Later, in Venice, I photographed her at the Hotel Danieli and so am able to recount some choice Maxwellisms:

EM (on being witty): It's very difficult to be witty not at the expense of others; humour and wit are two different things, wide apart. Larry Olivier, for instance, is full of humour, but he's not witty. The Duchess of Windsor is not exactly witty; she's a wisecracker. Now, David Niven is a witty man.

RB: Who make the best friends, the English?

EM: The Greeks and the Spanish! The English have good-looking men and charming women. The French cultivate unfriendship! They have the art of conversation, of controversy.

EM (on songwriting): I've been writing songs since the age of four – was a songwriter before Noel Coward. We are great friends. I knew him when he was poor, going back and forth from a poor section of London. We met at a country house, and I discovered he had never been abroad. I said I was going to France and would take him. 'You must be very rich', he said. I answered, 'No, I am poor. The rich aren't generous, the poor are!'

EM (on social obligations): 'If you owe people a dinner, send it to them by room service!'

109 Louise de Vilmorin, French author, socialite and the last companion of André Malraux, Paris in the fifties.

110 Ada Smith Duconge, American celebrity and club owner, Rome, 1960.

Madame Ada Smith Duconge – Scott Fitzgerald called her 'Bricktop', and Cole Porter wrote a song for her, 'Miss Otis Regrets', which made them both famous. Usually to be found swathed in mink and leaning on the bar of her Roman nightclub on the Via Veneto, Bricktop is photographed here in her Roman penthouse, against a background of icons. She was a very religious woman and the benefactress of many orphanages.

111 Gregory Corso, American poet, in the gardens of Castle Rocca Sinibalda, Italy, a house guest of Caresse Crosby in the early sixties.

Gregory Corso, the American Beat poet, liked to pose naked with a laurel crown as Bacchus. He woke us up each morning with a pistol shot. Once I spent a day and much of a night swinging on a 'dondola' while he explained to me how the real artist should live. It lasted until the moon went down. ... Gregory was eccentric and fond of violent gestures. I suppose Beat poets were supposed to be.

112 Helena Rubinstein, Italian fashion and cosmetics queen, Rome, 1958.

Primal vitality radiated out from her petite and aristocratic person, and you felt she could take command of anything.

113 Diana Vreeland, American fashion editor and special consultant to the Costume Institute of the Metropolitan Museum, New York, on a visit to Tiber Terrace, Rome, 1981.

No one has ever gone through my archive with more total absorption or undivided attention. ... Perhaps I've never received such a compliment. Of course, she knew everyone in the archive. 'But your portraits are different from anyone else's, Roloff. These are the famous without their masks!'
 Naturally, I felt no hesitation about asking her to join the archive. I found a huge length of lovely material and asked her to improvise a costume with it. She draped herself impeccably, and posed away happily and professionally.

114 Fleur Cowles, American author and socialite, at home in London, 1975.

115 Elsa Schiaparelli, Italian fashion designer, Paris in the early fifties.

From the window of my ramshackle and shady little mansion, I could spy on Elsa Schiaparelli's garden. When finally we met at the Vicomtesse Marie-Laure de Noailles' annual costume ball, I confessed my voyeurism and Madame Schiaparelli invited me over. Hidden under a Chinese coolie's hat, she served tea to her Lhasa terrier. She didn't follow, she set style.

116 Valentina (Nicholaevna Sanina Schlee), Russian-American designer, during her annual visit to the Gritti Palace Hotel in Venice in the seventies.

117 Niloufar Afshar, Persian aristocrat and a close friend of Roloff, photographed at Tiber Terrace, Rome, 1979.

Stage
and Cinema

ROLOFF, WITH HIS EXTRAVAGANT GESTURES AND FLAMBOYANT dress, was himself something of a showman – drawn naturally to the exciting world of Italian theatre and film.

Rome, noble, wild, languorous, was known as Hollywood-on-the-Tiber. It was also a provincial, parochial town where there were no secrets. Fellini's revolutionary film La Dolce Vita *appeared in 1960 and summed up a decade which I'd just lived through; in fact, probably half the cast had wandered through Tiber Terrace at one time or another. Aristocrats turned up on the sets at Cinecitta to play as extras in spectaculars like* Ben Hur, Cleopatra *and* The Bible, *milling amidst the rough-and-ready technicians and the muscle boys from Roman slums. Afterwards, everyone went off to a party, or a picnic, or danced all night. It was a society which was entranced by itself and which needed a set of mirrors to be sure it existed.*

In retrospect, a curious innocence hovered over the 'sweet life'. Late nights, abundant wine, dressing with flair. To be decadent in the style of Rome in the fifties, one must have been a child – a very spoiled child, precocious and naughty, but above all, charming. Otherwise, one would not be invited anywhere.

Roloff's strong portraits of the great Italian directors, Federico Fellini and Pier Paolo Pasolini, are some of his finest works as is the relaxed image of Marcello Mastroianni between takes. International stars flocked to Rome for holidays, as well as work, and Jean Marais, Noel Coward, Luise Rainer and Robert Morley, among others, made a point of dropping by Tiber Terrace for a glass of wine and a chat.

Hermione Baddeley, the British actress and comedienne, introduced Roloff to many leading figures of the stage and cinema in Hollywood, New York and London. Roloff, always an avid theatre-goer, especially enjoyed sneaking backstage after a performance when Margaret Rutherford, Paul Scofield, or Laurence Olivier were unwinding.

Throughout her life, Roloff maintained a deep and profound attachment to the beautiful British actress, Vivien Leigh, always mentioning her in hushed tones of awed adoration. For it appears that, just as Cecil Beaton experienced Garbo, Roloff – as he once reminisced – also came for one brief glimmering evening 'too near the Scarlett flame'.

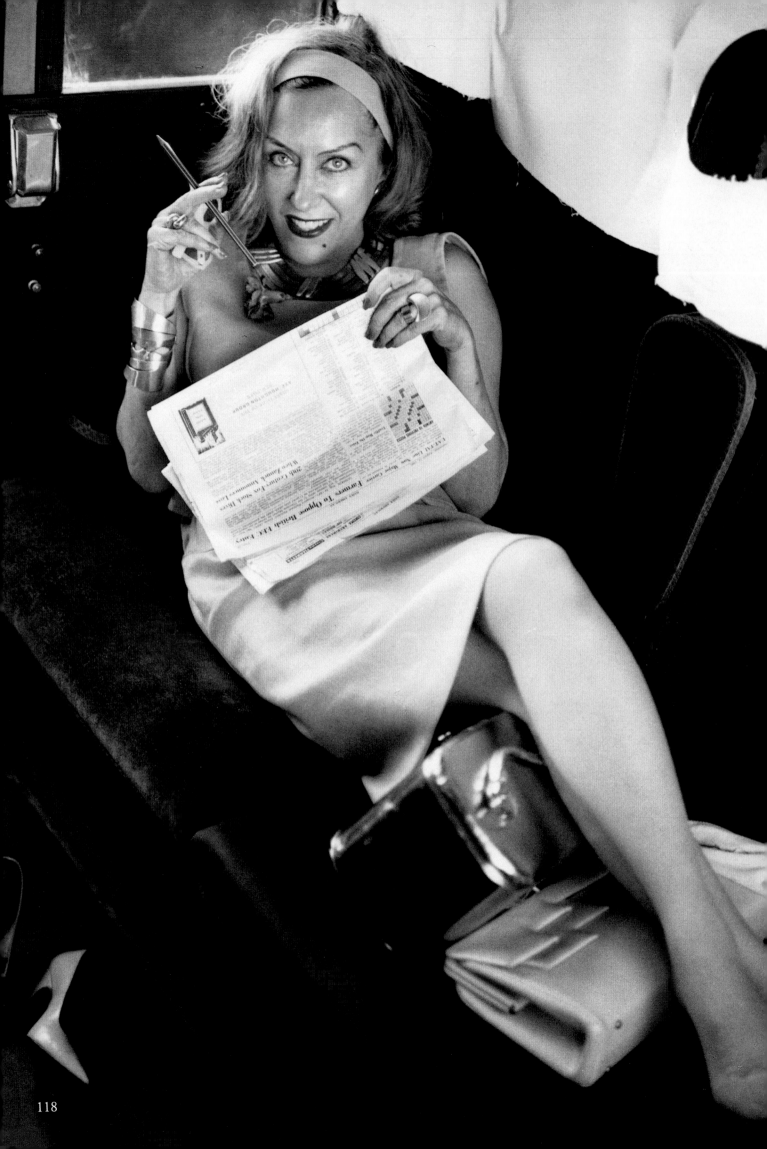

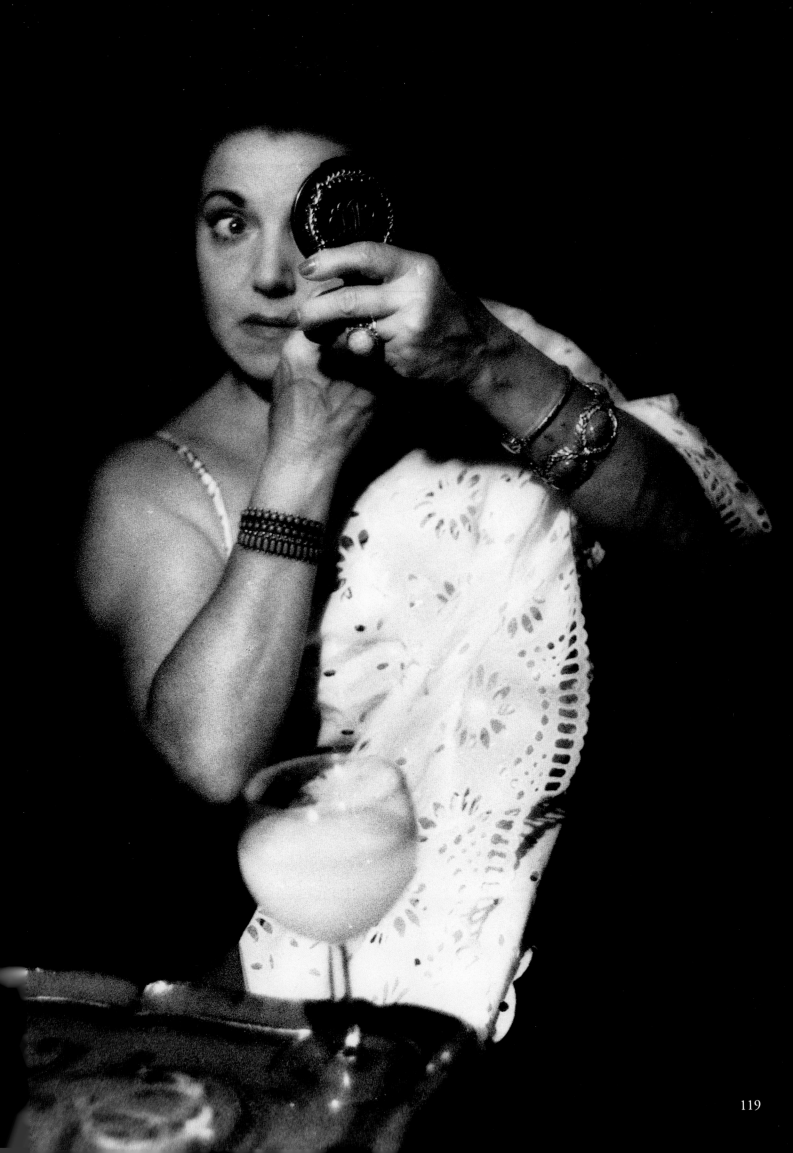

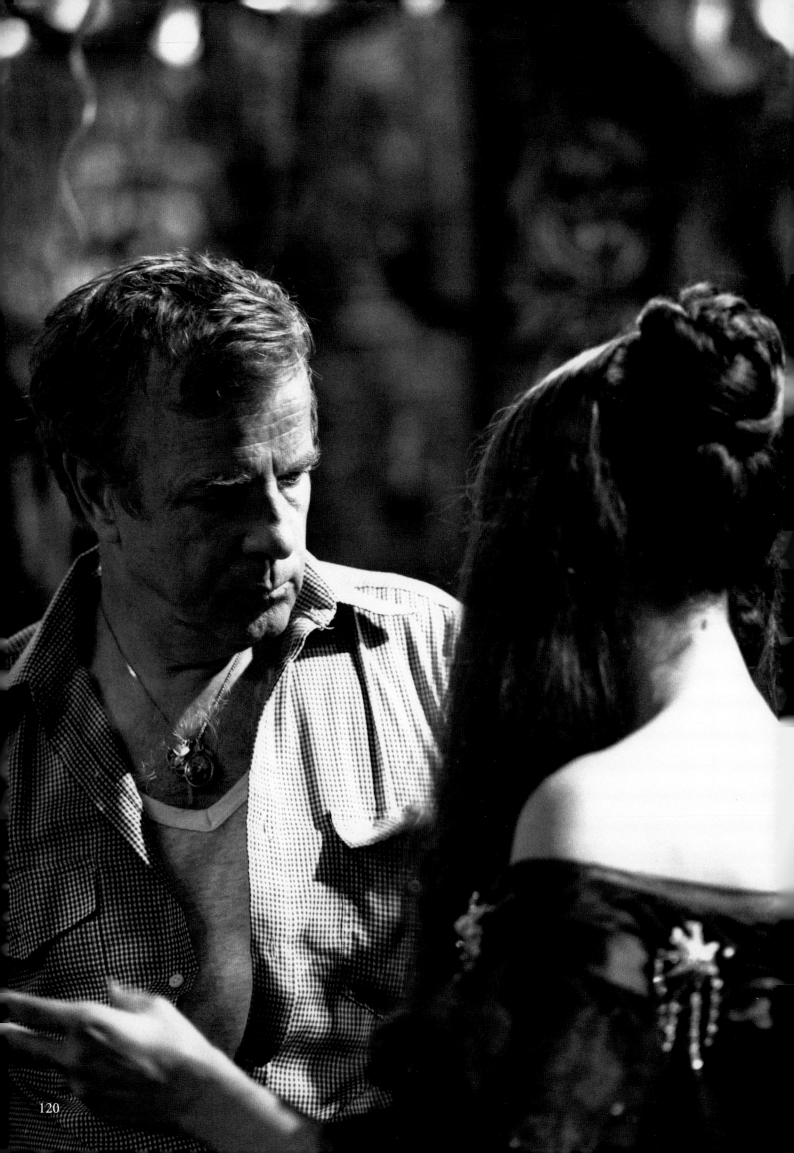

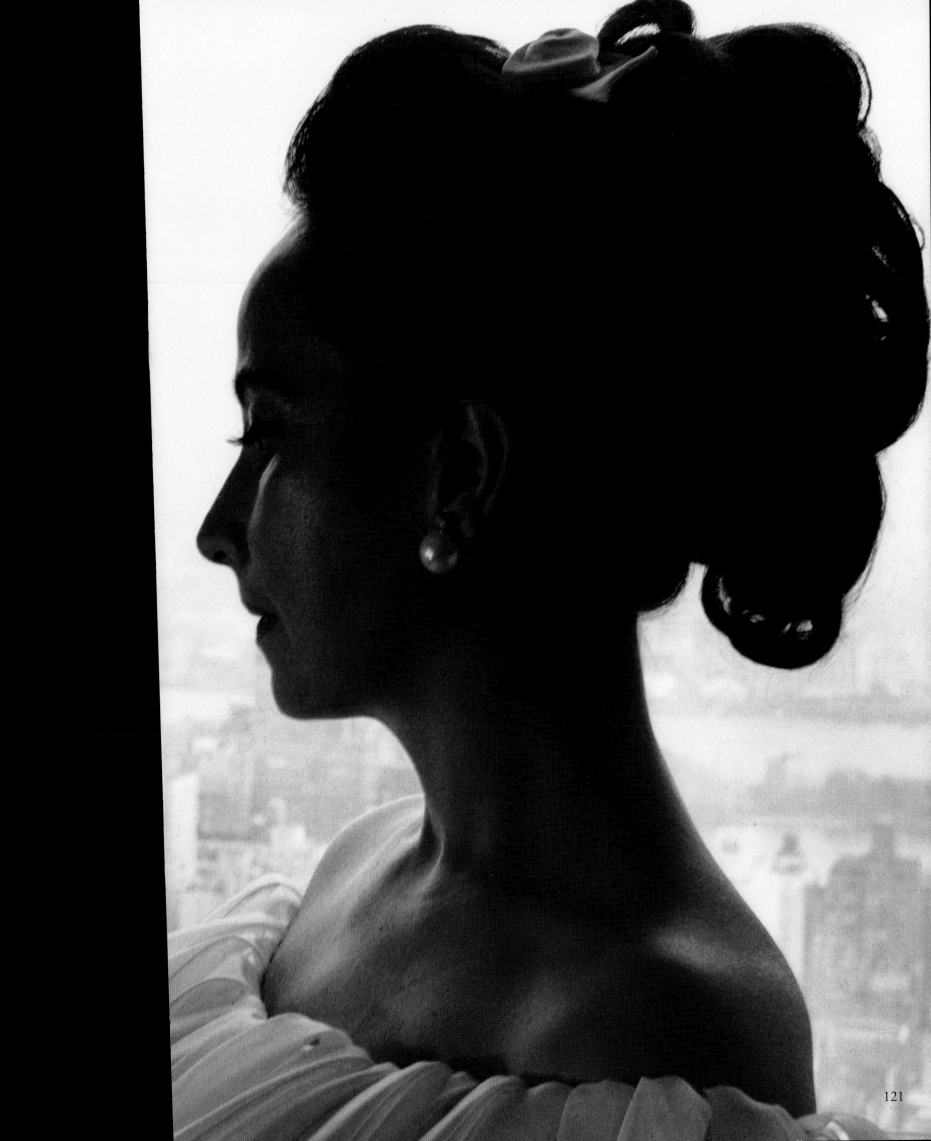

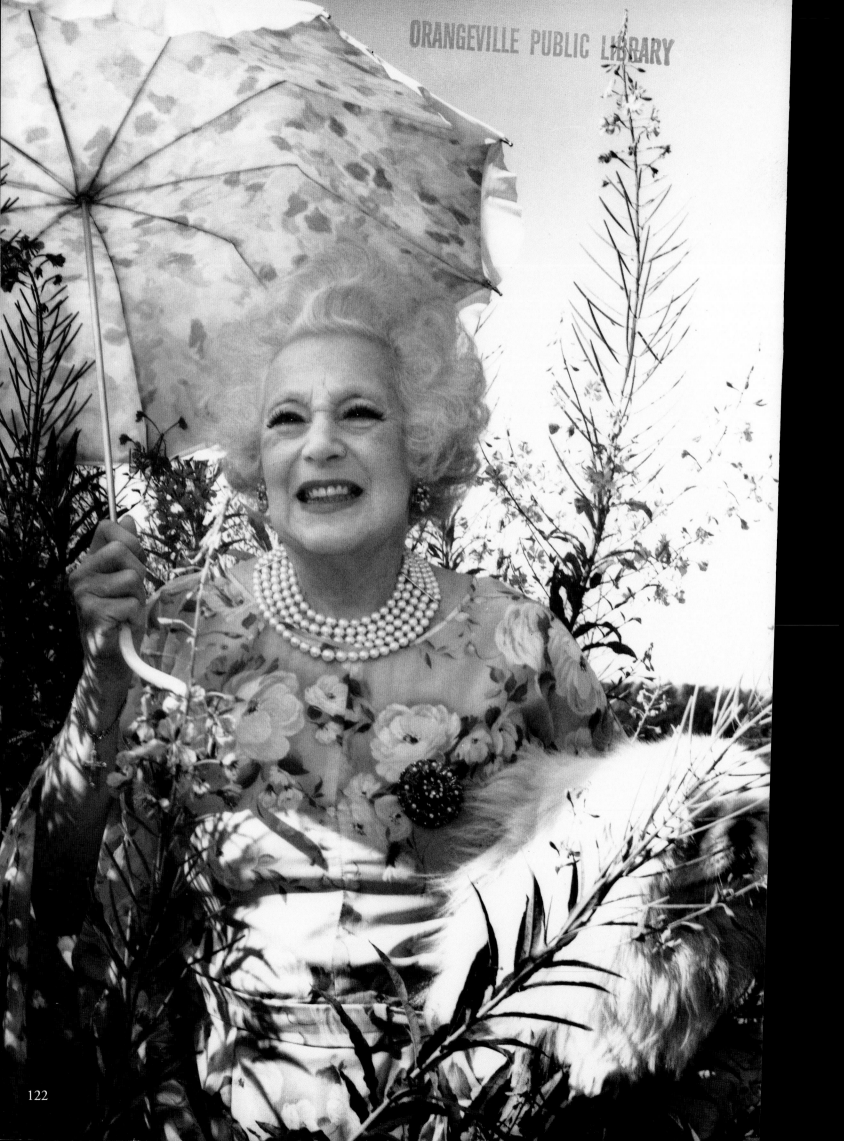

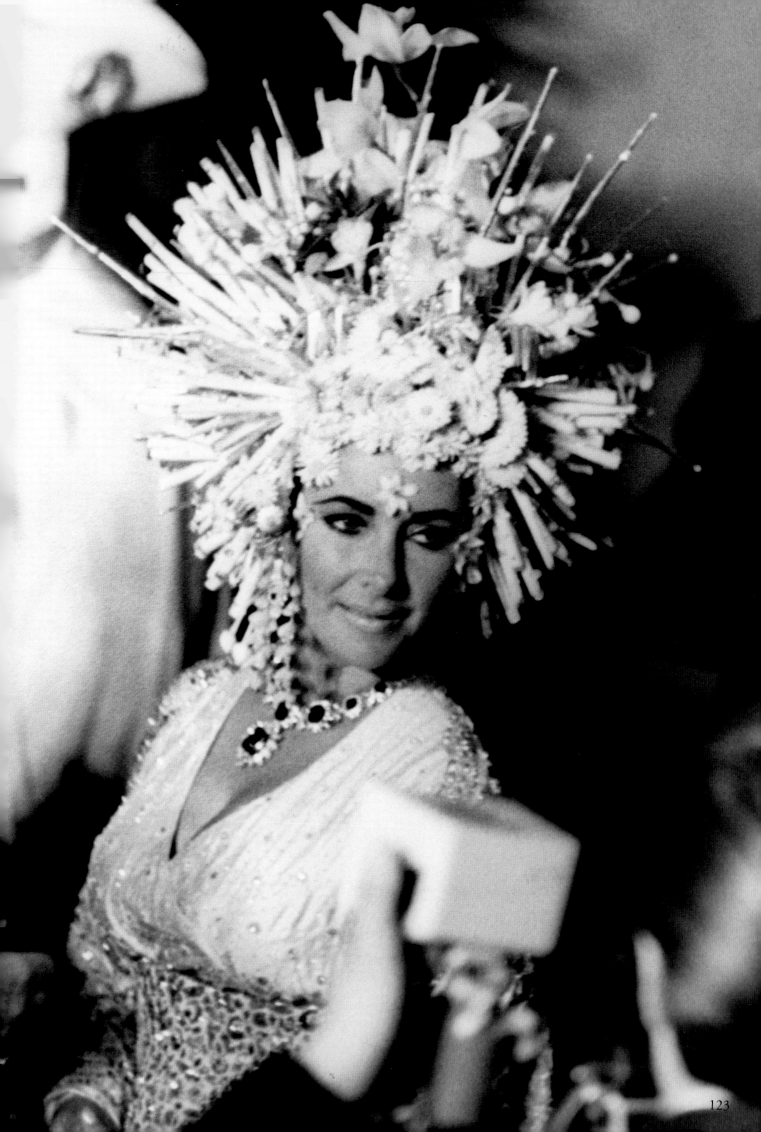

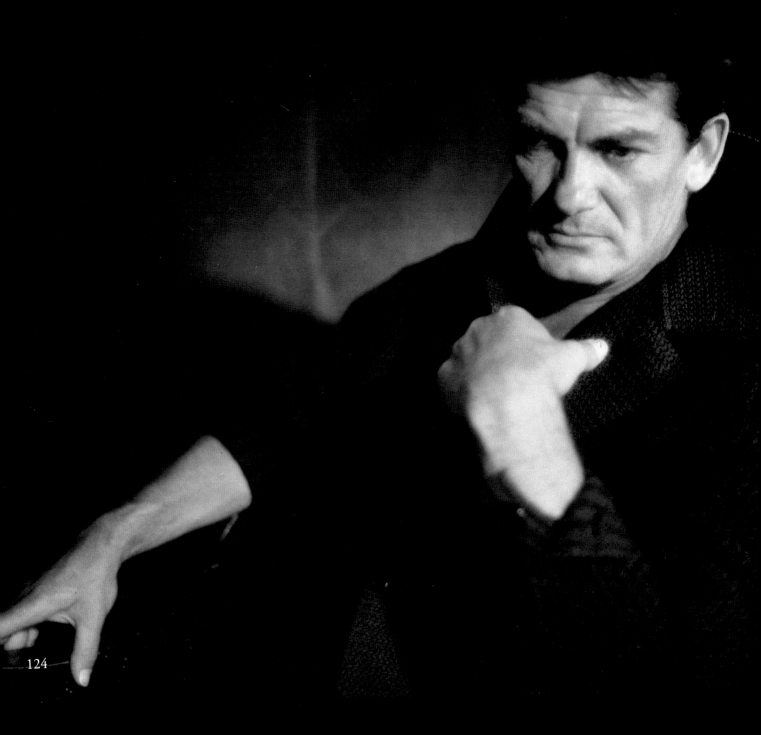

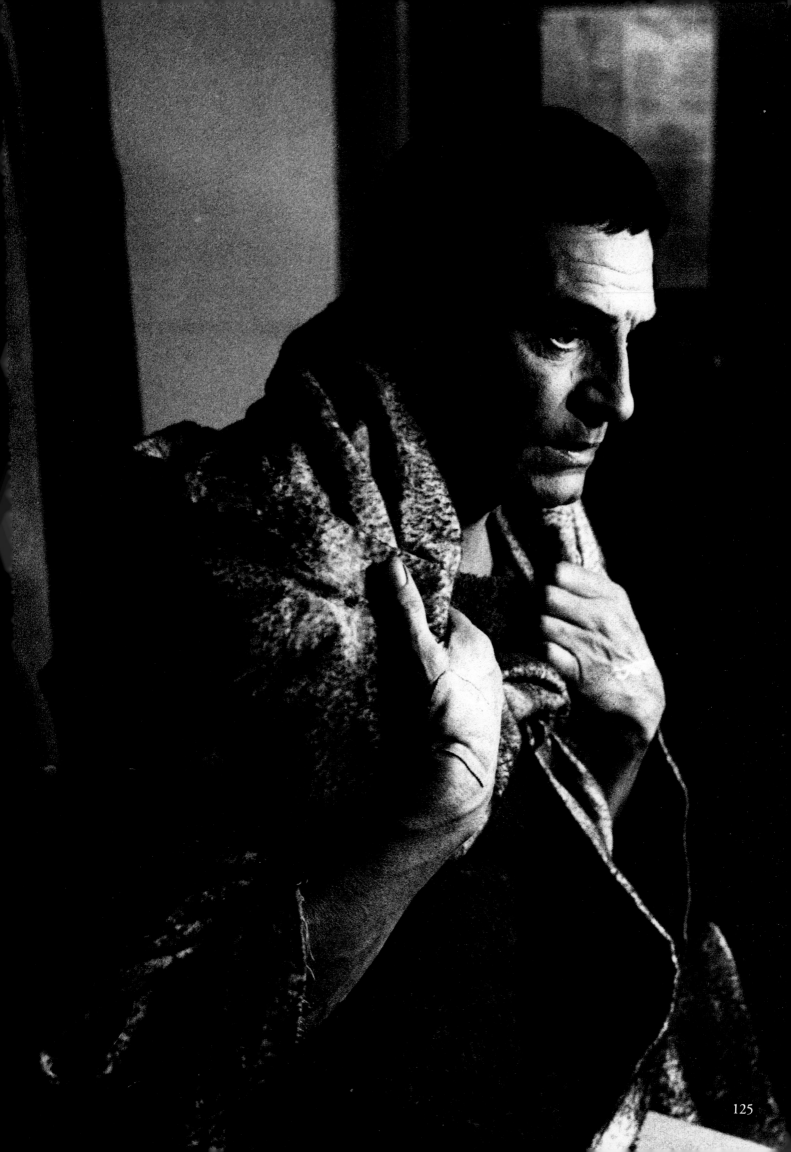

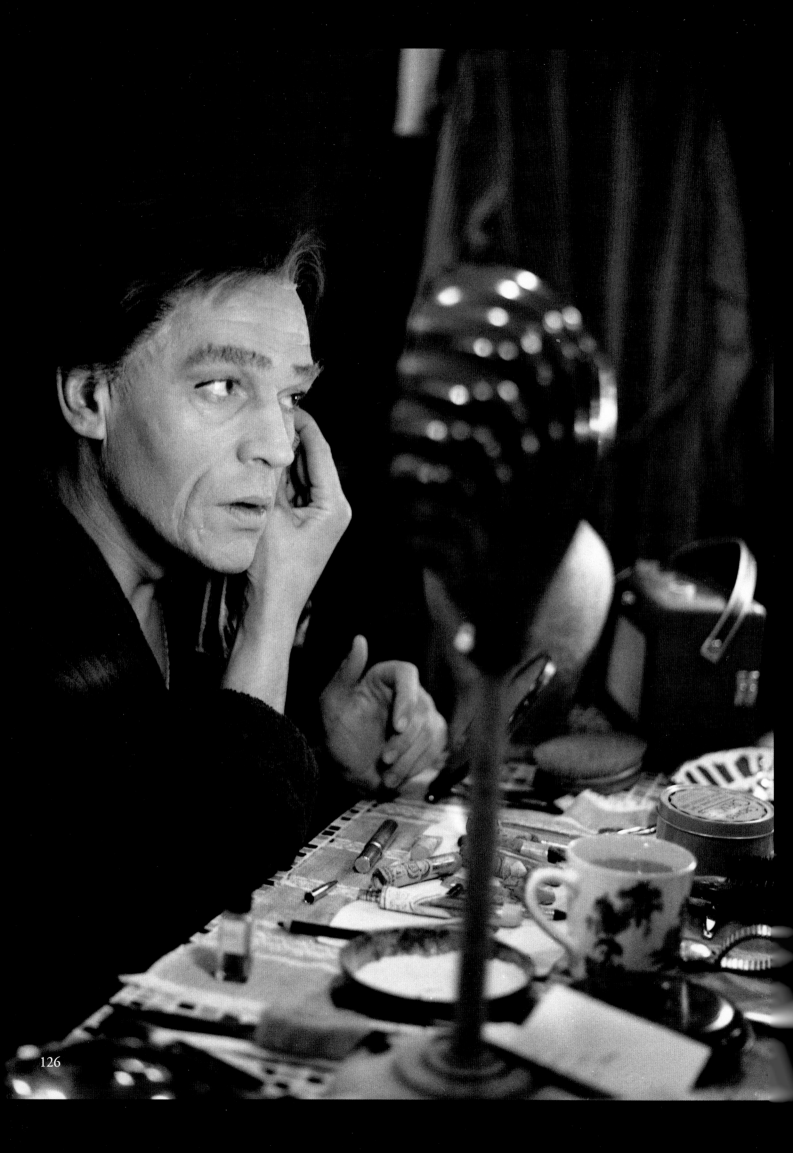

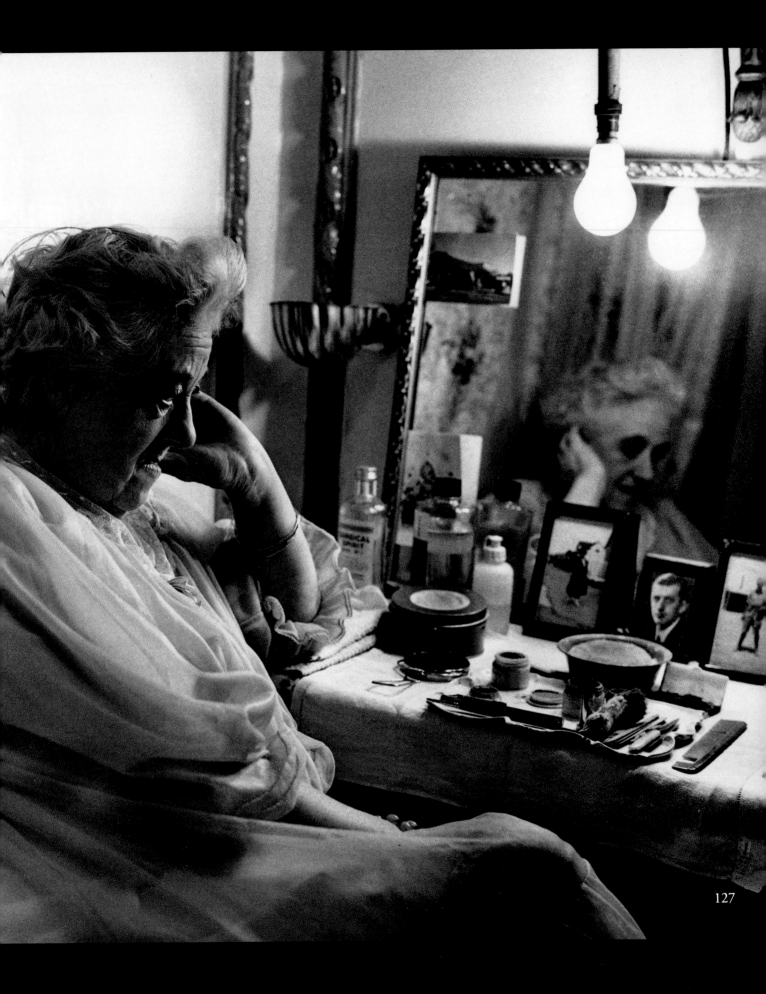

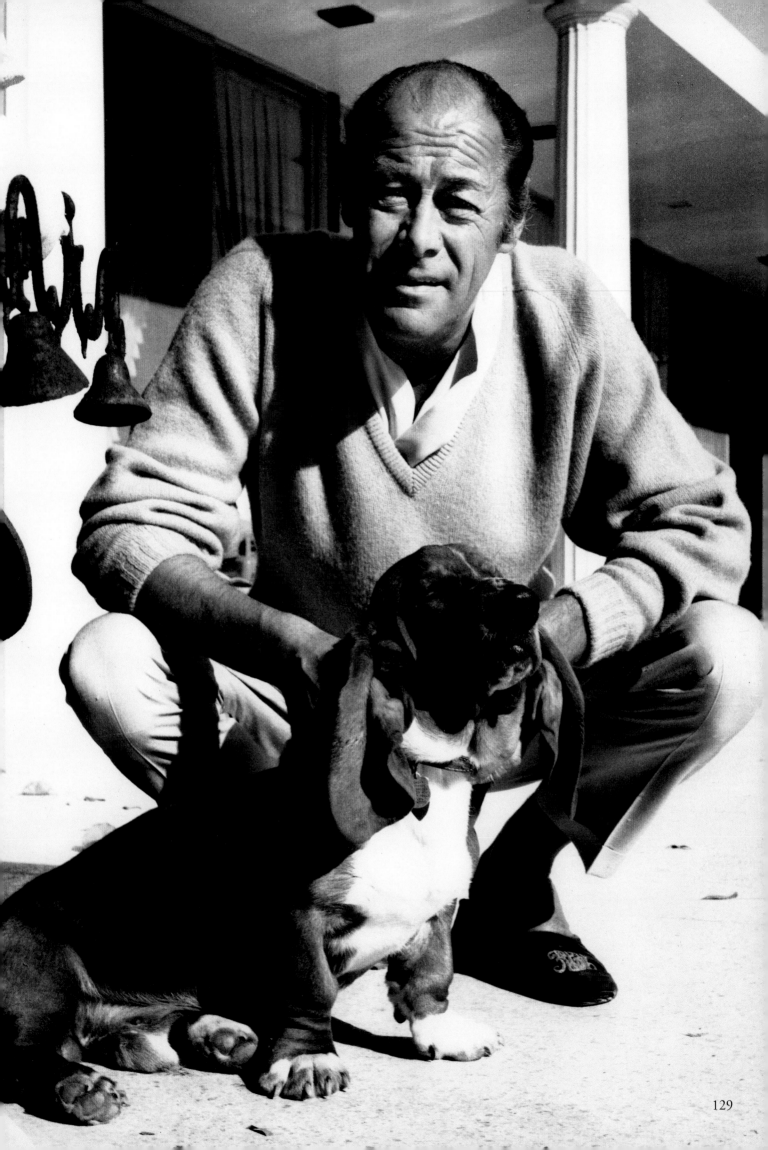

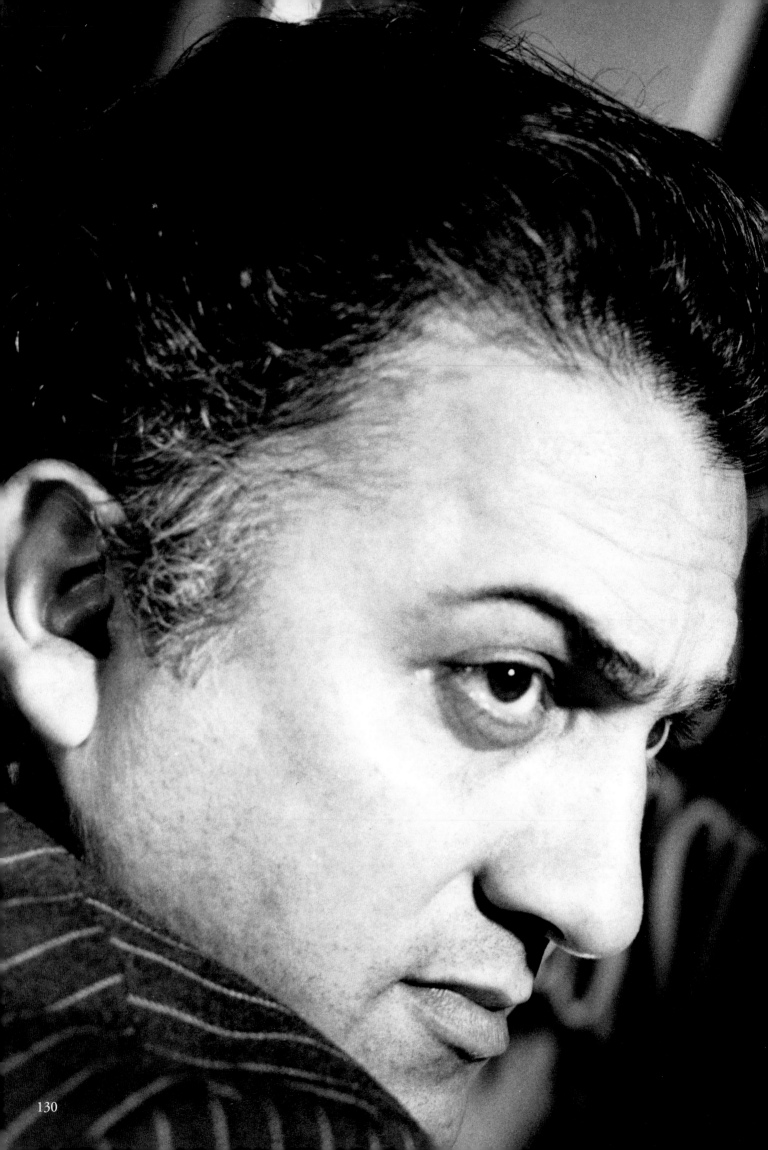

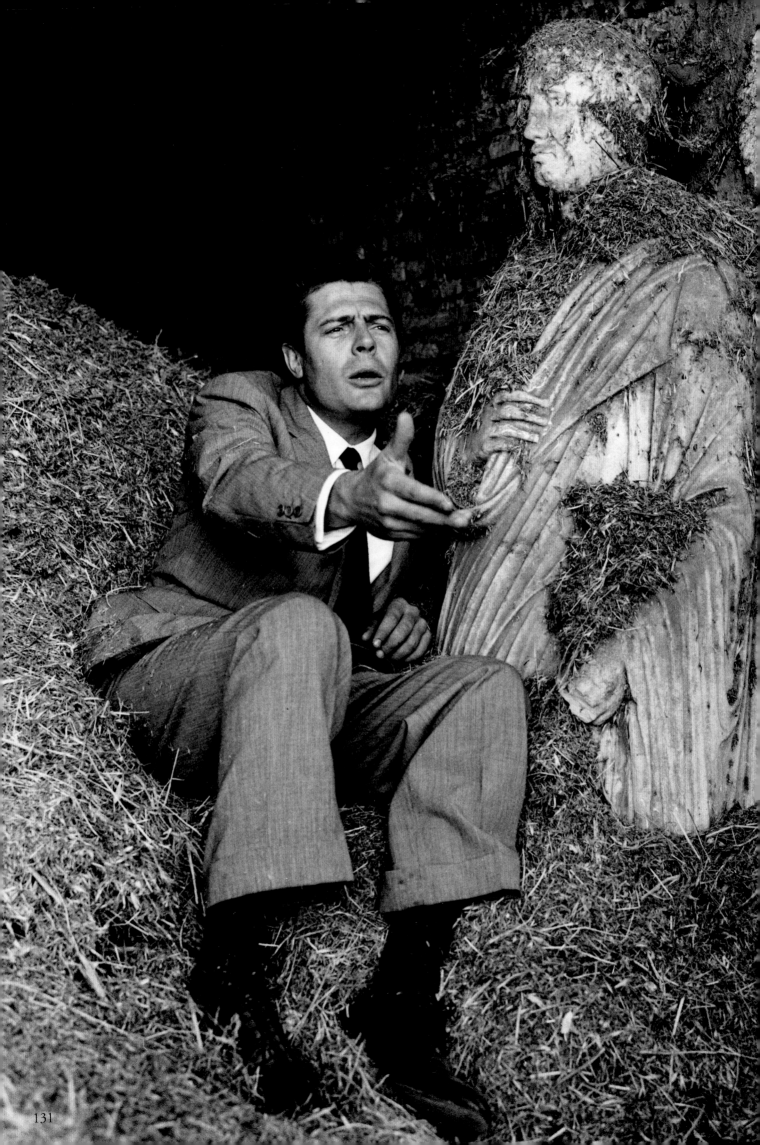

131

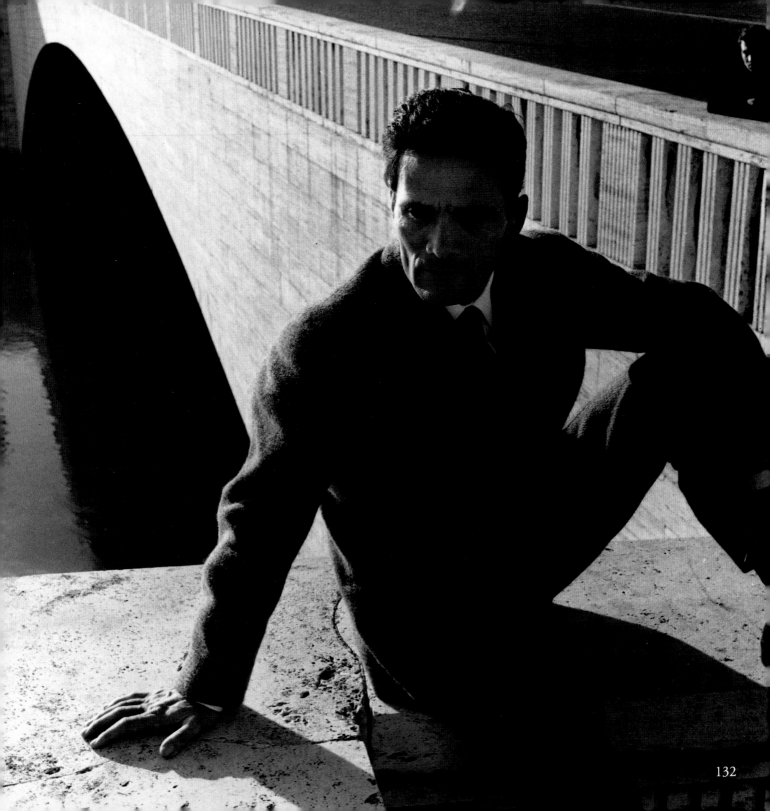

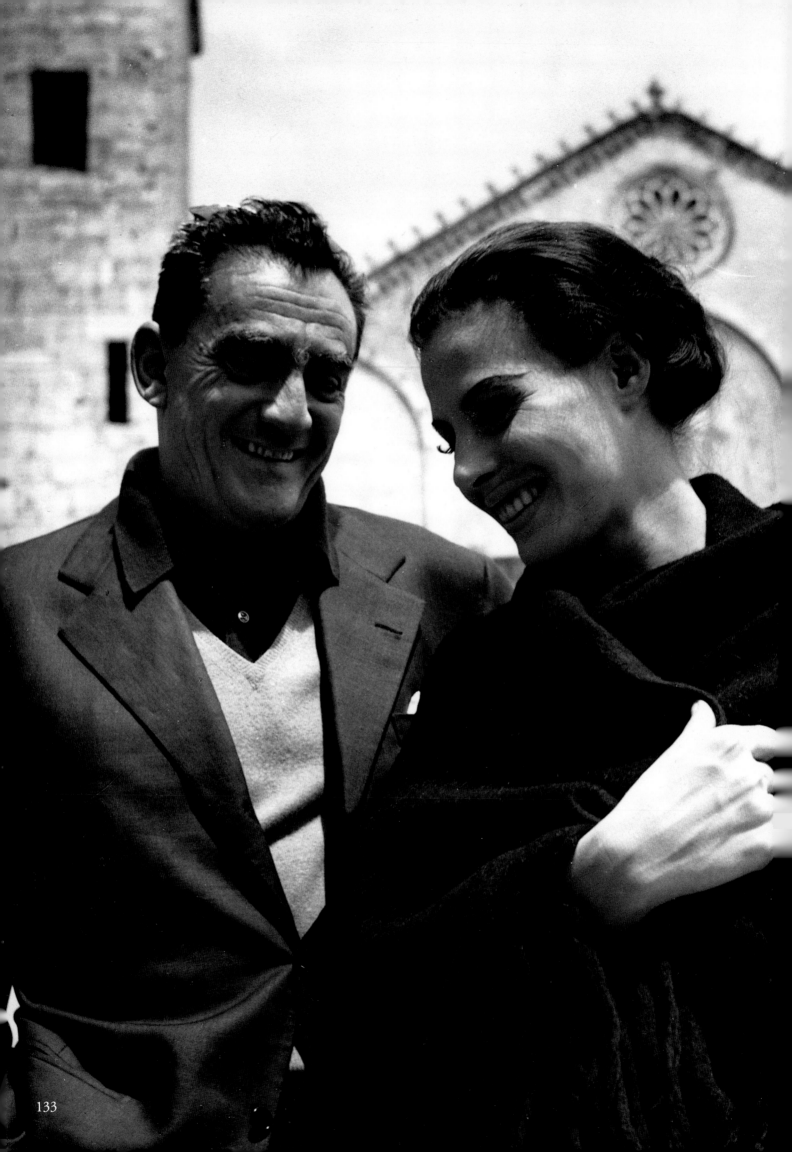

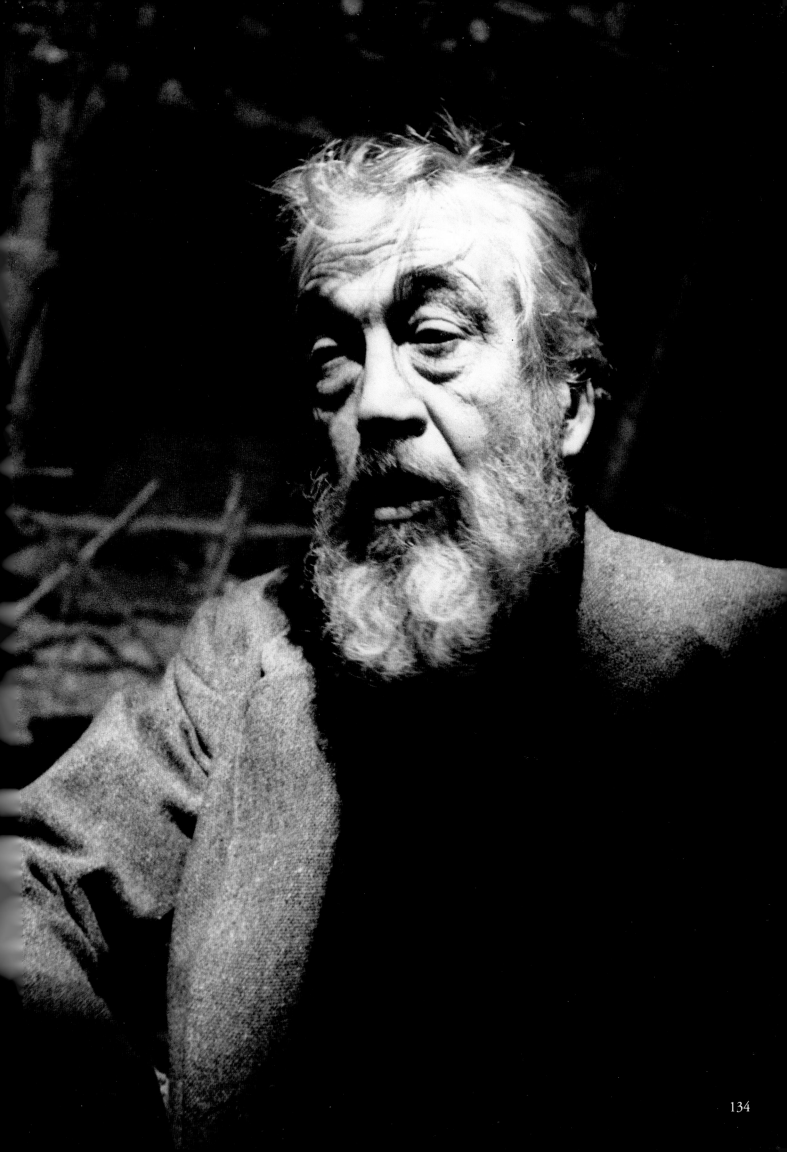

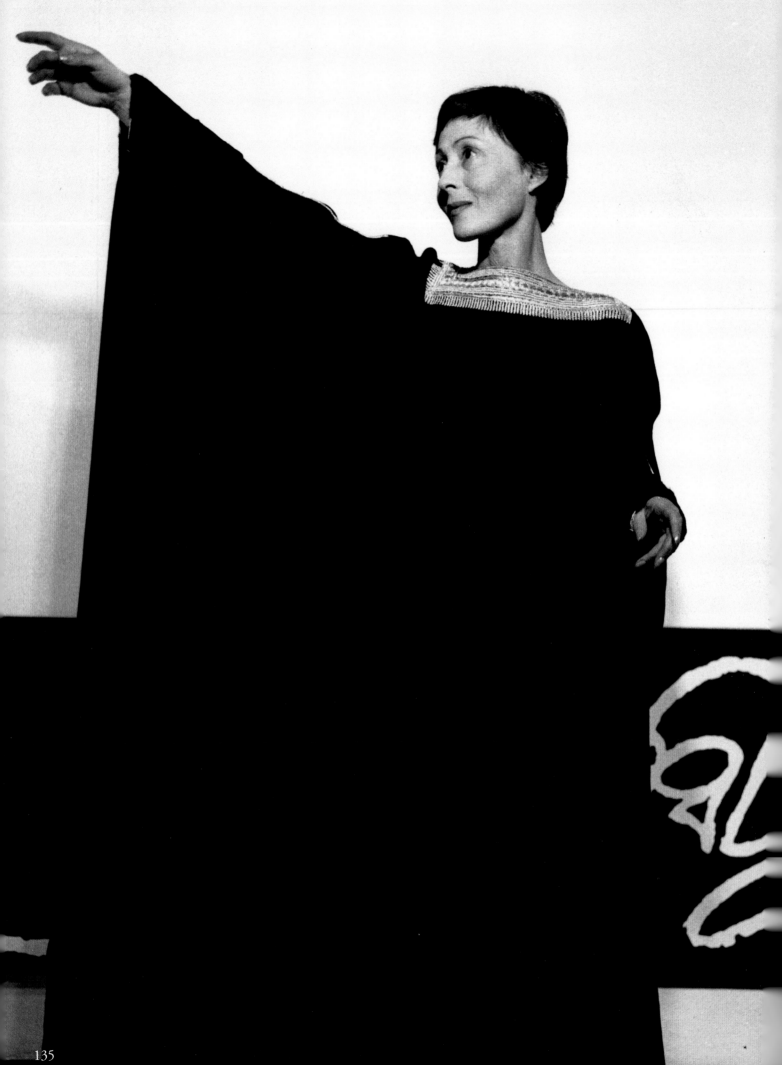

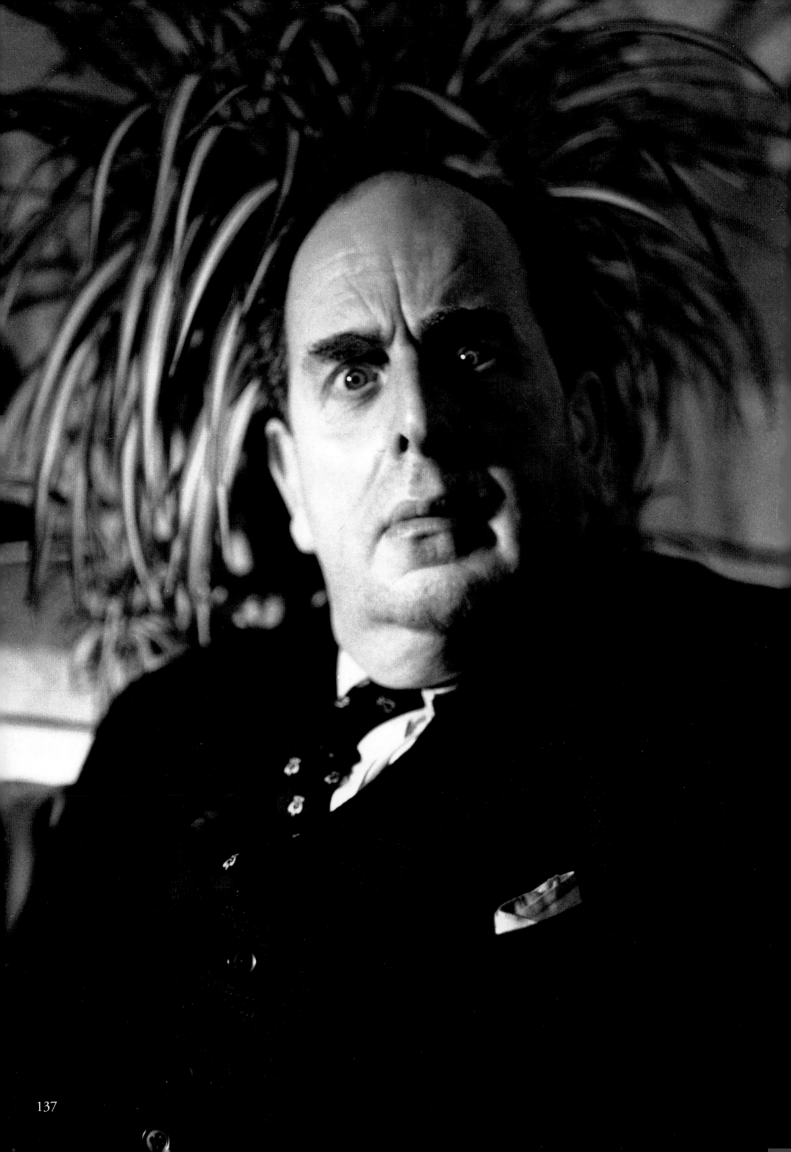

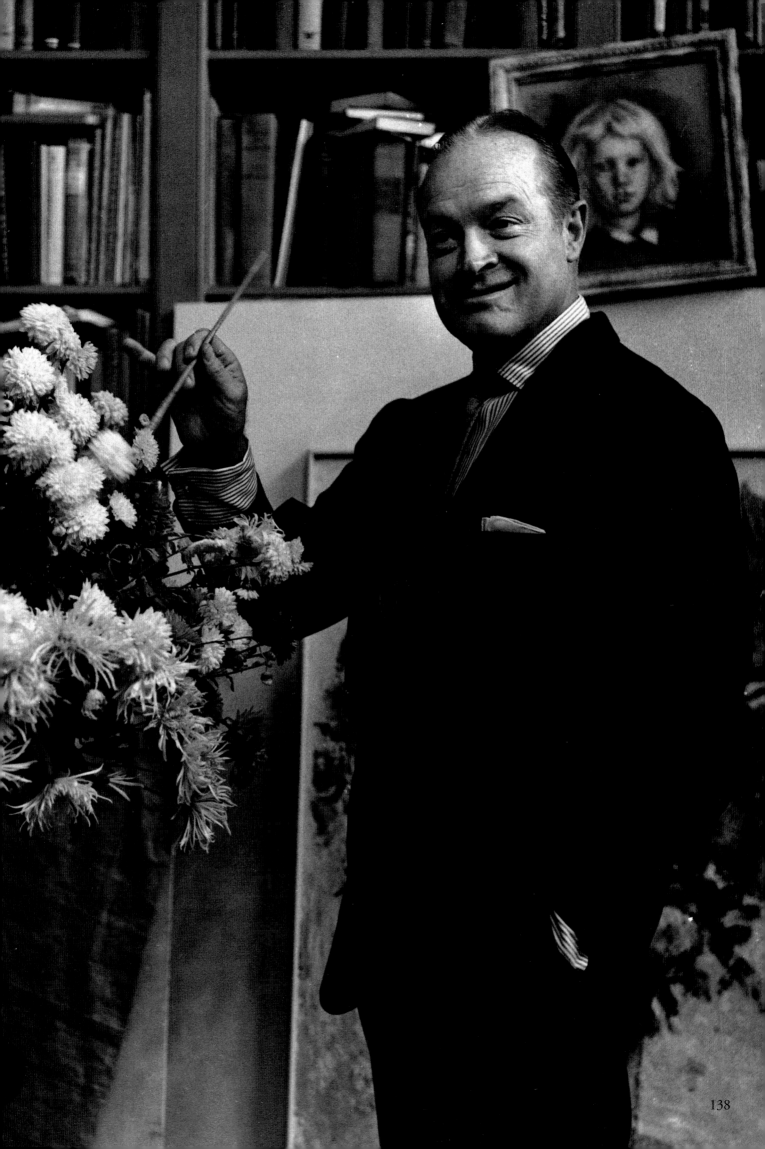

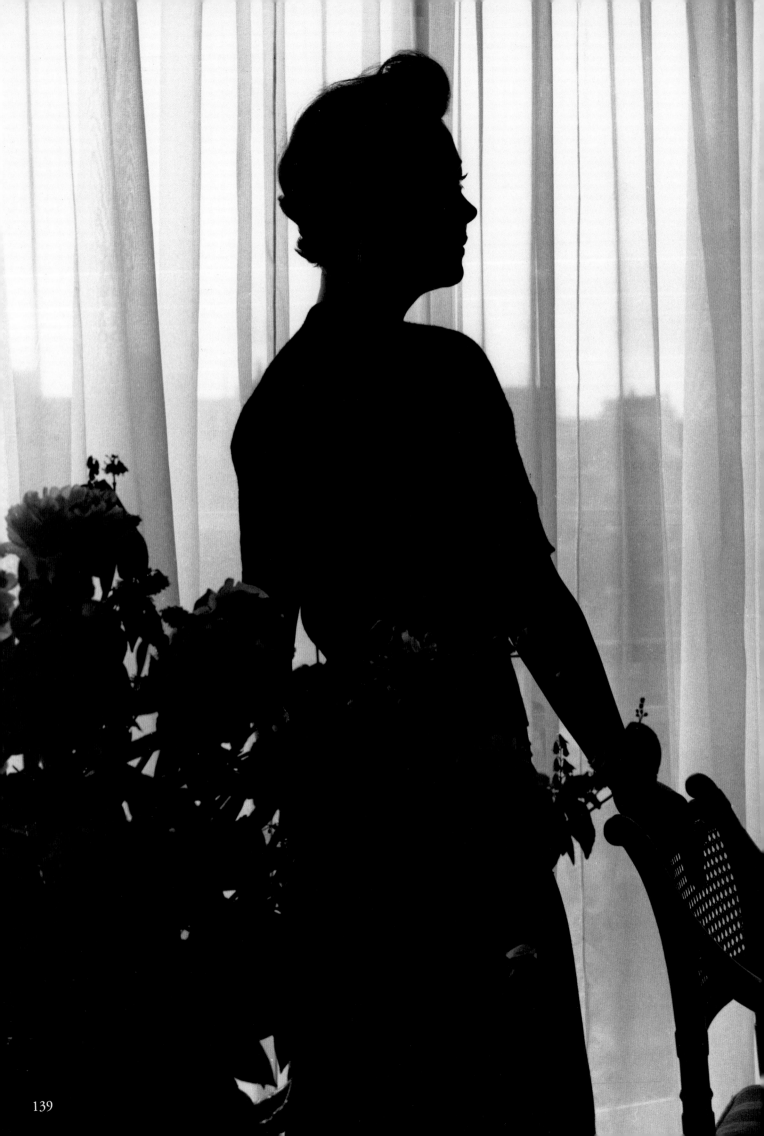

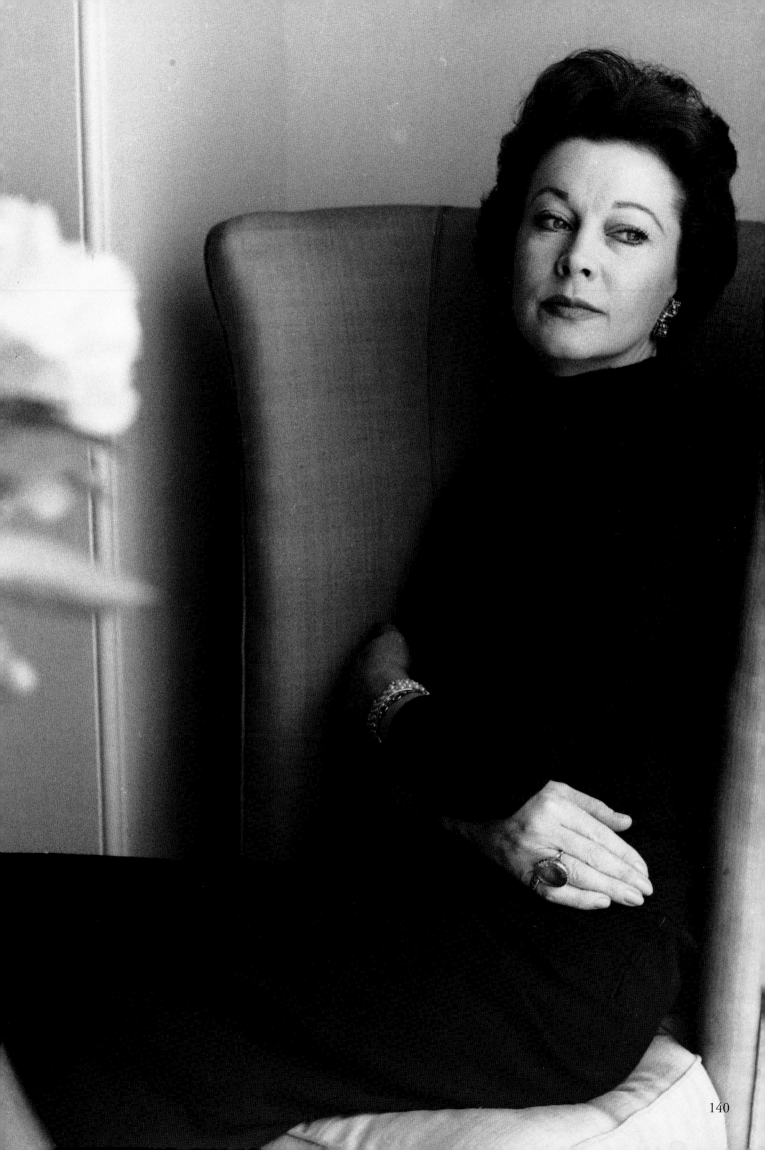

140

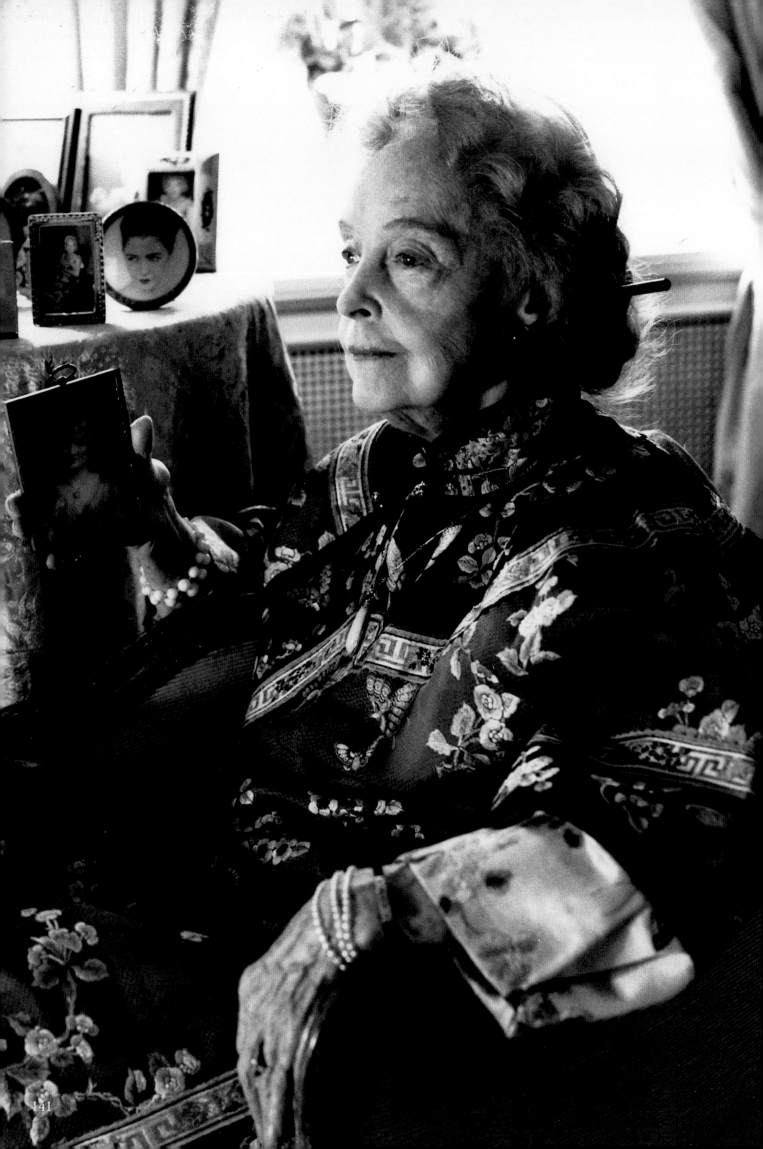

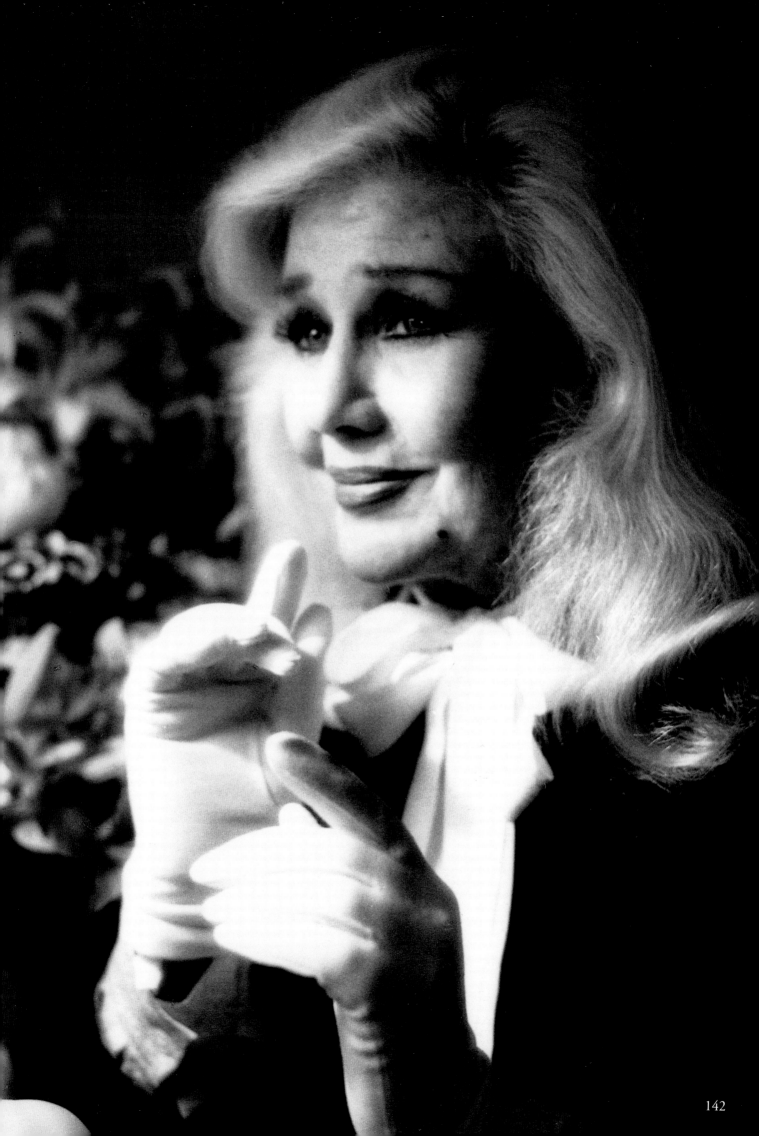

118 Gloria Swanson, American actress, in a wagon-lit on a cross-country tour, 1961.

Gloria Swanson was one of the more sensational and vital women I ever photographed: tiny, always in motion, with a radiant smile that filled the room; flitting from her chair to perch on a windowsill or coffee table or even the floor.

119 Hermione Baddeley, British actress, putting on her make-up for a performance on the London stage in the early sixties.

I first met Hermione at Spoleto where she was appearing in Tennessee Williams' play, The Milk Train Doesn't Stop Here Anymore. *'I must have a little bit of American blood somewhere', she said. 'Walt Whitman has always been my favourite poet; I've always said Lincoln's the greatest man who ever lived, and my favourite playwright is American. Ever since I saw* The Glass Menagerie, *I've wanted to be in one of Tennessee's plays.'*

120 Franco Zeffirelli, Italian director, and Teresa Stratas, Italian soprano, Rome in the early eighties.

The set of La Traviata *was a magnificent, glittering affair. I visited Franco and his crew at Cinecittà one afternoon where I took these photographs of him and his star, the tempestuous and talented Teresa Stratas.*

121 Merle Oberon, British actress, at her suite in the Waldorf-Astoria Hotel, New York, in the early sixties.

122 Barbara Cartland, British novelist and aristocrat, in the garden of her home near London, 1981.

I was invited to a country ball near London and there was Barbara Cartland, prolific romantic novelist, famous eccentric, relative of Princess Di, totally engulfed in raspberry pink chiffon. She knew my books and we hit it off famously. We even danced together, and she invited me to her country house at Canfield, in Sussex, for lunch the following day.
 I asked to photograph her, and we went out into the garden with a white umbrella and found a patch of purplish weeds. 'Make me beautiful!' she commanded. 'Make me … nineteen!' We finished up with champagne and kisses.

123 Elizabeth Taylor, British actress, at a gala ball hosted by Aristotle Onassis in Venice, 1975.

124 Jean Marais, French actor, at Tiber Terrace, Rome, 1961.

Jean Marais was discovered by Cocteau and became his protégé. He often decorated my Tiber Terrace over the years with his presence. Jean was the most beautiful man around; few could resist his charms.

125 Laurence Olivier, British actor, backstage after his performance in *Coriolanus* at Stratford, England, 1959.

After the first night, the crowd was cheering wildly in admiration, but as he came offstage his only interest was in getting a typewritten list of the fluffs he'd made during the performance. He thought nothing of public adulation, only of how to improve his work. I saw the play over and over. A few nights later, I was waiting for him backstage, overcome with emotion at his brilliance. I rushed into his dressing room and found him just emerging from the shower, ran to kiss him on both cheeks and stepped squarely on his bare toes. He gave a yowl of pain. 'For heaven's sake, Wilfie, try to control your emotions and your clumsy feet and relax until I've gathered myself together. Have a Scotch, old boy!'

126 Paul Scofield, British actor, putting on his make-up for *A Man For All Seasons*, London, 1961.

Scofield was very rugged, handsome and virile, and surprised me by saying he'd begun his career playing Juliet at his public school. He must have been the most butch Juliet in history. He also confessed, 'The theatre is not an all-absorbing thing for me, but I'm stuck with it. There is nothing else I can do.'

127 Margaret Rutherford, British actress, London in the late fifties.

I found Margaret Rutherford in her dressing room at the Garrick Theatre after her performance in Farewell, Farewell, Eugene. *A bundle of chiffon, languidly removing mascara with a rabbit's foot, she said, 'I think if we're going to do a serious photograph, we'd better have a drop of Dubonnet … and just a drop of gin as well.'*
 Several hours later, I remembered what I'd come for and managed to focus my camera. 'What can I give you, young man?' she wondered. 'Oh, here, take the rabbit's foot for good luck.' The porters swept me out into the night and I floated off on the London fog.

128 Noel Coward, British actor and director, posing in the Piazza Esedera, Rome, while on vacation, 1962.

Noel Coward in his chalk white, canary yellow and cerulean blue suits. I first met him through Gielgud and the Oliviers; when Vivien was having a breakdown on a film set and Noel rushed to her rescue.
 In Rome, he proclaimed himself jealous of my pictures of Vivien and demanded I do a photographic essay to be called 'The Roman Autumn of Noel Coward'. We combed the eternal city in a chauffeured limo, posing him while he quipped non-stop, like the script of one of his plays.

129 Rex Harrison, British actor, at his home in Hollywood in the early sixties.

The sitting with Rex Harrison was to take ten minutes. But when Lady Joan and I arrived, he led us on a tour of his villa. … His new bride, Rachel Roberts, sang for us at the piano. The ten minutes lengthened into several hours, and I suddenly remembered that I had a plane to catch and snapped Rex in his monogrammed slippers.

130 Federico Fellini, Italian film director, at his Roman studio, 1960.

131 Marcello Mastroianni, Italian actor, relaxing during filming in Rome in the early sixties.

132 Pier Paolo Pasolini, Italian director, posing on a bridge in the heart of Rome near Tiber Terrace in the early sixties.

Pasolini had an intensity which prefigured his tragic destiny. In the year before his death, he prophesied a rising tide of pitiless brutality and violence. In 1975, he was murdered and mutilated on a vacant lot near the sea. His art and his life were over-shadowed by his own anti-heroes – boys from the Roman slums and sidewalks.

133 Luchino Visconti, Italian film director, with Ornella Vanoni, popular singer, Spoleto, 1958.

At the Festival of The Two Worlds in Spoleto, I caught this moment of warm complicity between Visconti and Ornella Vanoni, both from the upper crust of Milan. Luchino was always profoundly intrigued and inspired by social phenomena of all kinds. In those days, Ornella gave superb renditions of songs from the Mala Vita, *tough and touchy.*

134 John Huston, American actor and director, on the set of *The Bible* in Rome, 1965.

John Huston asked me to re-create the Garden of Eden for him. Originally, he was intending to shoot the Adam and Eve scenes in Ceylon, which is as close as you can get to paradise today, but I convinced him to use a miniature garden and promised to design it for him in Japan, using bonsai trees. He was enchanted by the idea. I did it, but De Laurentis got cold feet and it was vetoed.

135 Luise Rainer, Austrian actress, Rome, 1959.

Luise Rainer in Francis McCann's gallery on the Tiber Island in early 1959. Luise had nothing suitable to wear, so I loaned her my Libyan burnous, and she recited Tagore's poetry in front of huge panels of his calligraphy.

136 Gian Carlo Menotti, Italian composer, Spoleto, 1961.

Vibrant but elusive, Menotti, who usually lives in his castle in Scotland, created the Festival of The Two Worlds in the small Umbrian hill-top town of Spoleto in 1958. It soon became one of the most prestigious world festivals, and artists and celebrities of every nation and art form now gather in the small theatres and squares of this delightful town.

137 Robert Morley, British actor, Rome in the early sixties.

I often saw Robert in Hollywood, but this photograph was taken at Tiber Terrace when he popped in carrying his pet rabbit, and looked becomingly startled when I took it away from him.

138 Bob Hope, American actor and comedian, Hollywood, 1959.

While I was at the home of Marion Pike, the portrait painter, her neighbour, Bob Hope, popped over for tea. When I asked him what he would do in my place, as a photographer photographing the greatest professional wit of our time, he answered, 'I'm in a painter's home; naturally, I'd pick up a paint brush.' He rummaged in Marion's things and came up with a brush. As I poised the camera he began to daub oil paint on to a living flower in a vase on the table. 'Noblesse oblige. … I think I'll just touch up these fading flowers.'

139–140 Vivien Leigh, British actress and a close friend of Roloff, London, 1958.

Vivien Leigh ranks high on my list of fascinating women. Her quick movements were unforgettable, her features mobile and expressive, her eyes glittered and shimmered with her changing moods. In an hour she could range from deep introspection through a gleam of controlled temper, to a passionate child-like enthusiasm. These volatile qualities defy the camera and made her a difficult person to photograph. I did these portraits in her apartment in Eaton Square in London.
 Vivien is many women in one, from child and minx to siren and grande dame. In a sense, she is the eternal woman, forever beautiful.
 I worshipped her, both from afar and from far too near. The idol merged into a very real, dear person – and no one I've ever known affected me more deeply. In the end, her beauty was fragile – and frightening.

141 Lillian Gish, American actress, photographed at home in New York, Christmas 1983, a few months before Roloff's death the following February.

142 Ginger Rogers, American actress and dancer, at her New York apartment, 1983.

Royalty and
Heads of State

WHEN ASKED IF HIS FASCINATION WITH ROYALTY AND RULERS was a form of snobbism, Roloff loftily replied, 'Rather, shall we say, a form of philosophy. I apply the principle of tennis, my favourite sport. I was taught that in order to learn to play well you must have an adversary who is better than you. Well, a head of state generally serves well and has a powerful wrist. Why should I play at a mediocre level?'

Roloff first encountered royalty at the age of fifteen as a young scout in Medicine Hat, Alberta, when he photographed King George VI and Queen Elizabeth on their royal tour across Canada in 1939. When he moved permanently to Rome in the mid-fifties, Roloff was introduced to many of the aristocratic families of Europe. He loved the old palaces and villas, the candle-lit dinners and the fading glory so reminiscent of his own timeless paintings and photographs. Among his most sensitive portraits of royals moved off centre stage by the forces of history are his studies of the Duke and Duchess of Windsor at home in Paris and his haunting portrayal of the Grand Duchess Olga Alexandrovna, the sister of the last Romanov Tsar, in exile in Canada.

Roloff's photographic books were grand and expensive to produce and he soon realized how to open not only the doors to monuments, but also those to the corridors of power. Indira Gandhi and Karan Singh, the Maharaja of Kashmir and her Minister of Tourism, pledged support for the *India* and *Rajasthan* books and back home in Canada, Pierre Trudeau, Prime Minister of Canada, remained throughout Roloff's life a loyal supporter and friend.

Iran, however, provided imperial patronage on a scale beyond even Roloff's wildest dreams. The Shah and Shahbanou commissioned two magnificent volumes evoking the past glories and contemporary achievements of the country. Roloff was invited to virtually every public and private function of the Pahlavi family and his comprehensive photographic record of the last years of the Shah's reign is the only one to have survived.

Roloff was devastated by the loss of Iran. He turned to the monarchs of Greece and Spain, who were generous in their warm welcome and hospitality, but no commissions materialized. In desperation he approached a country he knew well and a world leader he deeply admired. Anwar Sadat, Prime Minister of Egypt, met Roloff privately several times – sharing his aesthetic vision for a book on Egypt – but he, too, was swept away before the project could wind its way through the labyrinth and intrigue of bureaucratic Cairo.

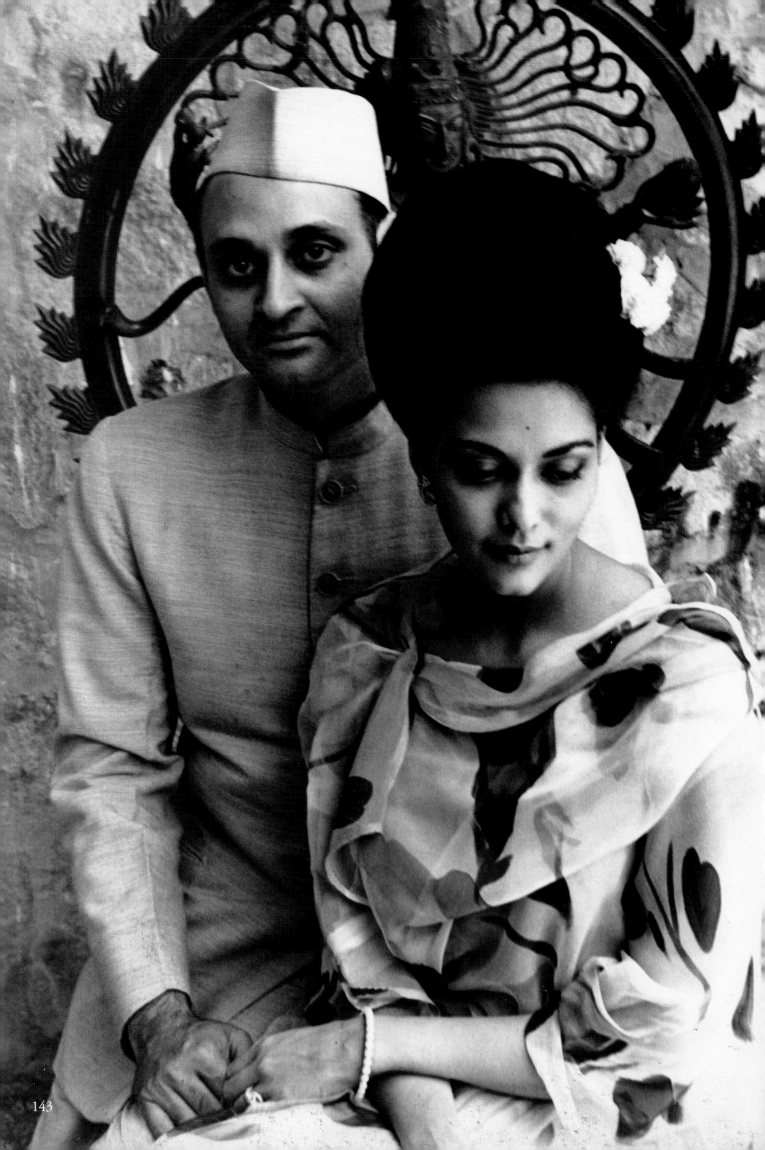

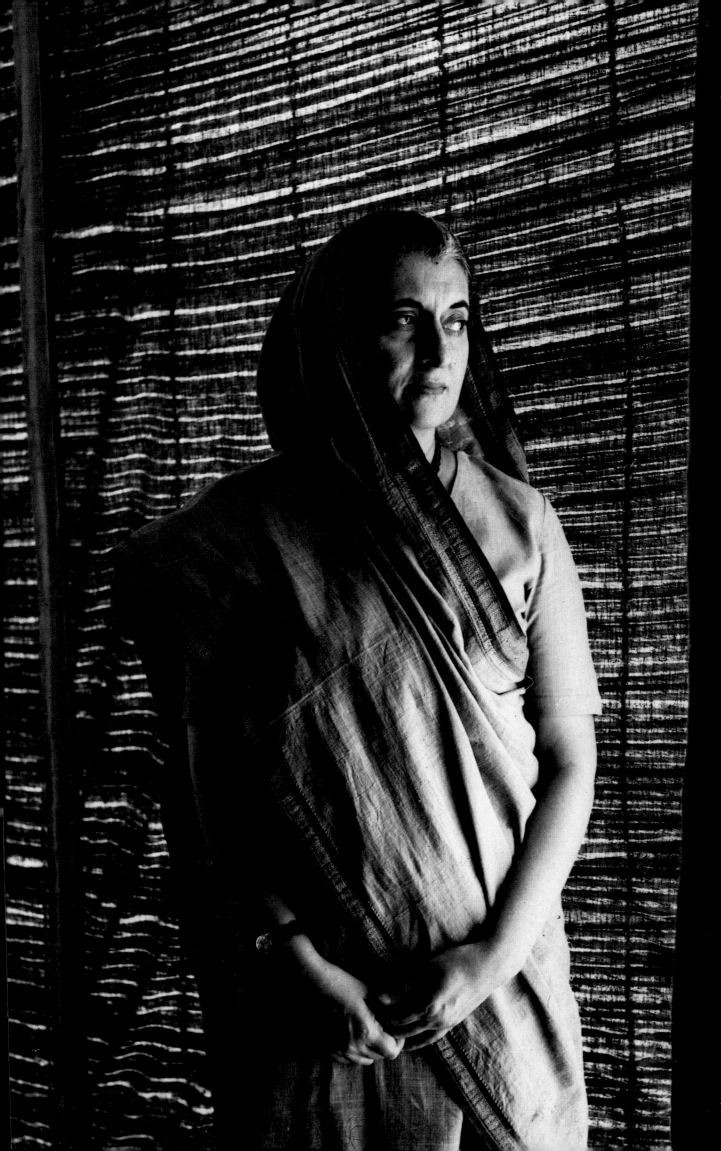

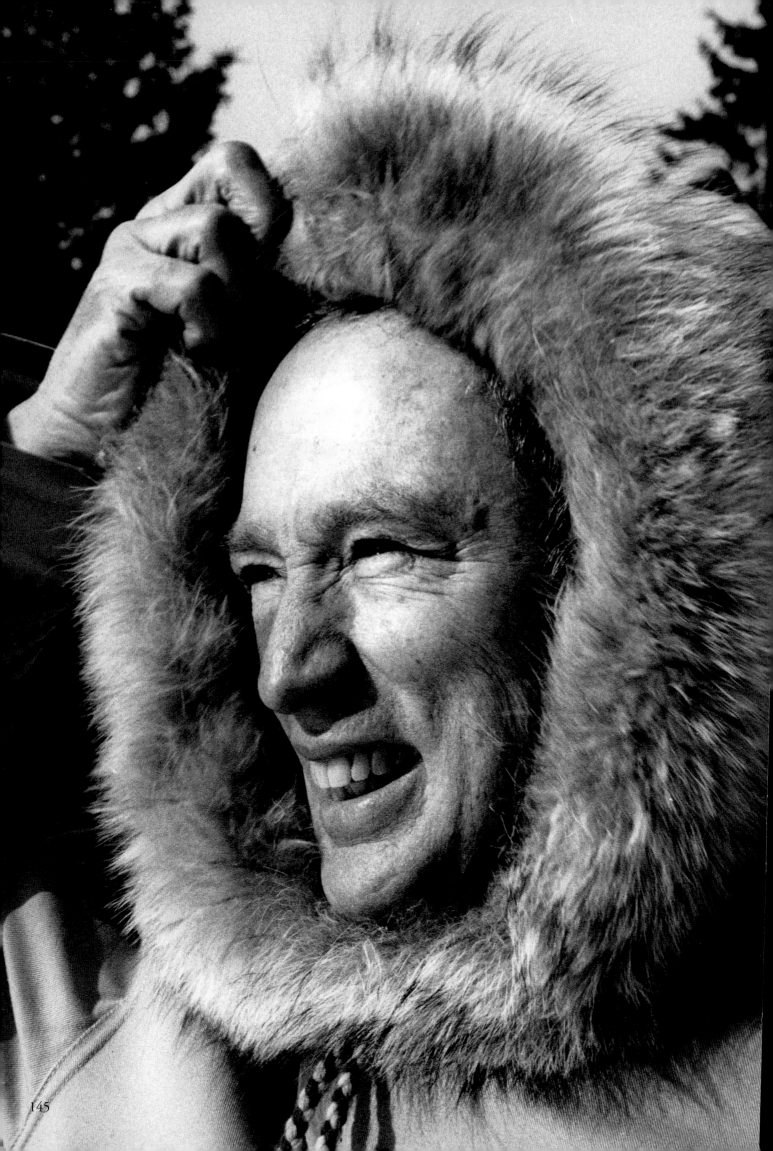

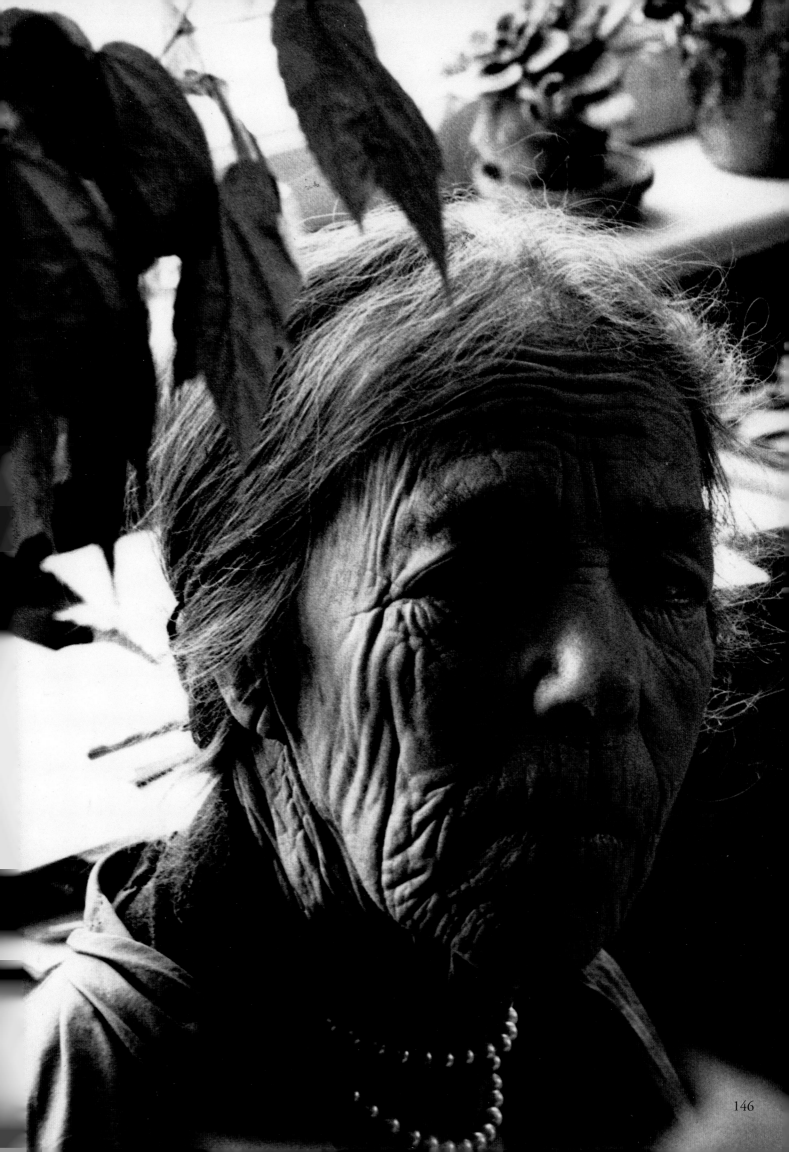

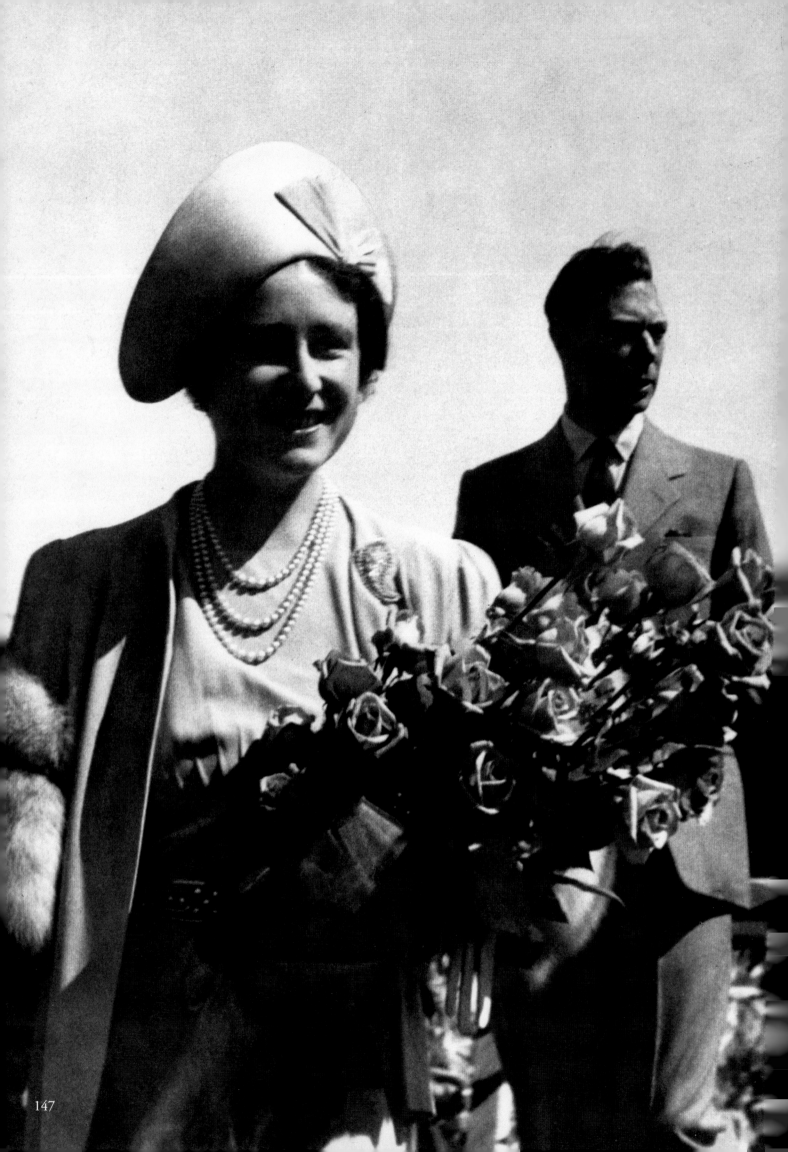

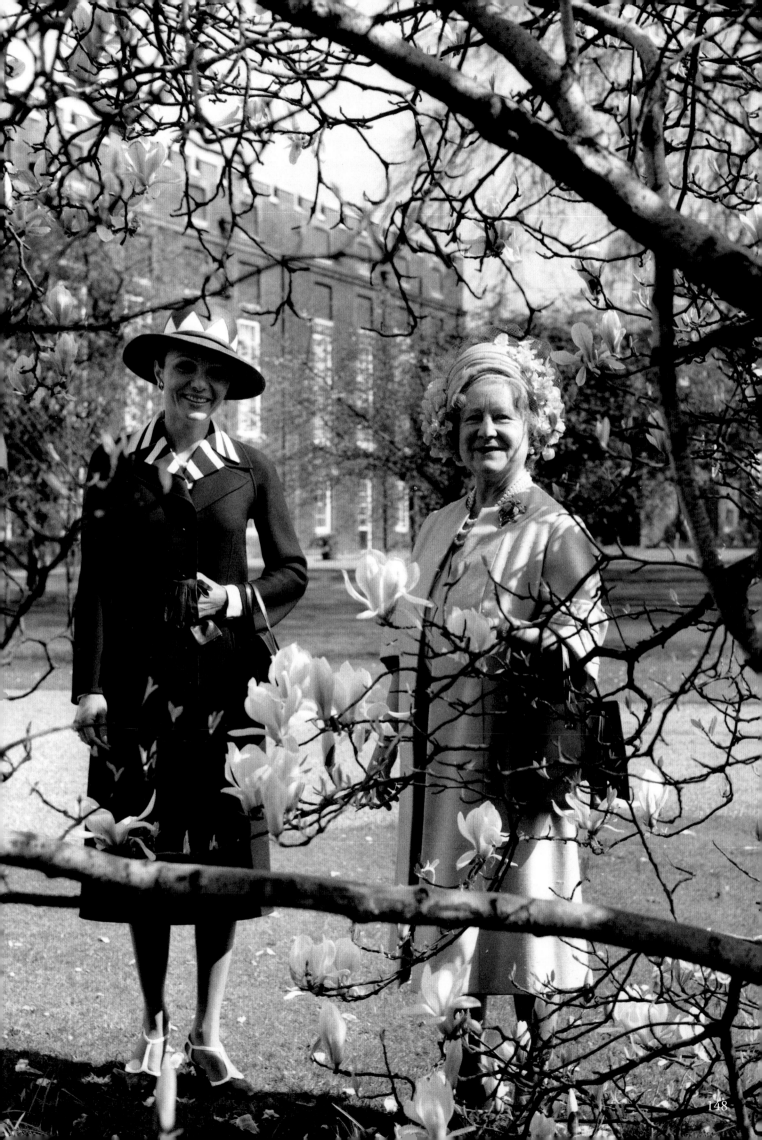

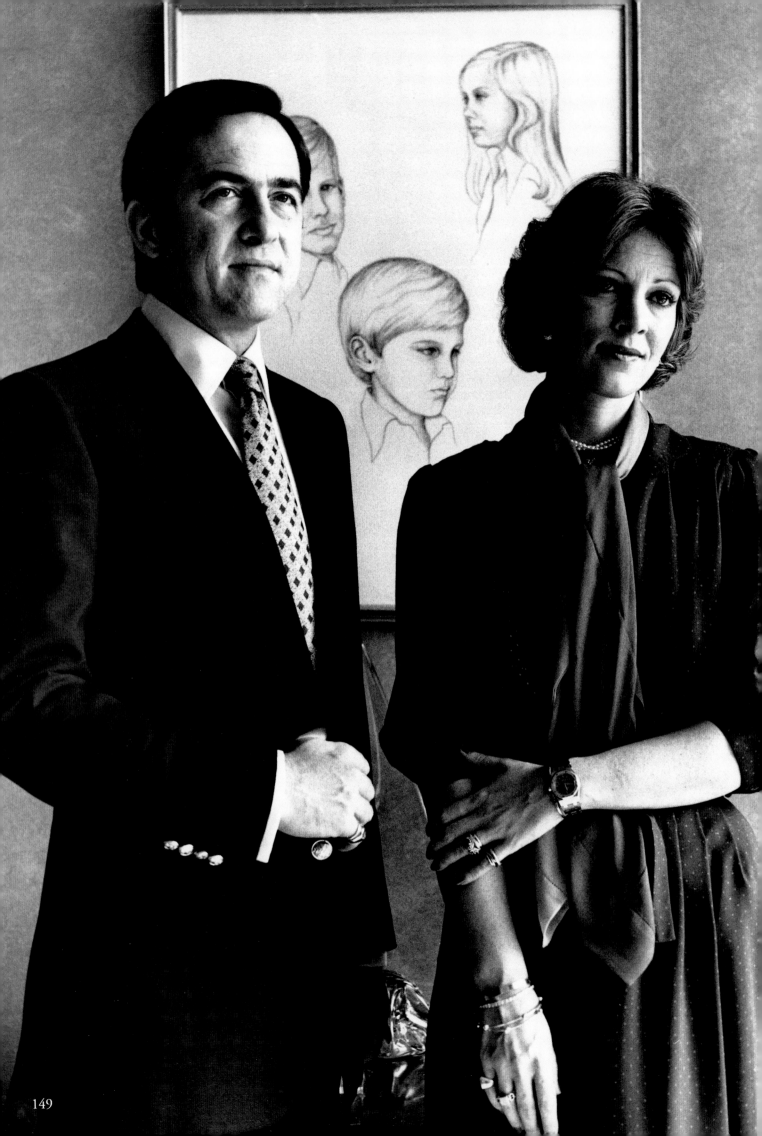

149

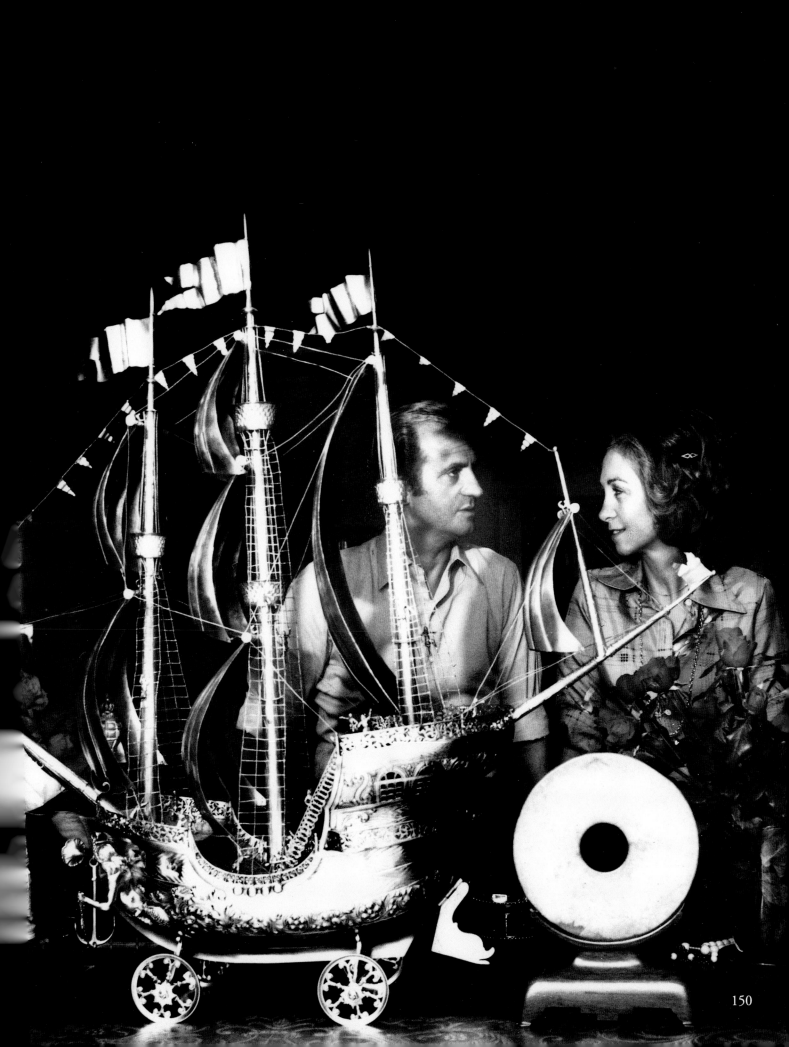

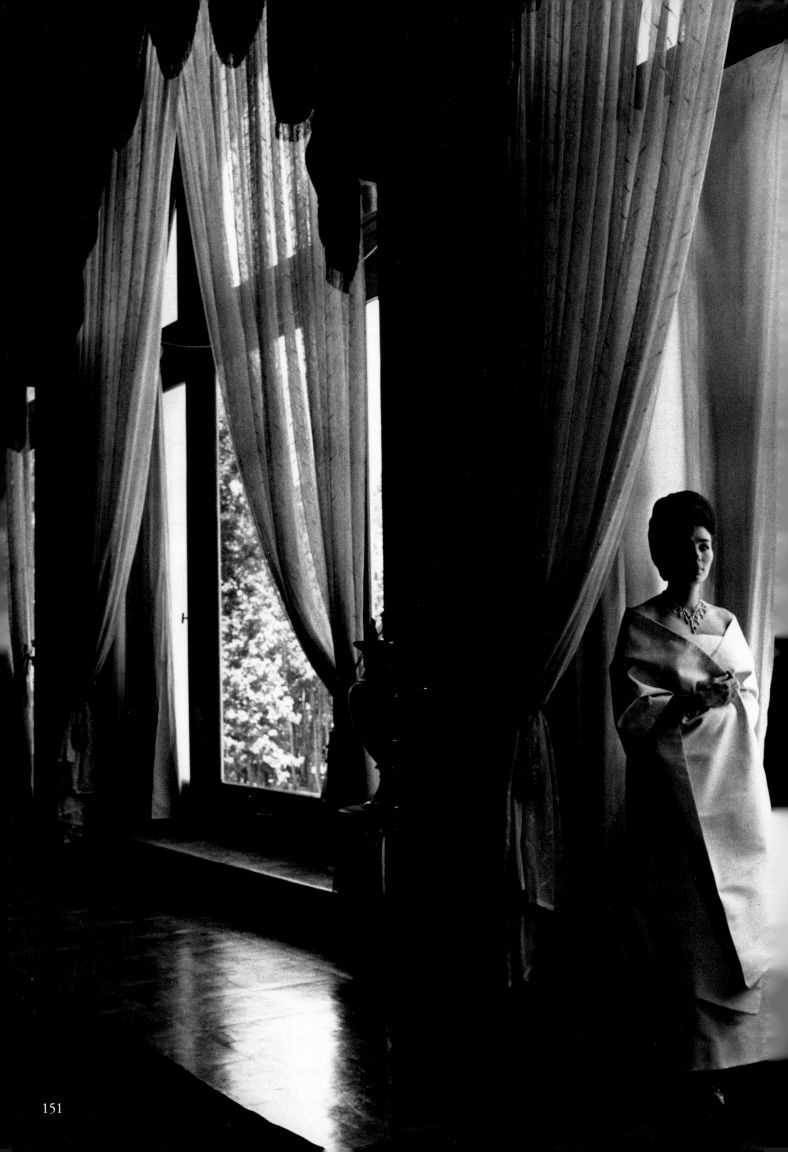

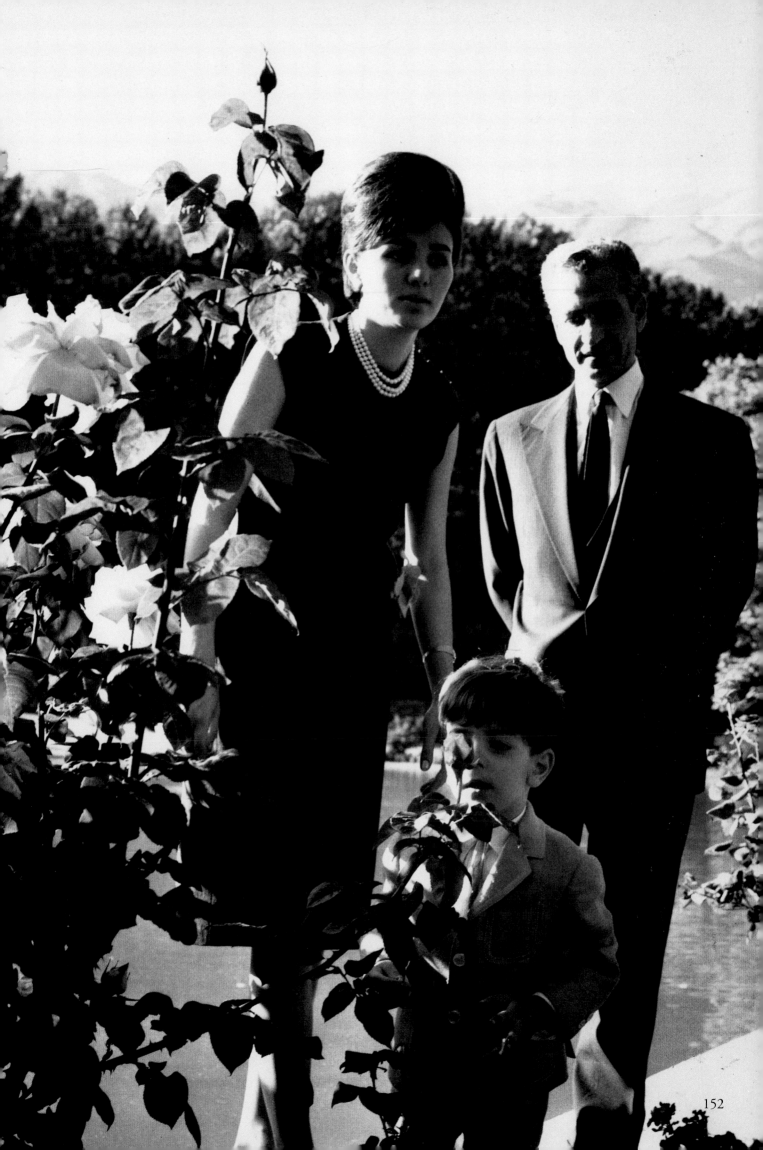

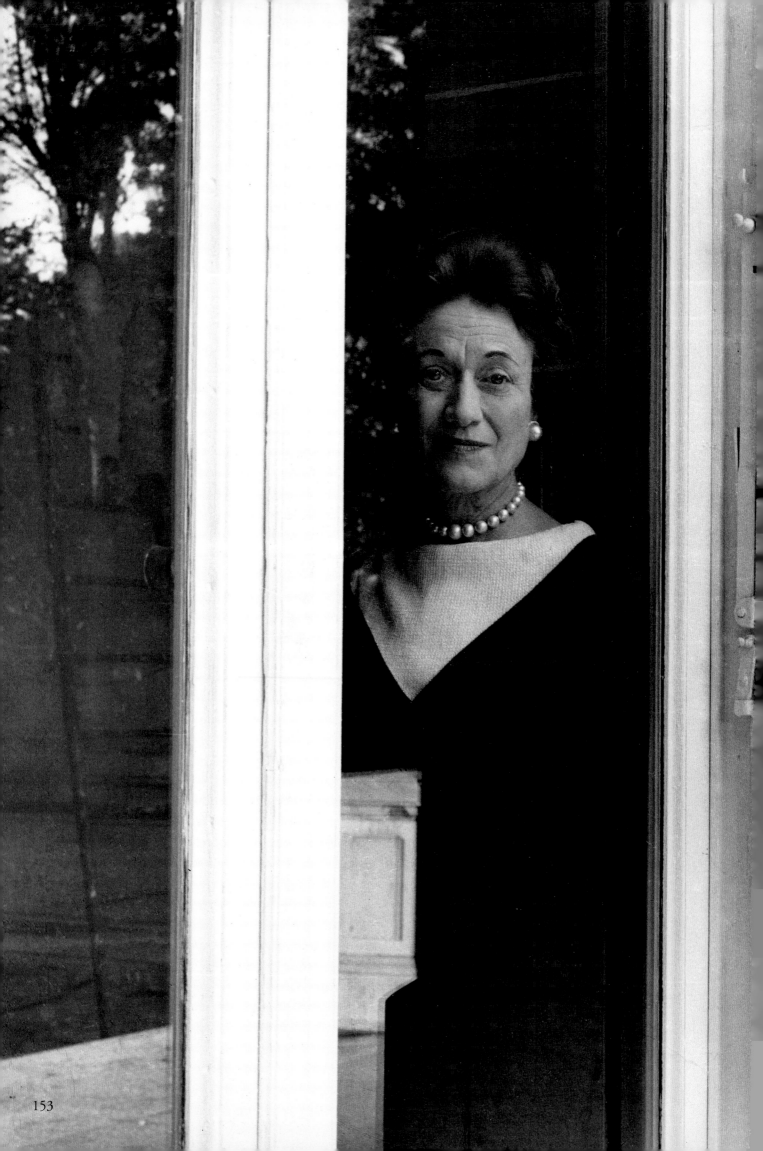

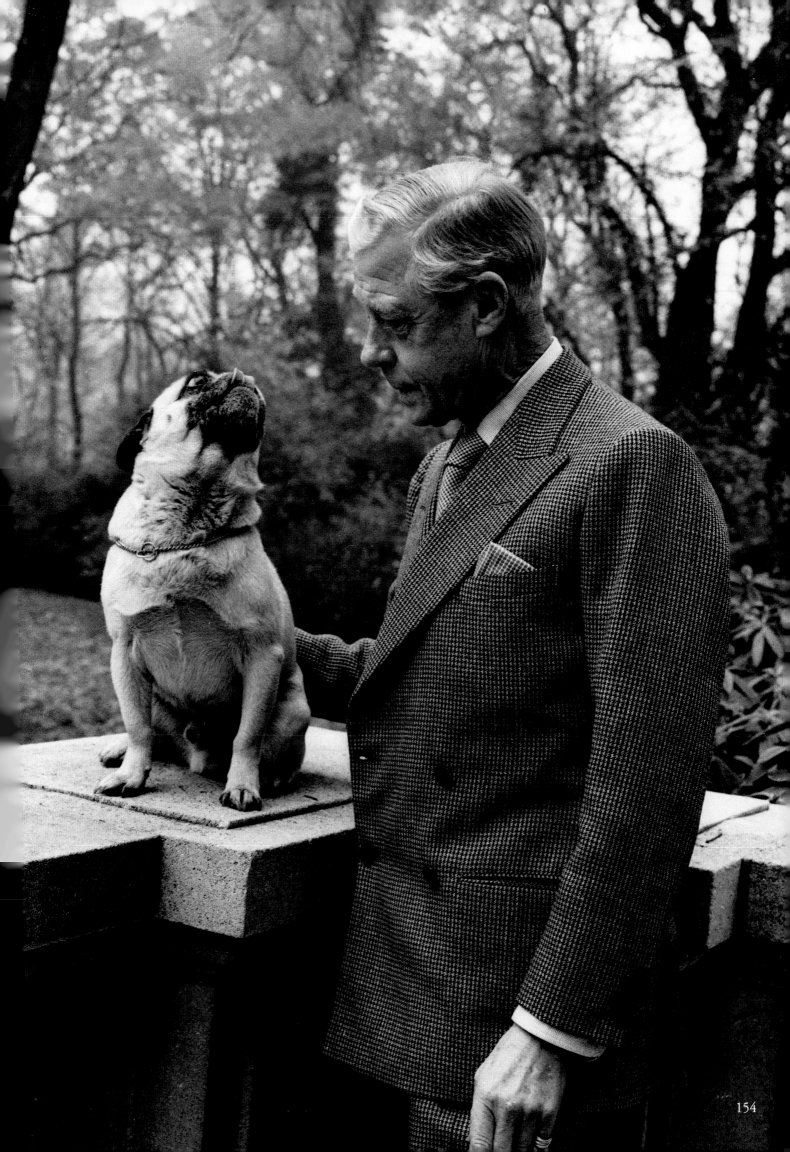

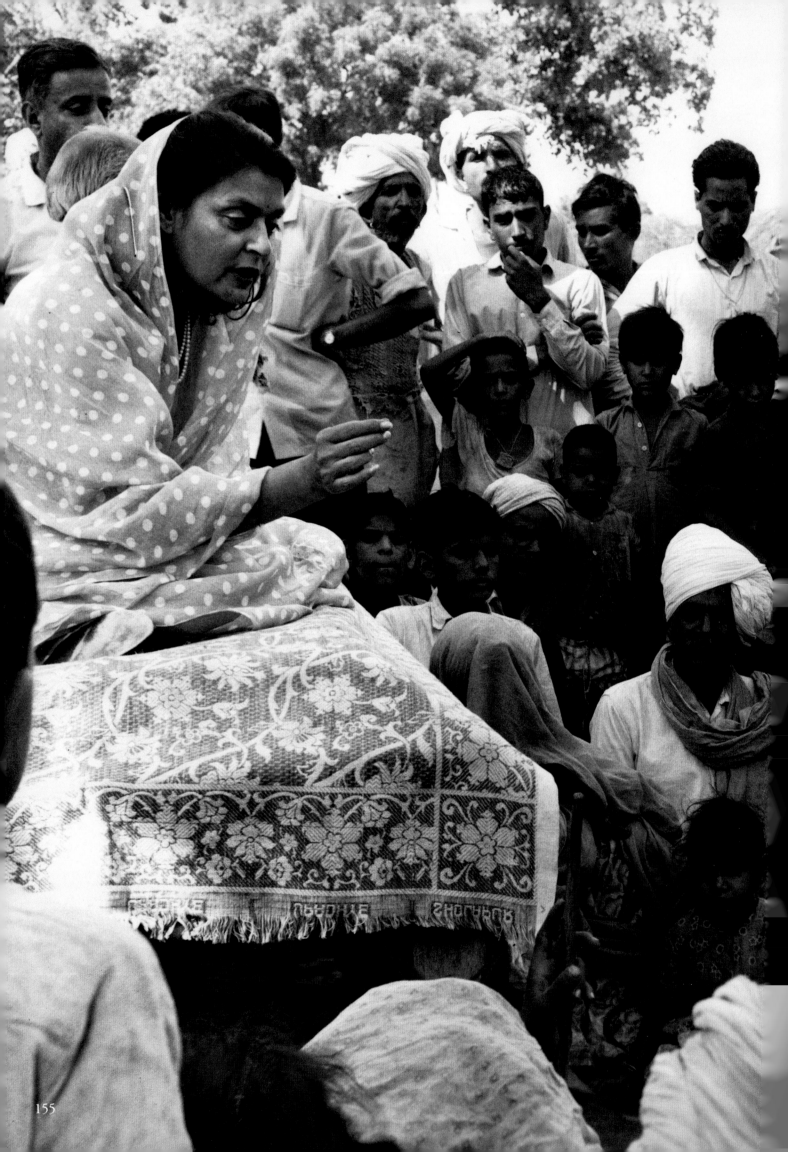

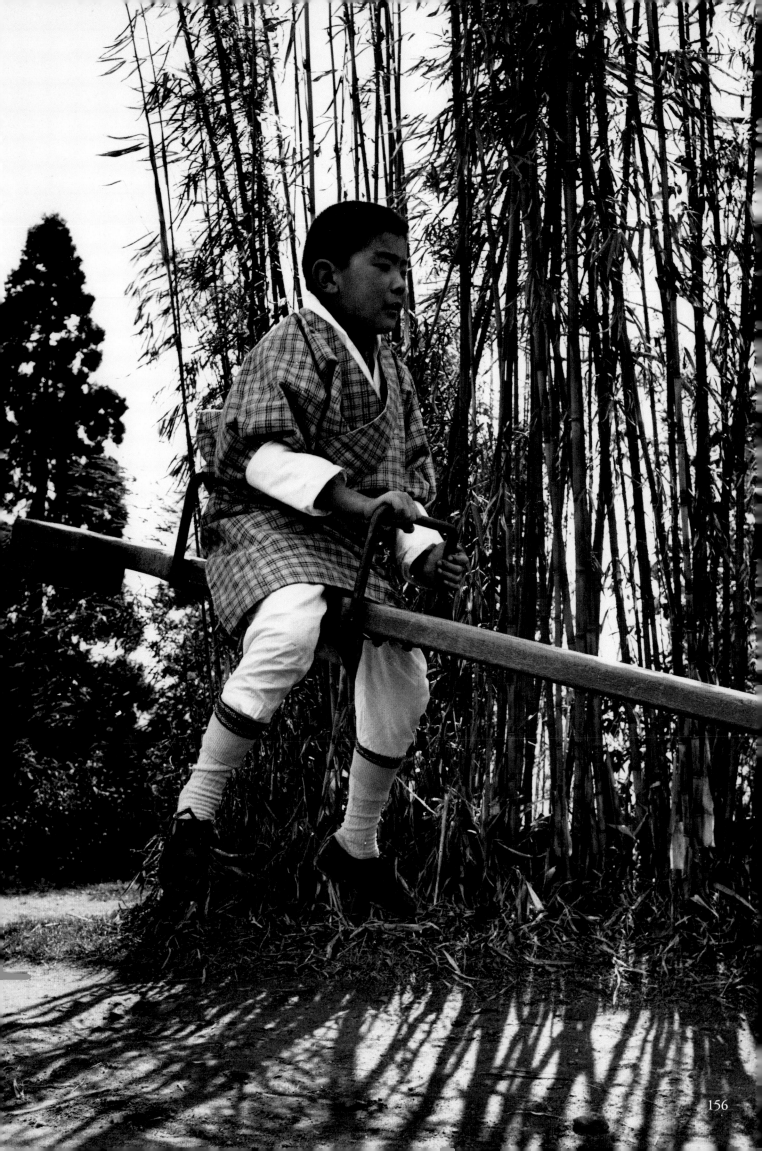

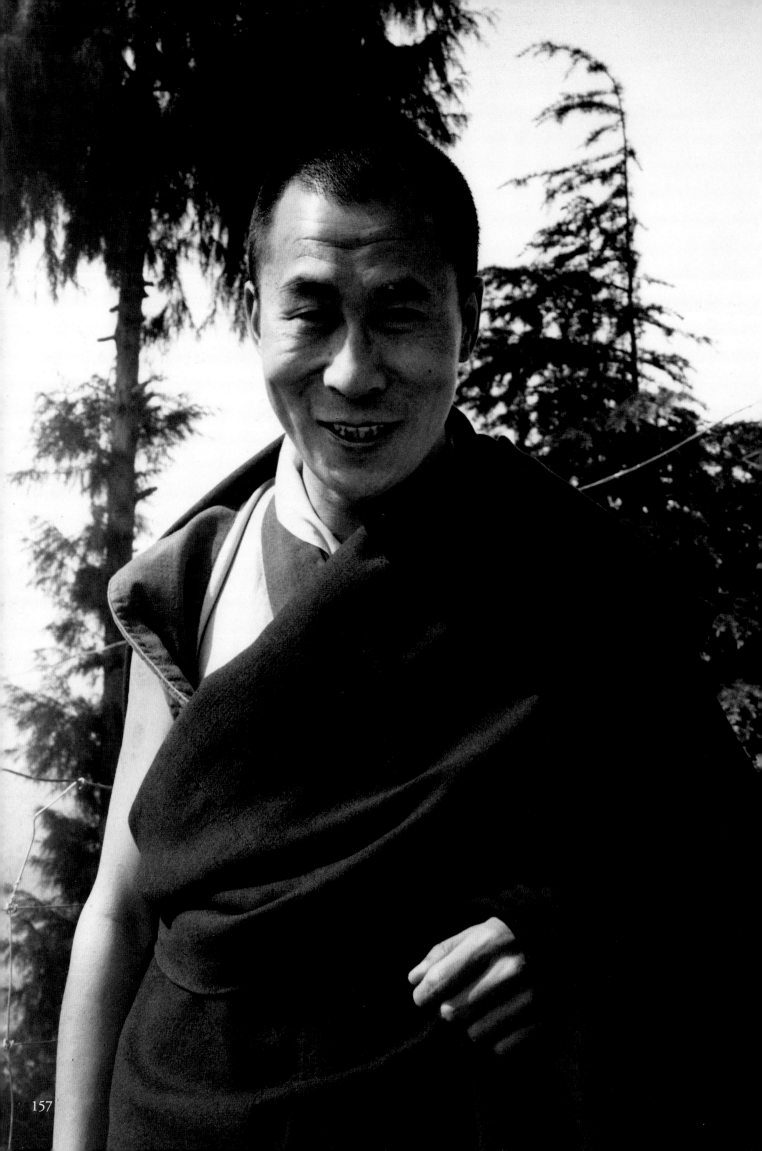

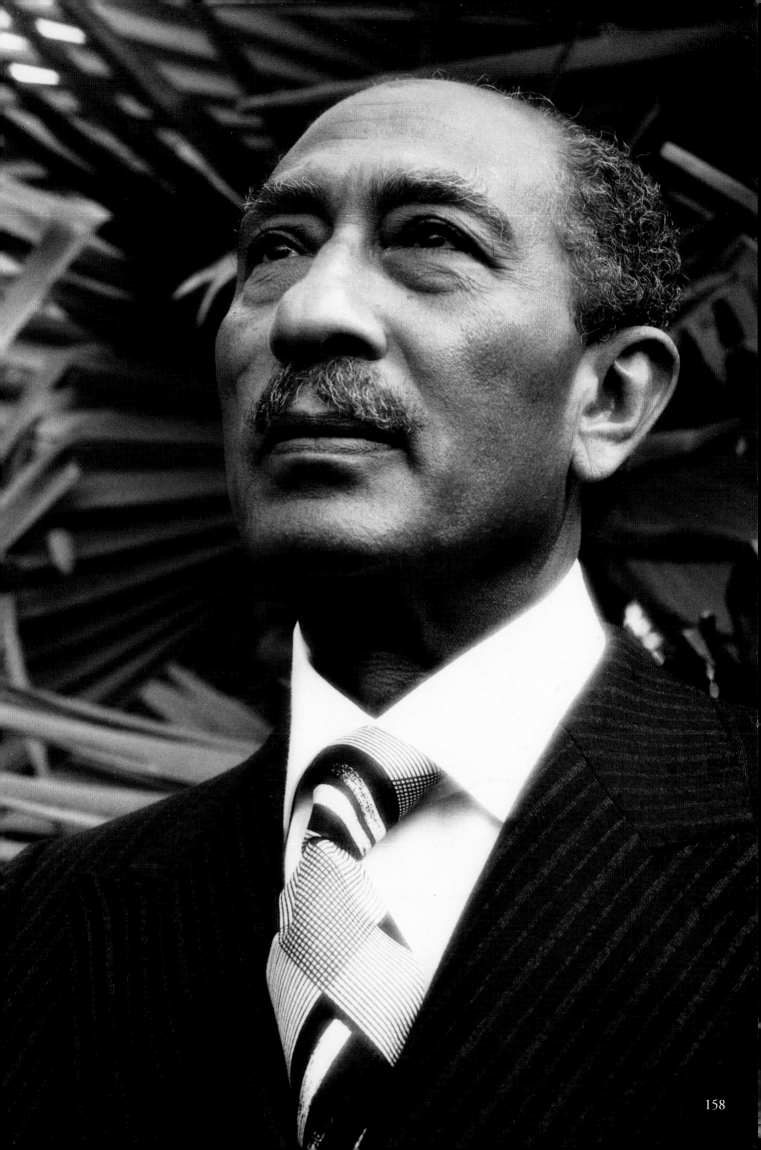

143 Maharaja and Maharani of Kashmir, Srinagar, India, in the early sixties.

Peggy Guggenheim had agreed to accompany me on the first leg of my India tour, and we were invited to stay with Karan Singh, the Maharaja of Kashmir, but in the twilight we lost our way and wandered aimlessly in search of the elusive palace, until suddenly there it was – all fairy-like minarets, balconies and gorgeous armed sentries. We stumbled in late and sweaty and full of apologies and asked if we were expected to dress for dinner. 'As you wish', said the Maharaja. … Too tired and hungry to change, we rushed to the table. To our horror, everyone else arrived in black tie and jewelled sari – except for His Highness, who appeared in emeralds and quilted caramel silk. With butlers in livery, we dined off individual jumbo silver trays.

I slept in a bed not long since vacated by the Duke of Edinburgh. It was flanked by seven stuffed rampant tigers. Peggy's bed was suspended from the bellies of four stuffed water buffaloes. In horror, she retreated to my room. 'I can't, I simply can't' – we spent the night huddled between the tigers.

144 Indira Gandhi, Prime Minister of India, New Delhi, 1969.

I photographed Mrs Gandhi beside the bamboo screens inside the Nehru Museum, formerly her father's house. She was entertaining groups of dancers who had congregated for Republic Day, and was literally flying like Mary Poppins from group to group in an attempt to greet them all individually. At the end, she was garlanded from head to toe with marigolds and jasmine.

145 Pierre Trudeau, Prime Minister of Canada, at home in a snow-bound Ottawa, January 1983.

Roloff's notes from an earlier meeting with Trudeau, when he dropped by Tiber Terrace in June 1980:

About eleven, just as some guests and I were sitting down to a late supper, we heard the sound of a great motorcade shrieking down the Tiber. Then my bell rang and over the intercom I heard the voice of Trudeau's security chief, saying: 'The Prime Minister has arrived. May we come up?'

Trudeau was a bit bored by official duties and had decided to sneak away and have a peak at my pad. Luckily, I had prepared a huge basin of Salmon Pasta à la Rome and Medicine Hat, so there was enough for the new arrivals.

'Well,' smiled Trudeau, 'I'd love to see the famous twelve million dollar archive!' He put his feet up and relaxed. I could kick myself for not photographing him, but I didn't want to intrude.

146 Grand Duchess Olga Alexandrovna, sister of Nicholas II, the last Romanov Tsar, in exile in Canada, 1959.

I had an audience with the Grand Duchess in her little white clapboard cottage near Cooksville, Ontario. She wore a necklace of pearls, and told me it had once been a knee-length strand, so long she had to loop it several times around her neck, but over the years of exile she'd sold them, one by one, till all that remained was that simple choker. Once renowned for her beauty, related to every royal family in Europe, her face was etched like a map of the Russian steppes.

147 King George VI and Queen Elizabeth, Medicine Hat, Alberta, 1939.

When I was in my early teens, I plunged into photography, inspired by my Scout Master, Colonel Bruce Buchanan. Many years later, in the mid-seventies, when I was working on my autobiography in Rome, Colonel Buchanan mailed me negatives of photographs I'd taken of King George VI and Queen Elizabeth during their first state visit to western Canada in 1939.

When I was photographing the Queen Mother at Clarence House in London with the Shahbanou of Iran in 1976 (see plate 148), I was thus able to amuse her by telling her she had been my first inspiration as a photographer, and that I had snapped her in Medicine Hat with a Box Brownie, 'and a very good camera, too!' she remarked.

148 Elizabeth, the Queen Mother, and Farah Pahlavi, the Shahbanou of Iran, at Clarence House, the London residence of the Queen Mother, 1976.

149 Constantine, King of the Hellenes and Queen Anne-Marie, at home in London, 1979.

150 King Juan Carlos and Queen Sophia of Spain, photographed at Zarzuela Palace in Madrid next to a resplendent golden galleon, a gift for their wedding from his father, 1979.

My first audience with King Juan Carlos and Queen Sophia was at Zarzuela, one of the nicest and homeliest palaces I've seen. The royal couple were handsome and welcoming, and very flattering about my books on Iran. They invited me to stay for a state dinner in honour of the Chancellor of Austria, and the next Sunday morning I was with them at their private chapel in the palace.

The Crown Prince acted as altar boy, and I took some evocative and very Spanish-looking photographs. After Mass, the royal dogs greeted us with great enthusiasm outside in the garden. I distributed cowboy hats and maple-leaf pins among the children, the King took off his tie and relaxed, the children posed with their dogs, and the Queen with her Lhasa terrier.

Suddenly, a footman appeared with an urgent message. I was to call home at once. With great difficulty, I placed a call to Canada and learned that my mother had died four days before and that my family had been trying since then to locate me. Queen Sophia said, 'Be brave, go and do your duty. But come back to us.'

151 The Shahbanou of Iran in Saadebad Palace, Tehran, 1963.

Though my interview was over, I very much wanted to photograph Her Majesty in a white dress for a collection that I was compiling of the world's most beautiful women photographed in white, and so now I made my request.

The next day, I found myself in the state reception room on the second floor when Queen Farah entered – a regal vision – wearing a deceptively simple white satin dress. She overwhelmed me with her beauty. A necklace of turquoise and diamonds was arranged at her throat and brocaded shoes twinkled on her feet. 'They are my favourites', she said. 'I wore them at my wedding.'

I felt encouraged to move her to the more subtle shadings of the vast curtained windows, where she could be in a less formal standing position and her natural grace would be revealed. I looked out over the quiet gardens and saw that the fountains were still. I had noticed how lovely they were the day before when they were playing and I wished that I had photographed them then. Hoping for a second chance, I asked the Queen if they might be turned on so that I could photograph them on my way out. 'With pleasure', she said and waved her hand in the direction of the dormant waters. Deep in the garden, a servant obeyed her signal and the fountains came to life.

152 The Shah, Shahbanou and Crown Prince of Iran in the gardens of Saadebad Palace, Tehran, 1963, during a time of severe civil unrest in the capital.

With an impatient gesture to his generals, the Shah approached me. 'Where would you like us to go, Mr Beny?' I suggested the rose gardens and he nodded, wheeled about and set off towards them. Queen Farah tried to keep up with him, but the freshly watered lawn was soft and her elegant heels kept sinking into the grass.

An aide-de-camp slowed the procession momentarily by bringing a walkie-talkie to the Shah, who was keeping

himself informed of every movement of the insurgents in the bazaar. As he talked, Queen Farah knelt sideways in her narrow skirt to retrieve the Crown Prince who was skipping about dangerously close to a pool. The Shah issued orders into the walkie-talkie in Persian, talked to his wife and child in French, and addressed me in English. The five generals stood on the steps of the palace silently watching me photograph the royal family.

153 The Duchess of Windsor, looking from the drawing room to the gardens of her Paris home in the Bois du Boulogne, 1959.

After a briefing by the secretary, I was guided into the Duchess' sitting room overlooking the park – all primrose yellow and gold, furnished in her favourite Jacobean furniture. The Duchess came briskly in, bubbling with apologies for 'the state of the house'. Apparently, she had tired of gold and beige – workmen on ladders were applying silver leaf to the panel moulding in the drawing room; she was overseeing the work. I got the impression that if they'd done something wrong she would have climbed the ladder herself and showed them the correct technique. A copy of my Thrones was before her and she insisted on going through it page by page.

Photographs of her, ah yes! Would I care to see her clothes? Coveys of French maids were summoned to open endless rows of cupboards and offer for my inspection dozens of gowns and coats and cloaks. With footmen scurrying around in the background we set to work, the Duchess graciously cooperating with all the minutiae of posing, crackling with wit in her Baltimore accent. As I worked, she described her formula for successful dinner parties (which were perhaps her major passion in life): mingle the bores with the brilliant around the table, so that the former cannot dominate any corner of conversation, and the latter will not have to compete with each other. Menus and table settings are not to be left to the staff. She dictates linen, china, silver, decorations, food, everything, and makes final

adjustments herself. Her manner towards the staff, I observed, was courteous but unbending.

154 The Duke of Windsor at home in Paris, 1959.

My biggest coup in Paris: The Duke and Duchess of Windsor. Lord Patrick Kinross, who was editing the Duke's papers, arranged it for me and briefed me on protocol.

The car left the hustle-bustle of the city behind, sped through the Bois du Boulogne and at last penetrated the wrought-iron gate with its design of gilded cords and tassels. It had been decreed: separate sittings for Duke and Duchess. She was photographed first and on the second day I was sitting in the secretary's office when the Duke popped in, preceded by mysterious snorts and clicks – his four dogs, inseparable companions, close at his heels, their nails rattling smartly on the parquet. 'Oh, hullo, Mr Beny', he said, seemingly unembarrassed by the chewed-up old slipper he held in one hand. 'I hope you find my suit appropriate for a photograph.'

Rather an understatement for the man who invented the Windsor Knot and the concept of matching tie and kerchief! In fact, no photograph I'd ever seen had prepared me for his fresh colouring and radiant vitality, nor for his easy and relaxed Grand Manner. He knew exactly how to behave before the camera and received my compliments with, 'Well, after all, I've had some practice!'

He was delighted to discover my origin from Medicine Hat which he'd visited some forty years ago. 'Alberta, you know, was named after my great aunt, Princess Louise Alberta, Queen Victoria's daughter, who married the Governor-General of Canada in the late nineteenth century.'

155 Rajmata Gayatri Devi of Jaipur campaigning for the Indian Parliament in a remote Rajasthani village in the early sixties.

156 Crown Prince of Bhutan in the bamboo gardens of the palace, Bhutan, in the late sixties.

157 His Holiness, the Dalai Lama, Simla, India, in the early sixties.

I photographed the Dalai Lama in the fake Shangri-la of Simla, where the rhododendrons were in blood-red full bloom. When I asked His Holiness why he stayed in India, he said, 'I prefer to deal with the wolves I know rather than be exploited by those I don't know.'

I found him an inspiring person; the light of his smile filled the room and seemed to fill all nature. He said goodbye with a bear-hug embrace and I felt an aura flow through me, as if I were a harp being strummed.

158 Anwar Sadat, Prime Minister of Egypt, at the Barrage, his retreat, near Cairo, 1979.

I was invited to Egypt on an official invitation and had great hopes to do a book on a country I had first visited more than twenty years earlier.

All three private audiences with the Prime Minister were exceptionally moving and particularly so when I think back to his courage and to what was soon to happen to him. He was always relighting his pipe and he looked into space a great deal, speaking very quickly with a beautiful sonorous command of English, which was quite amazing when you think of his humble background.

I showed him my books and portfolios, and he looked thoughtfully at each photograph. When I said I was concerned I would not be able to say anything new about such an ancient civilization as Egypt, he insisted I would see it in a new way. He always wore splendid high boots, up to the knees, and usually dressed in black, very casual and very elegant, or in splendidly tailored suits. I photographed him in one of those suits, on a day he was receiving a lot of ministers at his favourite retreat – the Barrage.

Sadat often urged me to work quickly on the book and as if he had a premonition, the last time we met he added, 'When destiny is there, you must take it by the hand.' He was a magnanimous and courageous person, perhaps the most impressive world leader I have met.

INDEX OF PORTRAITS

Numbers refer to the plates

Endpapers: Crossing the desert near the ruins of Leptis Magna, Libya.
The vignettes on the chapter openers and on p. 208 are taken from
Greek figure vases, a choice made in view of Roloff Beny's
special interest in this art.
Opposite: Hellenistic bronze mask of tragedy, found in Piraeus,
sea-port of Athens.

PHOTO CREDITS
From the Siebens gift to the University of Calgary: The Nickle Arts Museum of
"A Visual Odyssey" by Roloff Beny, 26, 89, 102–3, 135, 156

Text and photographs © 1995 Roloff Beny Collection, Accession No. 1986–009,
Documentary Art and Photography Division, National Archives of Canada,
Room 326, 395 Wellington Street, Ottawa, Ontario KIA ON3

Douglas & McIntyre
1615 Venables Street
Vancouver, British Columbia V5L 2H1

Published simultaneously in Britain by Thames and Hudson,
30 Bloomsbury Street, London WC1B 3QP

Canadian Cataloguing in Publication Data

Beny, Roloff, 1924-1984.
 People: legends in life and art

ISBN 1-55054-435-7

 1. Beny, Roloff, 1924–1984. 2. Portrait photography. I.
Crites, Mitchell. II. Title.
TR680.B46 1995 779'.2'092 C95–910268–X

Printed and bound in Singapore

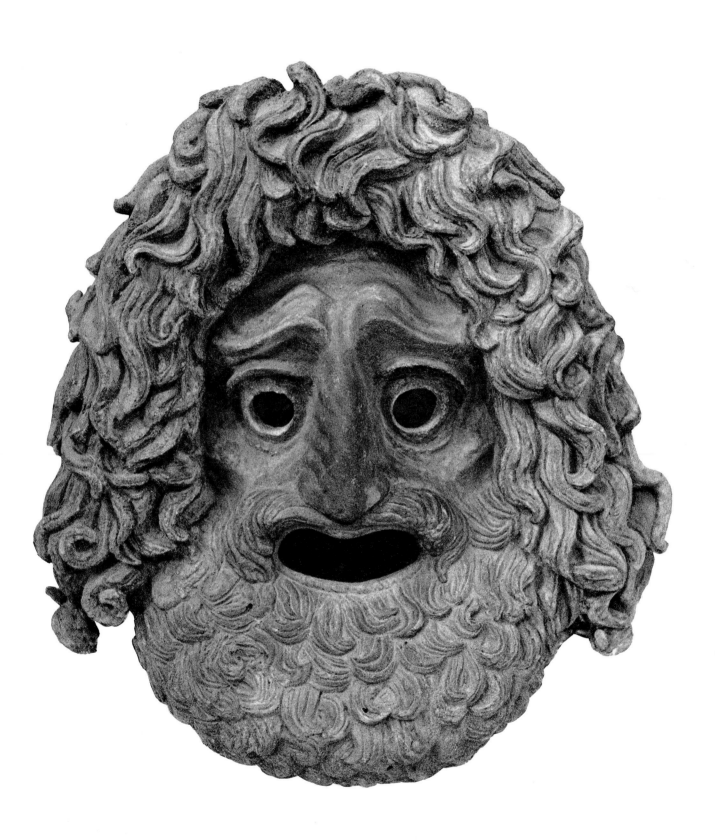

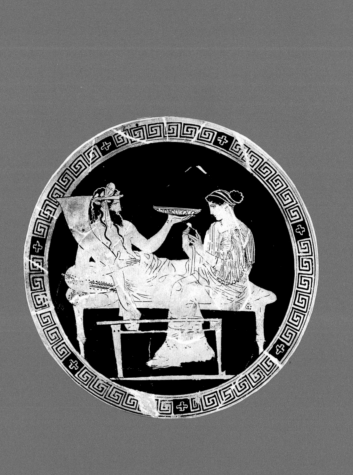

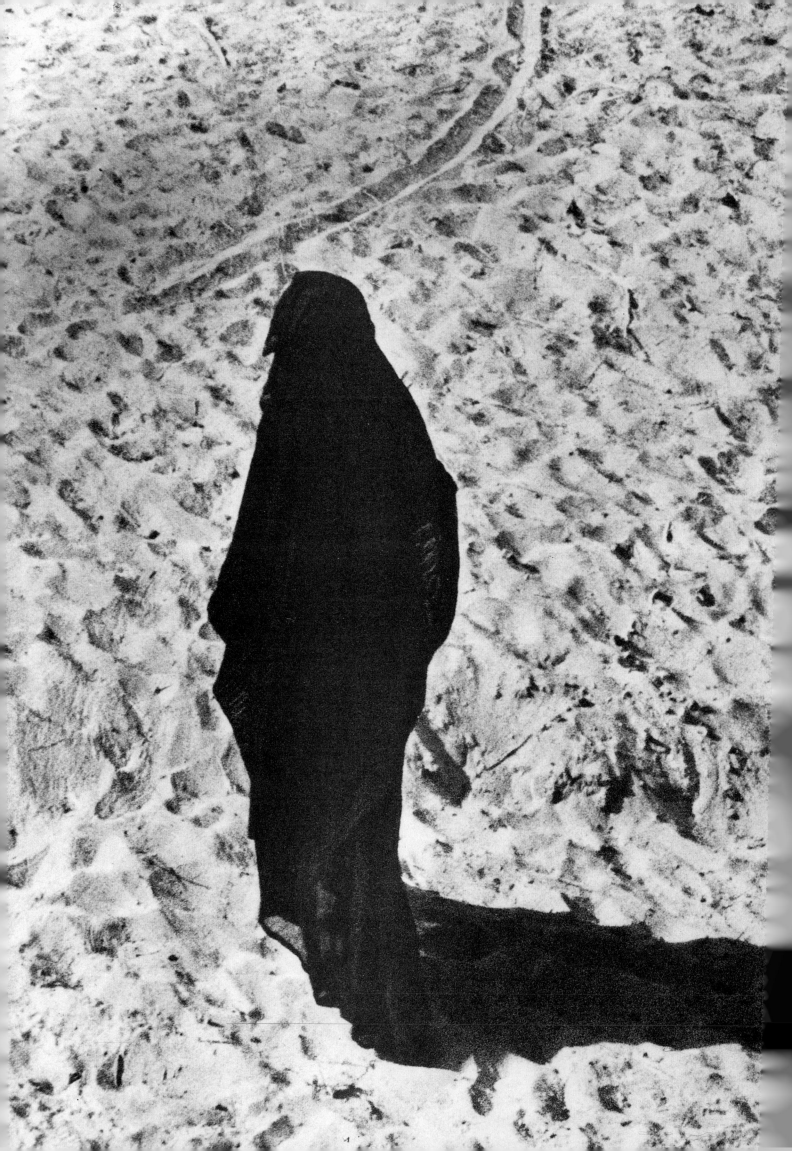